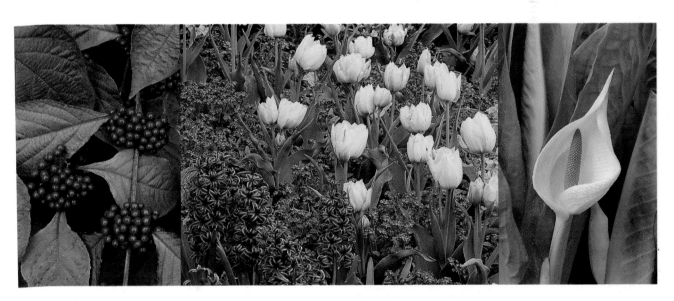

PHOTOGRAPHING
PLANTS & GARDENS

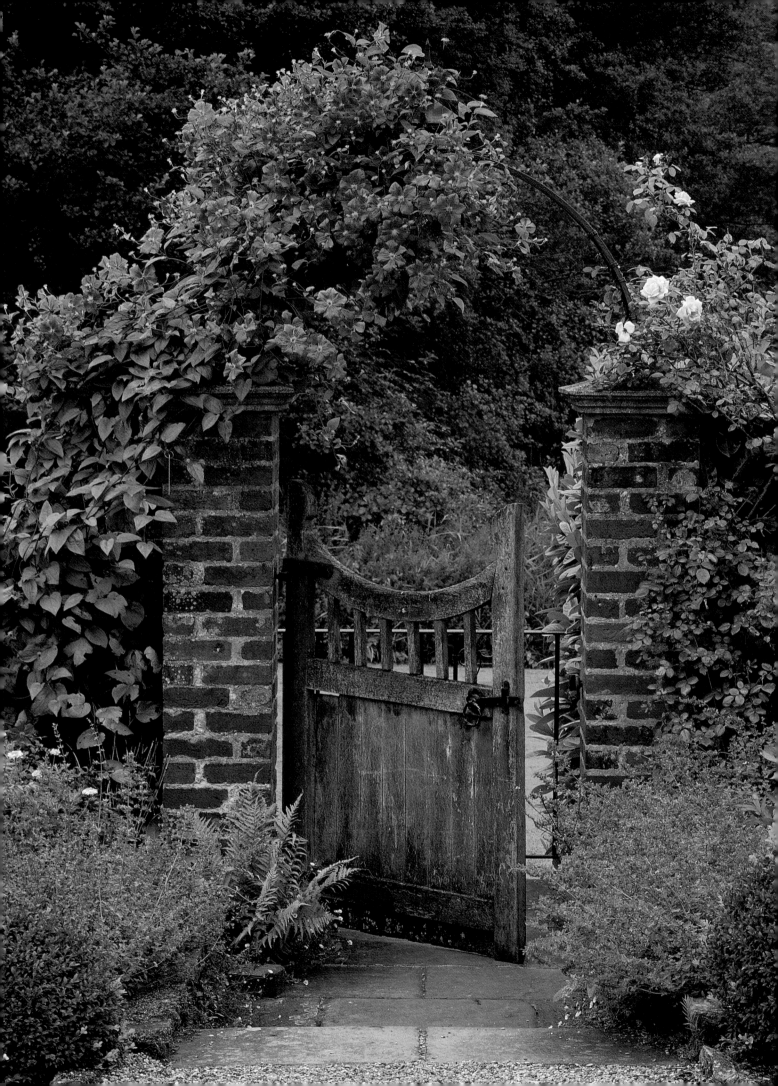

PHOTOGRAPHING
PLANTS & GARDENS

Clive Nichols

Published in association with
THE ROYAL HORTICULTURAL SOCIETY

David & Charles

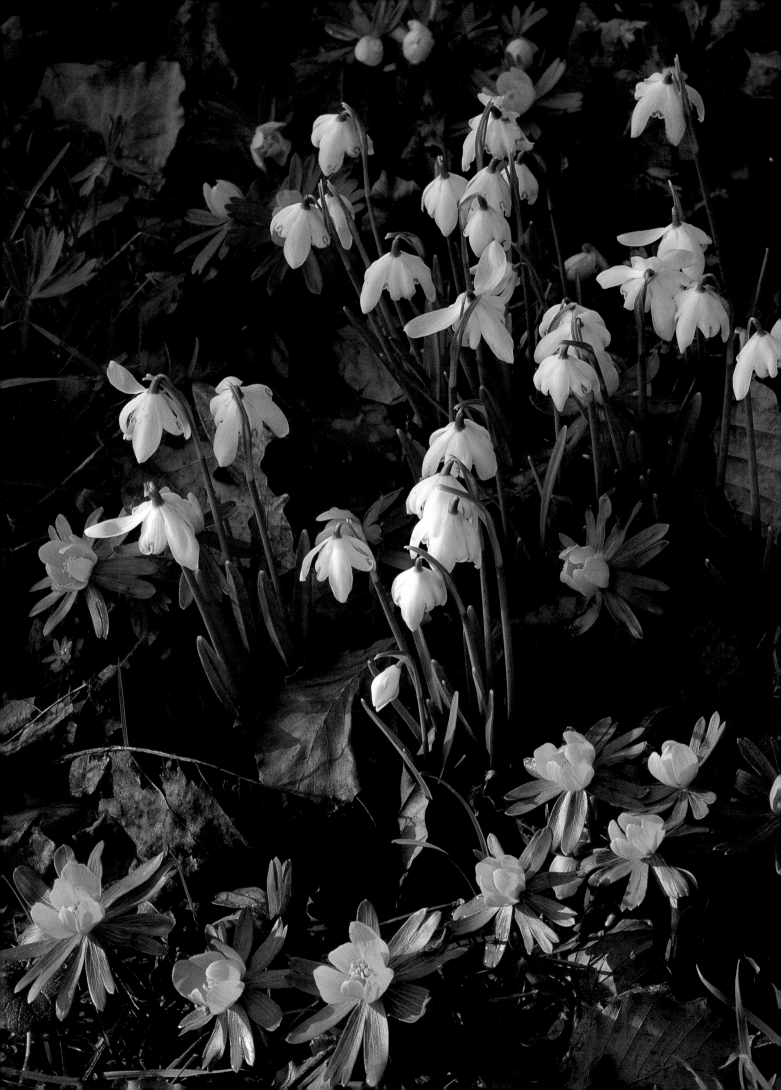

FOREWORD

Our gardens, large or small, are an important part of our lives, giving us deep emotional satisfaction, beauty and, yes, fresh air and exercise. Since the late nineteenth century, when cameras became widely available, both public and private gardens have been recorded with great enthusiasm but varying results.

Having been a keen photographer I, as much as anyone else, like to record the plants in my own garden and those that I see in my travels. I am always interested in learning how to take ever better photographs. In this lavishly illustrated book, Clive Nichols, master garden photographer explains the whys and wherefores to novice photographers, those with average skills and the more accomplished, all of whom want to take good photographs of plants and gardens.

The technology inherent in cameras, those most marvellous of 'toys', suggests that the camera will do all the work. However, as the author points out, 'even the most sophisticated computer-controlled camera still depends on the skill and aesthetic judgement of the photographer.' Despite having no photographic training Clive Nichols has achieved a successful career taking stunning photographs. Who better to understand and explain with advice, hints and illustrations how to become the photographer we all want to be?

The Royal Horticultural Society Gardens at Wisley, Rosemoor and Hyde Hall are more popular than ever, and garden centres everywhere tempt the home gardener with a wealth of interesting and irresistible plants. With your camera, and this book, you will be able to record plants and gardens in photographs that will accurately reflect beauty that is often only too fleeting.

GORDON RAE
DIRECTOR GENERAL
THE ROYAL HORTICULTURAL SOCIETY

Low-angled winter sunshine casts a warm glow over these aconites and snowdrops.

(Pentax 6 × 7, 55mm wide-angle lens, Fujichrome Velvia, f22, tripod. The Dower House, Gloucestershire.)

FRONT COVER INSET:
These beautiful 'Belle Amour' roses were captured early one summer morning.

(Olympus OM2, 90mm macro lens, Fujichrome Velvia, f22, tripod, Hadspen House, Somerset.)

BACKGROUND ILLUSTRATION:
The uniformity of colour and elegant curves of these hosta leaves create a striking composition when photographed from directly above.

(Olympus OM2, 90mm macro lens, Fujichrome Velvia, f22, tripod.)

PAGE 1:
(Left) Soft, early morning light coupled with the quality of the film saturate the violet fruits of *Callicarpa bodinieri* var. *giraldii*. The triangular arrangement of the berries is echoed by the leaves and dark background, strengthening the composition of the image.

(Olympus OM2, 90mm macro lens, Fujichrome Velvia, f22, tripod.)

(Centre) A telephoto lens has compressed the perspective in this photograph of tulips and hyacinths growing in a raised bed, making the flowers appear closer to each other than they actually were in reality. The strong, complementary colours within the composition automatically attract the viewer's attention.

(Olympus OM10, 80–200mm zoom lens, Fujichrome Velvia, f32, tripod, Harrogate, Yorkshire.)

(Right) This creamy white spathe of *Lysichiton camtschatcensis* was photographed beside a stream. I used my zoom lens to 'jump' the stream and produce a frame-filling portrait from a distance of 6m (20ft).

(Olympus OM2, 80–200mm zoom lens, Fujichrome Velvia, f32, tripod, Savill Garden, Surrey.)

PAGE 2–3:
(Left) The shape of this delightful arched gate, covered in *Clematis* 'Perle d'Azur', dictated the choice of a square picture format.

(Bronica 6 × 6, 150mm lens, Fujichrome Velvia, f16, tripod. Vale End, Surrey.)

(Above) Strong, early morning sidelight coupled with choice of film add punch to this exquisite association of *Allium christophii*, *Scabiosa* 'Butterfly Blue', *Linum perenne* and *Mertensia simplicissima*.

(Pentax 6 × 7, 55m wide angle lens, Fujichrome Velvia, f22, tripod. Ashtree Cottage, Wiltshire.)

(Below) I used the soft light of early morning to photograph this planting of roses, hostas and nepeta. I under-exposed by around 1/2 stop in order to saturate the colours in the transparency.

(Pentax 6 × 7, 55m wide-angle lens, Fujichrome Velvia, f22, tripod. The Nepeta walk, The Old Rectory, Sudborough, Northamptonshire.)

FOR MY WIFE, JANE

A DAVID & CHARLES BOOK

Copyright © Clive Nichols 1994, 1998

First published 1994
First paperback edition 1998

Clive Nichols has asserted his right to be identified as author of this work in accordance with the Copyright, Designs and Patents Act 1988.

A catalogue record for this book is available from the British Library.

ISBN (hardback) 0 7153 0135 7
ISBN (paperback) 0 7153 0715 0

Printed in Italy by LEGOSpA, Vicenza for David & Charles
Brunel House Newton Abbot Devon

CONTENTS

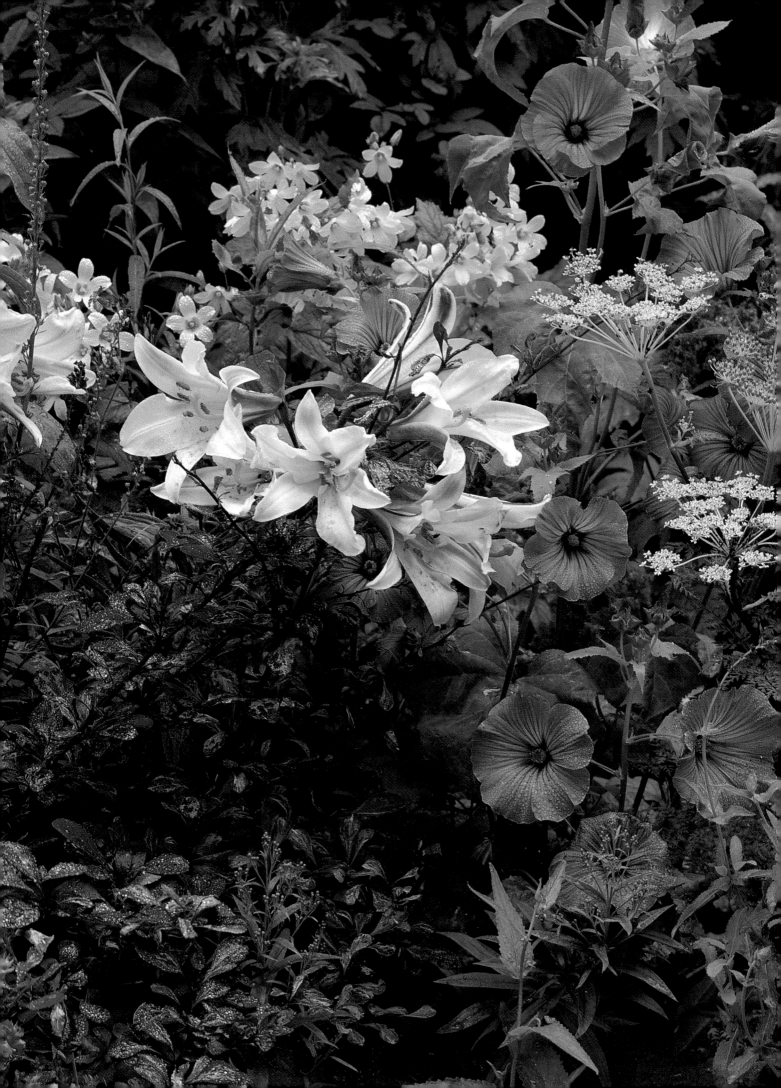

INTRODUCTION

During the past decade interest in gardening has grown to the point where it is now the number one hobby in Britain. Garden centres and nurseries have been thriving, attendance at the Chelsea Flower Show and The Hampton Court Palace Flower Show has reached record levels, and membership of the Royal Horticultural Society has risen to almost 200,000. Alongside this surge of interest in gardens and gardening has been a rapid increase in the number of books, magazines, calendars and partworks devoted to the subject. As a result, the demand for garden and plant photographs has increased and more and more photographers are specialising in this area.

It is a myth that a formal training in photography and a sound knowledge of horticulture is required to become a 'good' garden photographer. In this book I have tried to show that taking great photographs of flowers and gardens is not always as difficult as many people may think. When I first began taking garden pictures in 1989, I barely knew the difference between a peony and a petunia and having no real garden of my own, I was also forced to use other locations to practise my photography. Thankfully, there are many beautiful gardens open to the public and these paradises soon became my workplace. By trial and error, I improved my photographic technique and horticultural knowledge as I went along.

I owe a lot to the owners of the gardens. I am still amazed by their incredible generosity and tolerance. I would like to thank them all, for without their help this book could never have been produced.

CLIVE NICHOLS

Soft, diffused light and gentle rain illuminate this association of lilies, lavatera and berberis.

(Bronica 6 × 6, 80mm standard lens, Fujichrome Velvia, f22, tripod.
28 Hillgrove Crescent, Kidderminster, Worcestershire.)

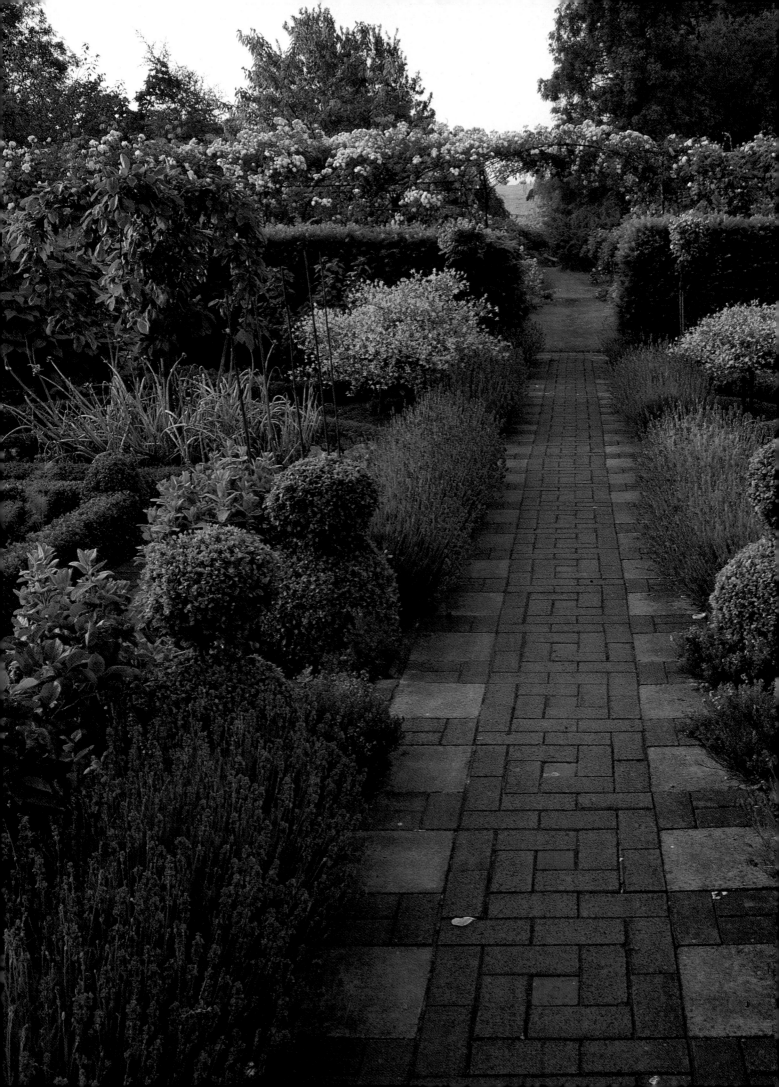

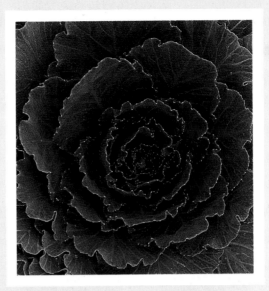

EQUIPMENT

✿ (Top) For this shot of a decorative cabbage I pointed the camera down into the heart of the cabbage from directly overhead.

(Olympus OM2, 50mm standard lens, Fujichrome Velvia, f22, tripod. Great ornamental potager, Château de Villandry, Loire valley, France.)

✿ (Above) Here a short telephoto lens compresses perspective thereby emphasising the juxtaposition of colours.

(Bronica 6 × 6, 150mm short telephoto lens, Fujichrome Velvia, f16, tripod. Sticky Wicket garden, Dorset.)

✿ (Left) A wide-angle lens intensifies the illusion of depth in the picture. A small aperture also ensures that the image is in sharp focus. The photograph was taken shortly after sunrise.

(Pentax 6 × 7, 55m wide-angle lens, Fujichrome Velvia, tripod. Potager, The Old Rectory, Sudborough, Northamptonshire.)

First Decisions

It is important to realise that good photographic equipment on its own will not produce stunning plant and garden images. Even the most sophisticated computer-controlled camera still depends on the skill and aesthetic judgement of the photographer to produce outstanding pictures. It is the individual photographer's choice of subject, composition and lighting that usually makes the difference between adequate photographs and exceptional ones. Cameras, lenses and accessories are simply the tools used in the production of these photographs.

From the huge range of photographic equipment currently on offer, what items are important to the aspiring horticultural photographer? You should start by deciding exactly what kind of subjects you wish to photograph and then try to work with as little equipment as possible. If, for example, you are interested in building up a collection of flower portraits, then a simple 35mm SLR camera with a macro lens will probably be adequate for your needs. Later on, you may decide that you want to take some garden vistas as well as just portraits; that is the time to purchase a wide-angle or telephoto lens. Only add extra lenses and accessories when you feel that there is a burning need for them. There is no point in spending heaps of money on expensive, back-breaking gear if you don't need it.

It is important to purchase good quality, reliable equipment at all times.

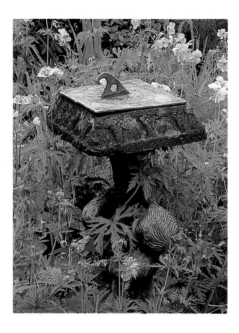

❦ A telephoto lens has picked out this sundial. To keep everything sharp I used a small aperture and as usual mounted the camera on a sturdy tripod.

(Olympus OM2, 300mm telephoto, Fujichrome Velvia, f32, tripod. East Lambrook Manor, Somerset.)

❦ Once you have become competent at handling the 35mm format you may decide to try out medium-format photography, like this shot of a border in the walled garden at Mottisfont Abbey.

(Pentax 6 × 7, 135mm short telephoto lens, Fujichrome Velvia, f32, tripod. Mottisfont Abbey (National Trust), Hampshire.)

If you can afford to buy brand new, then you should do so, for although second-hand equipment is considerably cheaper, it can often be unreliable. If you do decide to buy second-hand, always make sure that the equipment you purchase comes with a six-months' or a year's guarantee.

Before you begin to use a new piece of equipment, familiarise yourself with its features by studying the instruction booklets supplied with it. Do not become too disillusioned if your first results with a new piece of equipment turn out to be a little disappointing. Remember that in garden photography, as in all photography, practise makes perfect. So keep trying!

PROFESSIONAL·TIPS

FIRST DECISIONS

❦ Choose a camera suited to your main subject; start with a simple one, adding accessories as you need them.
❦ Buy new in preference to second-hand, unless you have good guarantees.
❦ Look for these useful features: through-the-lens metering, semi-automatic metering, depth-of-field preview button, cable release socket.

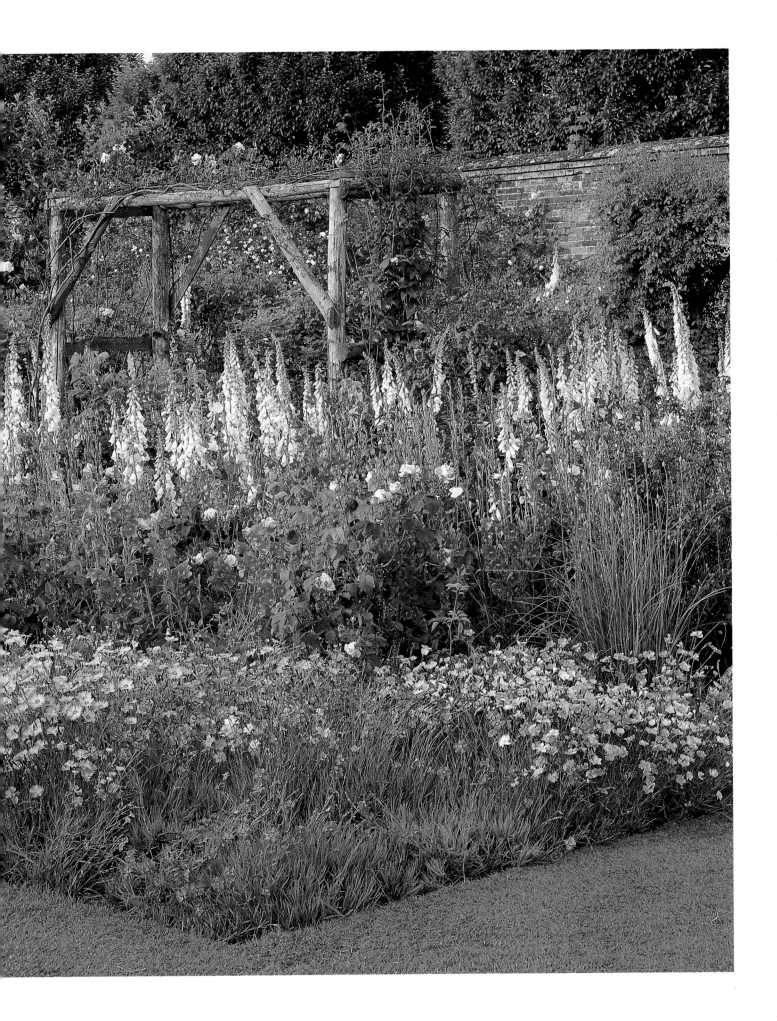

The Camera

Many of the cameras produced today are highly automated machines, relying almost entirely on electronics and built-in computers to control functions of the camera that were traditionally operated manually. As a result, facilities such as through-the-lens metering and automatic focusing have made cameras easier to use than ever before. But how do you begin to choose from the different makes and models currently on offer?

First, decide what you actually want the camera for. If, for example, you want a simple camera for snapshots of flowers and garden scenes, then a compact camera, which slips easily into your pocket and is fully automatic, should be perfectly adequate for your needs. If, on the other hand, you are likely to need a camera which has interchangeable lenses for great latitude in framing and composition, then you will need a single-lens reflex (SLR).

Single-lens reflex (SLR) cameras use a mirror, positioned at an angle of 45° between the film and the lens. When an exposure is not taking place, the mirror reflects the light coming through the lens upwards on to a focusing screen and pentaprism, allowing the photographer to see exactly the same image as the one that will be recorded by the film, no matter what lens is being used. To make the exposure, the shutter is released and the mirror flips upwards, blocking off the focusing screen and allowing the light to be transferred on to the film. When the exposure is completed, the shutter closes and the mirror returns to its original position, enabling the photographer to compose the next image.

The major advantage of SLR cameras is that they are able to accept lenses of different focal length very easily – some makes have as many as sixty or more interchangeable lenses to choose from. Also, unlike fixed-lens cameras, SLRs are 'system cameras', backed up by a whole range of impressive accessories which make even the most specialised areas of photography accessible.

Given that there is a growing trend towards automation, how sophisticated should your camera system be? While some features are undoubtedly of use to the flower and garden photographer, there are many which merely serve to complicate the picture-taking process. I have detailed on the following pages those features that I have found to be especially useful.

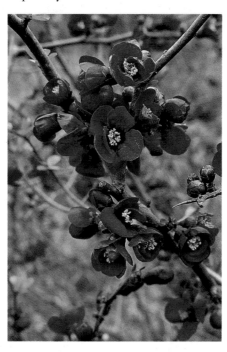

✿ The rich red flowers of *Chaenomeles* 'Jane Taudevin' appear in early spring. For this portrait I used a simple SLR 35mm camera and a macro lens.

(Olympus OM2, 90mm macro lens, Fujichrome Velvia, f16, tripod.)

✿ For this view of the ornamental potager at Barnsley House I chose a low viewpoint, used a wide-angle lens and stopped down to f22 for maximum depth of field.

(Pentax 6 × 7, 55mm wide-angle lens, Fujichrome Velvia, f22, tripod. Barnsley House, Gloucestershire.)

Through-the-Lens (TTL) Metering

Through-the-lens (TTL) metering measures the light entering the camera through the lens and is a feature common to most SLR cameras sold today. TTL meters are built into the camera's reflex viewing system and their readings are based upon the amount of light being reflected by the subject being photographed. Although TTL meters cannot be relied upon to give accurate exposure readings in every lighting situation, there is no doubt that they have helped to simplify the process of exposure calculation in flower and garden photography.

TTL meters are built into the camera, so a separate, hand-held light meter is not essential. Also, because they 'read' the light that actually passes through the lens, they are able to adjust automatically with changes in angle of view, lighting conditions and filters fitted to the lens. TTL metering has also made extreme close-up photography much more straightforward. Extension tubes and macro lenses move the lens further away from the film plane, thereby reducing the amount of light reaching the film. Calculating exposures for close-ups is especially difficult with a hand-held meter as an allowance for the loss of light incurred by extending the lens must be made manually. With TTL metering, the light loss is automatically taken into account.

A more detailed account of TTL meters and how they work is given in the section on Using the Light Meter (see p 60).

❀ For this autumnal shot of *Rosa* 'Elizabeth of Glamis', I set the aperture on my zoom to f8 in order to keep the roses sharp and throw the background out of focus. I then let the camera's through-the-lens-meter work out the appropriate shutter speed.

(Olympus OM2, 80–200mm zoom lens, Fujichrome Velvia, f8, tripod. Eastgrove Cottage Garden, Sankyns Green, Worcestershire.)

❀ To photograph this *Dahlia* 'Ellen Houston' I set a small aperture to obtain maximum sharpness in the flower and the camera's through-the-lens meter then worked out the shutter speed.

(Olympus OM2, 90mm macro lens, Fujichrome Velvia, f22, tripod. Hadspen House, Somerset.)

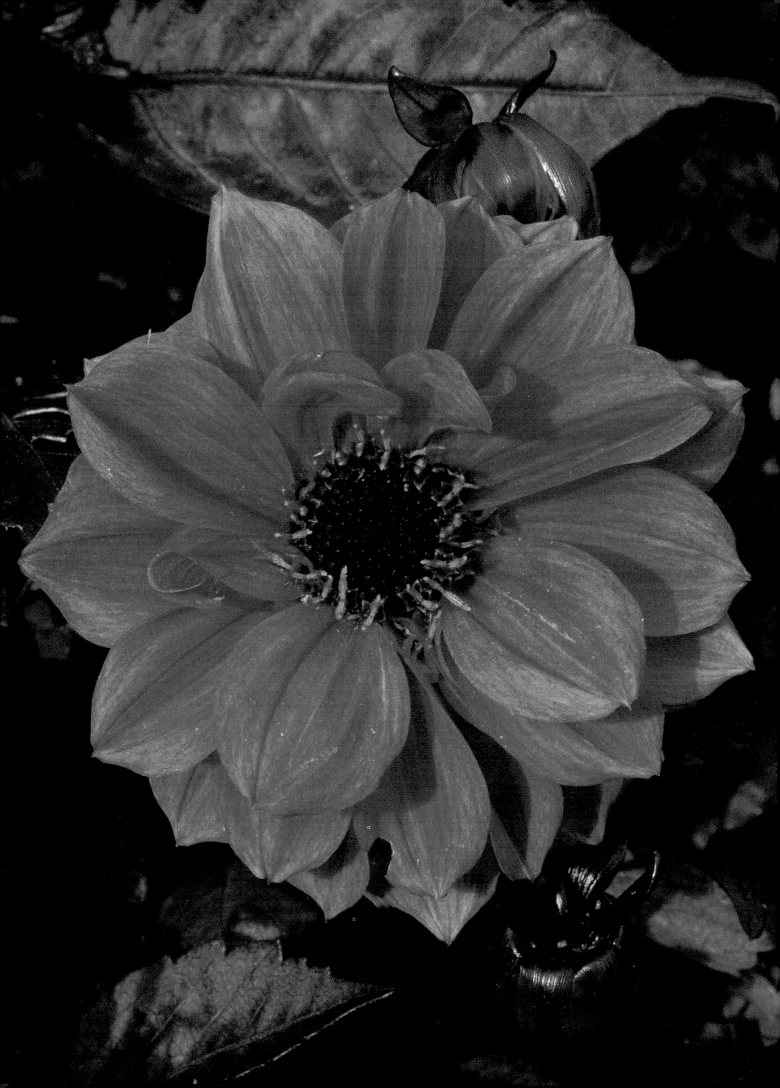

Semi-automatic Metering Systems

Exposure – the intensity of light that acts on the film – is controlled by a combination of lens aperture and shutter speed. While the lens aperture setting determines the depth of field in a photograph (see Depth-of-Field Button, p 20), the shutter speed is important for stopping or freezing movement (fast shutter speed) or for recording moving subjects as a blur (slow shutter speed).

Many through-the-lens meters are linked directly to the camera's controls, so that either one or both of these exposure settings can be set automatically according to the readings given by the camera's TTL meter. Fully automatic systems, which set both shutter speed and lens aperture are of little use to the serious photographer because they do not necessarily choose the most suitable combination of aperture and shutter speed that a subject demands. Much more versatile are the two semi-automatic systems – aperture priority and shutter priority. Aperture priority systems allow the photographer to set the aperture (or f-stop) manually, and then automatically select the shutter speed. Shutter priority systems, on the other hand, automatically select the lens aperture once the photographer has decided on the appropriate shutter speed.

Over the years I have found the aperture priority system to be the most useful for flower and garden photography. This is because most subjects in this area of photography are fairly static, so controlling the amount of the scene that is sharply recorded – the depth of field – is often more crucial than selecting a certain shutter speed to control subject movement. When I am shooting a garden vista, for example, I usually like to show the maximum amount of detail in the scene, so I set the smallest aperture possible to give maximum depth of field and let the camera sort out the appropriate shutter speed. For a different subject – say, for example, a close-up of a poppy flower – I may want to show the flower itself as sharp but throw the background completely out of focus. Hence I would select a wider aperture setting to minimise the depth of field and again allow the camera to work out the corresponding shutter speed.

I used the aperture priority system to record this wall-mounted mask by setting the aperture to f16 and letting the camera work out the appropriate shutter speed.

(Olympus OM2, 80–200mm zoom lens, Fujichrome Velvia, 1/30 sec f16, tripod. Het Loo, Holland.)

My Pentax 67 camera is operated manually, so for this shot of a poppy I set an aperture of f16 and then took a separate, hand-held reading to find the appropriate shutter speed.

(Pentax 6 × 7, 135mm macro lens, Fujichrome Velvia, f16, tripod. The Anchorage, Kent.)

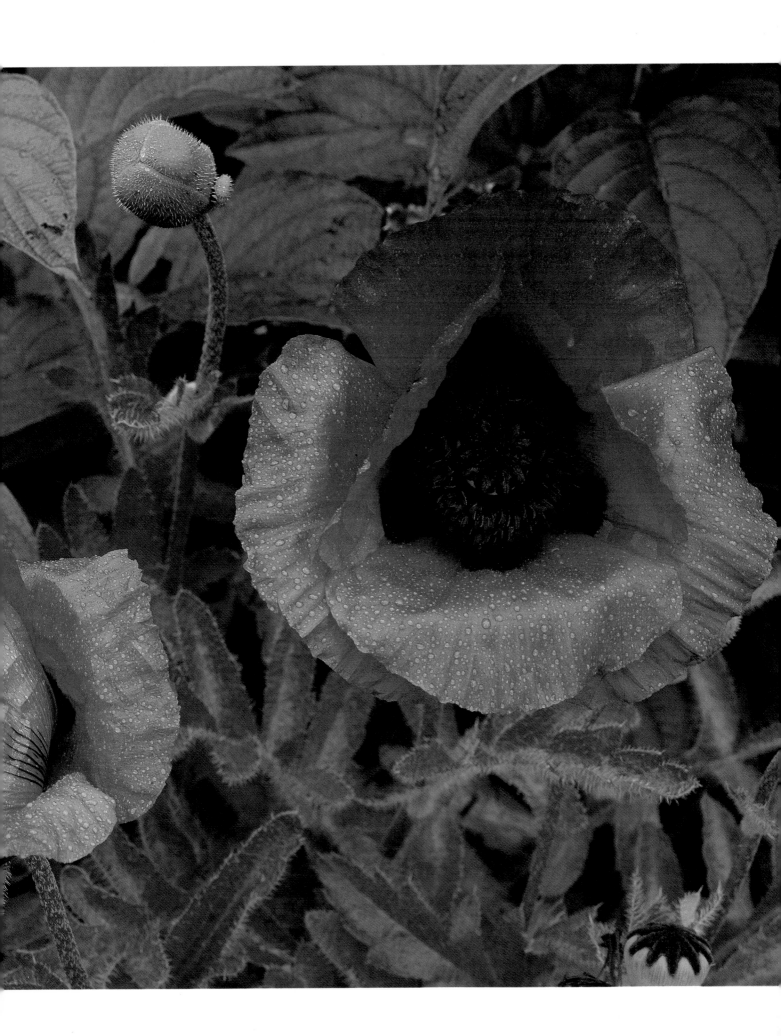

Depth-of-Field Button

Whenever a camera is focused on a subject, there is an area in front and behind the point of focus which appears acceptably sharp in the finished photograph. This zone of acceptable sharpness is known as the depth of field and its extent is controlled mainly by adjusting the lens aperture – the smaller the aperture opening, the greater the depth of field will be.

The depth-of-field button can be used to close down manually the lens iris to the pre-selected aperture setting before taking a photograph, thereby allowing the photographer to check how much of the subject in the frame is in sharp focus. It is invaluable for ensuring that a distracting background has been thrown completely out of focus or that a broad garden vista is pin-sharp from front to back.

Without a depth-of-field button, you will have to imagine the effect that any change of aperture will have on depth of field, because when an exposure is not taking place, the iris is fixed at its widest aperture to allow the maximum amount of light in through the lens so that the viewfinder is as bright as possible. I therefore recommend that if you purchase a new camera you choose one with a depth-of-field button.

✿ (Top) To freeze the movement of this bee on an helenium flower I needed to use a very fast shutter speed of around 1/500 second. As my Olympus is an aperture priority camera the only way to achieve this speed was to use the maximum aperture on my macro lens. Because of the lack of depth of field at such a large aperture the background has been thrown completely out of focus, concentrating the viewer's attention on the bee.

(Olympus OM2, 90mm macro lens, Fujichrome Velvia, 1/500 sec f2.5, tripod.)

✿ (Left) I used the depth-of-field preview button on my 90mm macro lens to check that the background did not detract from the osteospermum flower. A high viewpoint makes the flower appear to be floating in mid air.

(Olympus OM2, 90mm macro lens, Fujichrome Velvia, f4, tripod.)

✿ (Right) The depth-of-field preview button was depressed to check that this vista was pin-sharp from front to back.

(Pentax 6 × 7, 55mm wide angle lens, Fujichrome Velvia, f22, tripod. Brook Cottage, Oxfordshire.)

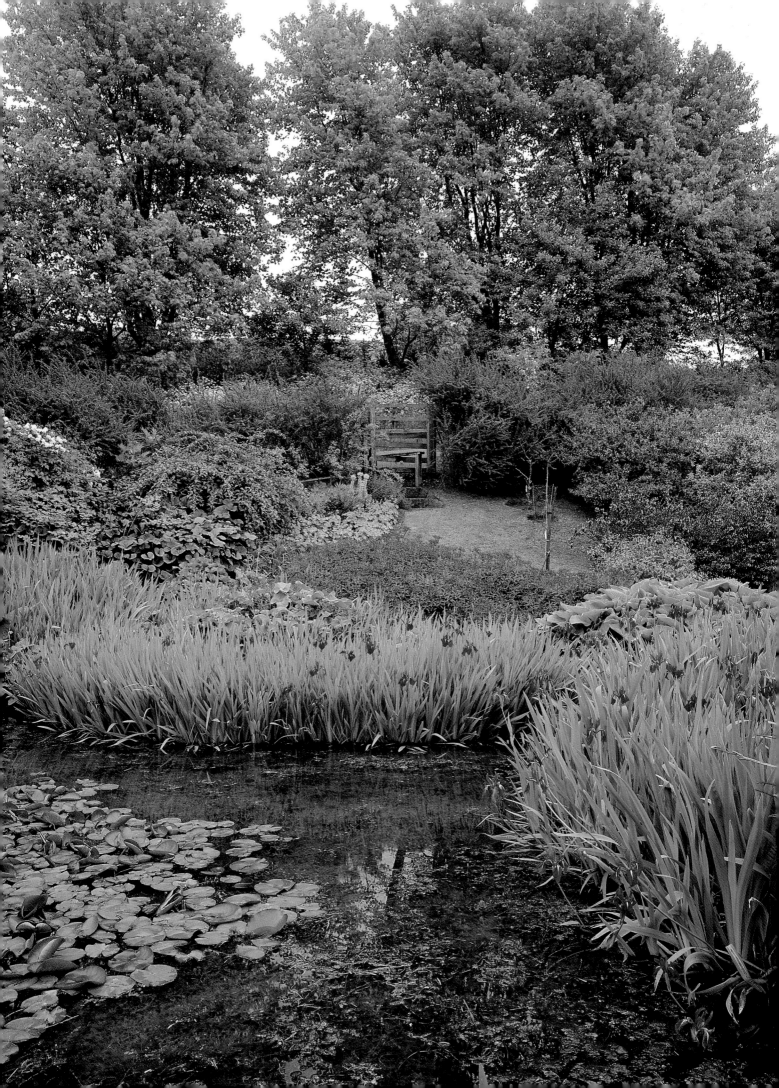

Camera Format

35MM FORMAT

The largest range of cameras, films and accessories is available in the 35mm format, which produces a rectangular image on film of 24 × 36mm. Up to thirty-six pictures can be taken on just one roll of film and the 35mm format is ideal for projection, as transparencies conveniently fit into universally available slide projectors. 35mm negatives are also large enough to allow high quality enlargements to be made from them.

Compacts are the simplest type of camera that use 35mm film. To view the subject being photographed, you simply look through the viewfinder at the top of the camera body. The light that actually reaches the film, however, takes a slightly different route and enters the camera via the lens. The difference between what your eye actually sees through the viewfinder and what the lens 'sees' is called parallax error. Although normally only a problem when photographing very close subjects, parallax error can spoil a photograph if it is not taken into consideration. For this reason, compact cameras display parallax correction marks in their viewfinders and keeping your subject within these marks will help to avoid any compositional problems.

Another drawback with compact cameras is that they have only one lens, which cannot be taken off the camera body. Although the more advanced compacts now feature a zoom lens for greater flexibility in framing and composition, none of them come close to offering the range of focal lengths of the SLR system.

In 35mm SLRs, the image is reflected from the mirror to a pentaprism, which enables the photographer to see, at eye level, exactly how the finished photograph will look. For this reason, parallax error is never a problem. Furthermore, because viewing is directly through the lens, focusing, depth of field and the effects of different lenses and filters can all be assessed easily before a picture is taken. Lenses can be changed on location with the minimum of effort and the camera's small size makes it very portable and easy to handle – important considerations in outdoor photography where the light and weather can change in an instant.

Not surprisingly, then, the 35mm SLR is the most popular camera. It is also the camera that the majority of today's professional garden photographers choose to work with.

Although advertisements will tell you that one make of 35mm SLR will perform better than another, in practice, there is very little difference between makes. All of the major camera manufacturers produce a very high quality product.

MEDIUM FORMAT

Many photographers begin to use a medium-format camera after they have become accustomed to the 35mm format. Medium-format cameras use 120 roll film (or 220, its double-length version), but the size of the image produced varies according to the make of camera being used. The Hasselblad, Bronica SQA and Rolleiflex, for example, produce 12 square images on a roll of 120 film that are $2\frac{1}{4} \times 2\frac{1}{4}$in ($6 \times 6$cm) in size. The Mamiya 645 and the Pentax 6×7, on the other hand, both yield rectangular pictures, one being 6×4.5cm, the other 6×7cm. There are also models available from Fuji which produce 6×8cm or 6×9cm images. Panoramic cameras, such as the Fujica 617 or Linhof Technorama, produce just 4 frames on 120 film that are roughly 6×17cm in size.

Most medium-format SLRs, such as models from Hasselblad and Bronica, come fitted with a standard viewfinder which requires the image to be viewed from waist level on a ground-glass screen mounted on top of the camera. What the photographer sees on the ground glass is what will appear in the final picture, only reversed from left to right. What this means in practice is that as the camera is moved to frame a scene, the image on the ground glass moves in the opposite direction, which takes a little getting used to. Thankfully, most medium-format SLRs can also be fitted with a pentaprism, which allows eye-level viewing and shows the image as laterally corrected.

The main advantage of using medium format as opposed to the 35mm format is that larger transparencies and negatives are produced. To the professional garden photographer who is trying to place work in printed media such as books, calendars, greetings cards and magazines, this can be a real boon. Most art buyers prefer to use medium-format transparencies whenever possible because, when reproduced, they exhibit greater sharpness and shadow detail than 35mm transparencies. Many of the images in this book have been reproduced from medium-format transparencies.

Several makes of medium-format camera also have interchangeable backs, which allow the photographer to change from one type of film to another, even in mid-roll. Polaroid backs can also be fitted so that a Polaroid test shot can be taken to check lighting, exposure and composition of a picture before the photograph is actually taken on negative or transparency film.

The main drawback with medium-format cameras is that they are very

PROFESSIONAL·TIPS

CAMERA FORMAT

❀ **M**ost garden photographers prefer a 35mm SLR. It is light, quick to use and lenses can be changed on site.
❀ **T**o produce transparencies with greater sharpness and shadow detail, use the medium format; some makes also have interchangeable backs. Medium format cameras tend to be expensive and bulky.
❀ **L**arge format cameras have good image quality but are slow and expensive to use.

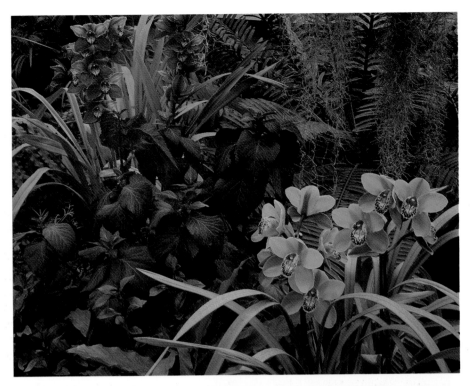

❧ By far the most popular format with plant and garden photographers today is the 35mm format. This picture shows a portrait of *Iris unguicularis* which was taken early in the morning with a macro lens on my Olympus OM2.

(Olympus OM2, 90mm macro lens, Fujichrome Velvia, f22, tripod.)

❧ This large-format photograph of orchids was taken on a sheet of 5 × 4in (12.7 × 10.2cm) film and is reproduced life-size. I used a very small aperture for maximum sharpness.

(MPP 5 × 4, 250mm standard lens, Fujichrome Velvia Quickload, 4 sec f64, tripod. Orchid House, RHS Garden, Wisley, Surrey.)

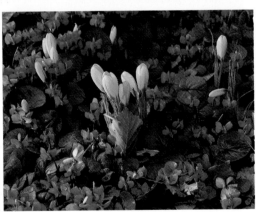

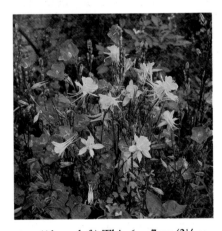

expensive and considerably more bulky than the 35mm camera system.

LARGE FORMAT

Sometimes referred to as 'view cameras' or 'technical cameras', large-format cameras are designed to take individual sheets of film in sizes such as 5 × 4in (12.7 × 10.2cm) or 10 × 8in (25 × 20.3cm). They have no viewfinder, and the picture is focused on to a ground-glass screen directly behind the lens. The image appears upside down on the screen, but at least it is possible to see exactly how the finished picture will look. Once the image has been composed and focused, the ground-glass screen is moved away and a sheet of film in a dark-slide holder is inserted, ready for exposure.

Large-format cameras deliver the ultimate in image quality, but unfortunately their use tends to be limited to the indoor studio and very few professional garden photographers ever attempt to work in this format. The reason for this is that most garden photographers do their work on location where speed and flexibility are important. Large-format cameras tend to be more cumbersome and slower to use than 35mm and medium-format cameras (remember that each exposure requires a new sheet of film to be loaded into the camera). Also, such high quality is not necessary if the pictures are being reproduced relatively small in magazines or books and the cost of film and processing makes it a very expensive system to use.

❧ (Above left) This 6 × 7cm (2¼ × 2¾in) medium-format image of crocuses and cyclamen was recorded using a Pentax 67 camera.

(Pentax 6 × 7, 55mm wide-angle lens, Fujichrome Velvia, f16, tripod. The Dower House, Gloucestershire.)

❧ (Above right) This is a square 6 × 6cm (2¼ × 2¼in) medium-format photograph of yellow aquilegias and campanulas taken in the rose garden at Mottisfont Abbey.

(Bronica 6 × 6, 80mm standard lens, Fujichrome Velvia, f16, tripod. Mottisfont Abbey (National Trust), Hampshire.)

Lenses

Lenses should be purchased with care, since more than any other factor, it is the choice of lens which determines the final look and quality of your garden images.

If you are attempting to take garden pictures for the first time, resist the temptation to rush out and buy all sorts of different lenses for your camera. It is always best to experiment with just one or two initially so that you can learn about their strengths and weaknesses. New purchases can then be made as your range of subjects increases.

Note: The focal lengths mentioned in the following sections refer to 35mm format only. For equivalent focal lengths in other formats refer to the table below.

STANDARD LENSES

The majority of 35mm SLR cameras sold in photographic shops today come fitted with a standard or 'normal' lens. Standard lenses usually have focal lengths of 50mm, with an angle of view of 48° – roughly equivalent to that of the human eye. They are relatively cheap, because they are made in large quantities, and have a very high optical quality, as well as being light and therefore easy to carry around.

In garden photography, a standard lens is useful for capturing general garden scenes without distortion and for photographing groups of flowers or foliage at distances of 50cm–1m (2–3ft).

When combined with one or more extension tubes (see p 136), standard lenses can also double up as macro (continued on p 26)

I used a standard lens on my Bronica camera to photograph this section of the red border at Hadspen House. The combination of a small aperture and choice of film produces great clarity and sharpness.

(Bronica 6 × 6, 80mm standard lens, Fujichrome Velvia, f22, tripod. Hadspen House, Somerset.)

This pleasing association of pinks and campanulas was taken with a standard lens. The rich, warm light of early evening makes the flowers glow.

(Bronica 6 × 6, 80mm standard lens, Fujichrome Velvia, f16, tripod. Mottisfont Abbey (National Trust), Hampshire.)

This moderate close-up of *Paeonia lactiflora* 'Bowl of Beauty' was taken with a standard lens at a distance of 0.9m (3ft). I stopped down to f22 for maximum sharpness.

(Olympus OM2, 50mm standard lens, Fujichrome Velvia, f22, tripod.)

FOCAL LENGTHS OF POPULAR LENSES FOR 35MM, MEDIUM- AND LARGE-FORMAT CAMERAS					
LENS TYPE	FILM FORMAT				
	35MM	6 × 4.5CM	6 × 6CM	6 × 7CM	5 × 4IN
ULTRA-WIDE ANGLE	20mm	35mm	40mm	45mm	65mm
WIDE-ANGLE	28mm	45mm	50mm	55mm	90mm
STANDARD	50mm	75mm	80mm	90mm	150mm
SHORT TELEPHOTO	85mm	140mm	150mm	180mm	270mm
MED TELEPHOTO	200mm	300mm	350mm	420mm	560mm
LONG TELEPHOTO	300mm	450mm	500mm	600mm	800mm

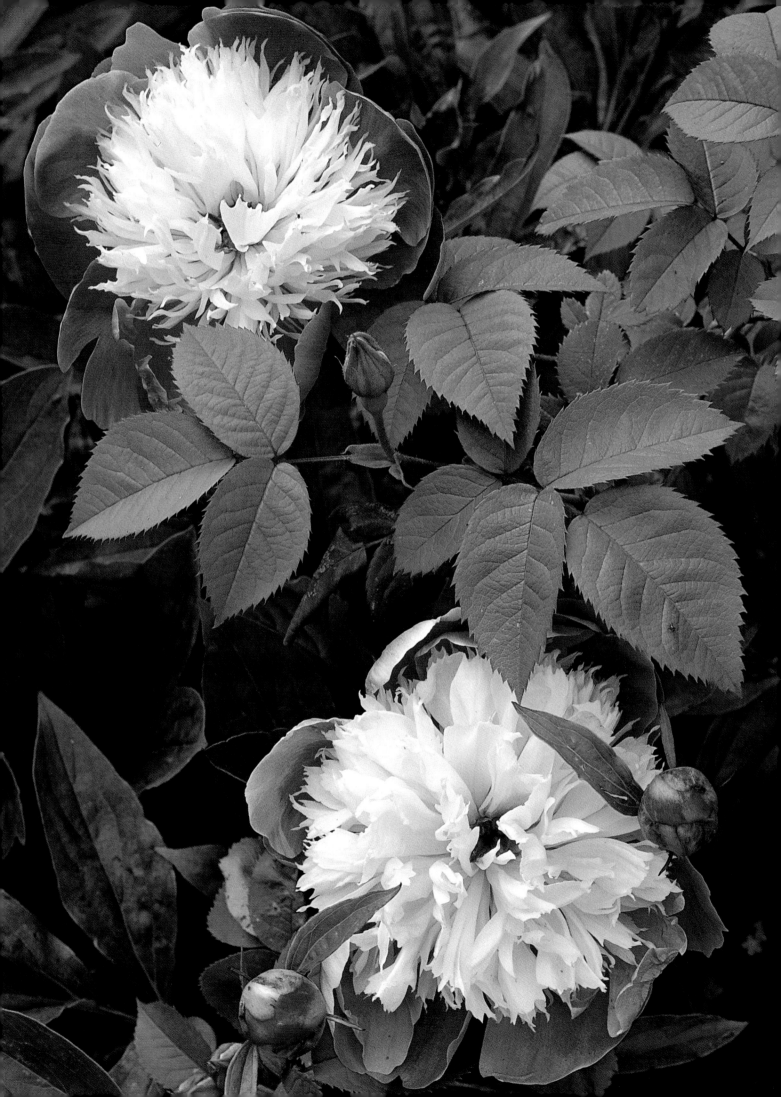

lenses, enabling frame-filling close-ups of subjects such as single blooms or berries to be taken. Close-up lenses, which screw on to the front of the lens and allow closer focusing and therefore greater magnification, are also available and cost far less, but they do not offer the same level of image quality. If you are serious about taking great close-ups of flowers, you should consider purchasing a pukka macro lens.

WIDE-ANGLE LENSES

Wide-angle lenses are designed to encompass a broader field of view than a standard lens. Their focal lengths range from 35mm to 6mm, with an angle of view from 60° to as much as 180°. Because they can be focused on objects as little as a foot away and have great depth of field, they are ideal for conveying a feeling of depth. Interesting objects such as statues and sculptures or a colourful clump of flowers can be placed in the foreground of the picture with other elements of the garden in sharp focus in the background.

Wide-angle lenses also come into their own in situations where space is limited. A clematis in full flower smothering the wall of a narrow alley may be impossible to photograph with a standard lens simply because physically the camera cannot be moved far away enough from the flowers to focus on them. However, because wide-angle lenses 'see' much more, they allow you to capture a broader area from closer range.

I have found that a 28mm wide-angle lens is the most useful for garden and plant photography. Not only does it give beautifully balanced scenic compositions, but it is also useful for taking moderate close-ups of plant groupings and associations. The 24mm and 21mm wide-angle lenses, though useful for recording tall objects such as trees, tend to distort certain elements within the picture, especially when tilted upwards. This distortion is especially noticeable where architectural structures, such as buildings, pergolas and doorways, are included in the view, with vertical lines tending to converge towards each other at the edges of the frame. This effect is even more marked with the most extreme wide-angle or 'fish-eye' lenses, which actually produce circular images with straight lines appearing as concentric curves. Fish-eye lenses range from 6–16 mm and have a 180° angle of view.

The problem of distortion and converging verticals can be minimised or even removed altogether by using a special wide-angle lens known as a 'shift' or 'perspective-control' lens. This works by moving or 'shifting' the lens elements off their normal axis, so you can include what you want in a picture without having to tilt the camera upwards. Though very expensive, it is worth investing in if your intention is to photograph gardens with lots of architectural features.

When using a wide-angle lens take care that your own shadow and that of your tripod does not encroach into the photograph. This problem is particularly common when shooting during periods when the sun is low and behind you, such as early in the morning or late in the afternoon.

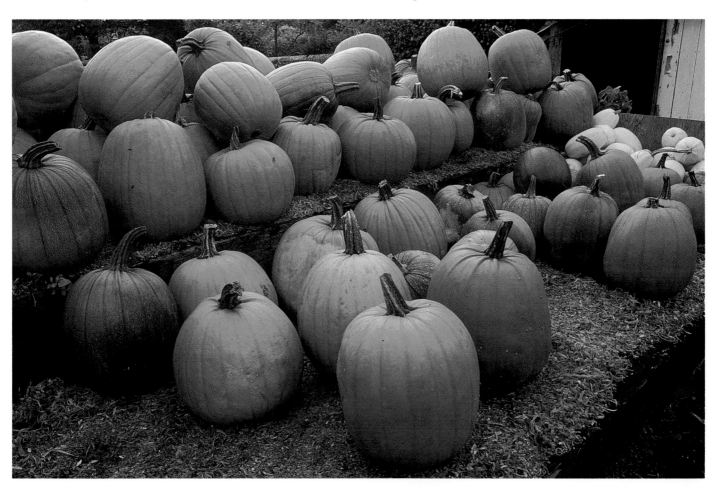

A wide-angle lens was chosen to encompass the large kitchen garden at Hadspen House. I used a step-ladder to gain height, focused on the yellow flowers in the foreground and used a small aperture to make everything in the picture sharp.

(Olympus OM2, 21mm wide-angle lens, Fujichrome Velvia, f16, tripod. Hadspen House, Somerset.)

(Left) A moderate wide-angle lens gives a pleasing perspective to these pumpkins.

(Olympus OM2, 28mm wide-angle lens, Fujichrome Velvia, f22, tripod.)

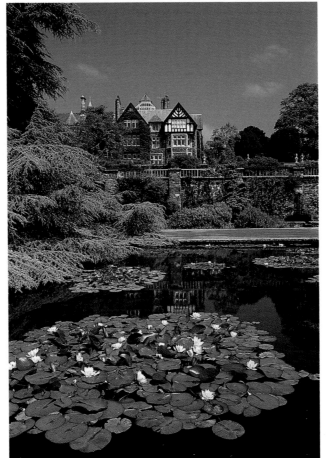

The lily terrace and house at Bodnant photographed with a moderate wide-angle lens. The waterlilies add strong foreground interest and the house is still in sharp focus because of the great depth of field. A polarising filter was used to reduce glare and deepen the blue sky.

(Olympus OM10, 28mm wide-angle lens, Fujichrome Velvia, f22, tripod. Bodnant, North Wales.)

TELEPHOTO LENSES

The term 'telephoto' is applied to lenses that have a focal length longer than that of the normal or standard lens. In reality, telephoto lenses have fixed focal lengths ranging from 80mm to as much as 1,000mm, with an angle of view from 30° to as little as 2°. Visually, they produce the opposite effect to wide-angle lenses. Rather than take in a broad sweep of the garden, exaggerating the distance between near and far subjects, they compress perspective, making subjects appear closer together than they actually are and allowing you to capture selective areas. They are excellent for making herbaceous borders look as if they are bursting with blooms, or for emphasising the association of one group of flowers or foliage with another.

Telephoto lenses are invaluable in situations where the photographer is unable to get close to the subject being photographed. They are useful if you want to fill the frame with a waterfall on the opposite side of a lake, or a waterlily in the centre of a pond. At short distances, they are ideal for isolating design features in a garden, such as an attractive piece of sculpture or a wooden bench. As they have the effect of magnifying the subject by effectively pulling it towards you, depth of field is greatly reduced, so distracting elements in front of and behind the subject can be thrown out of focus. This concentrates the viewer's attention on the main subject. The limited depth of field of telephoto lenses is a positive advantage in this respect.

One major drawback with telephoto lenses is that as their focal length increases, so does their weight and length, making them more difficult to hold still when you are making an exposure. This increases the risk of 'camera shake', so they should be used with a tripod and a cable release.

To reduce this problem in the longer telephoto lenses, lens manufacturers have developed cheaper, more compact lenses known as 'catadioptric' or 'mirror' lenses. They come in various focal lengths from 250mm to 1,000mm and are at least 50 per cent lighter and shorter than telephoto lenses of comparable focal length. These reductions are achieved by reflecting light entering the lens barrel back and forth, using a series of mirrors. The main drawback of these lenses, however, is that the aperture must be fixed (the 500mm mirror lens is usually f8), so control over depth of field is lost. The viewfinder image is also darker due to the fixed aperture, making focusing trickier.

❧ I was unable to get close to this waterfall in the model village at Babbacombe because of the lake, so I used a telephoto lens to draw the scene in.

(Olympus OM2, 300mm telephoto lens, Fujichrome Velvia, f32, tripod. Model Village, Babbacombe, Devon.)

❧ A telephoto lens has created a strong pattern in this picture of statues on the water terrace at Blenheim Palace. Although the statues appear to be quite close together they are in fact several metres apart.

(Olympus OM2, 300mm telephoto lens, Fujichrome Velvia, f32, tripod. Blenheim Palace, Oxfordshire.)

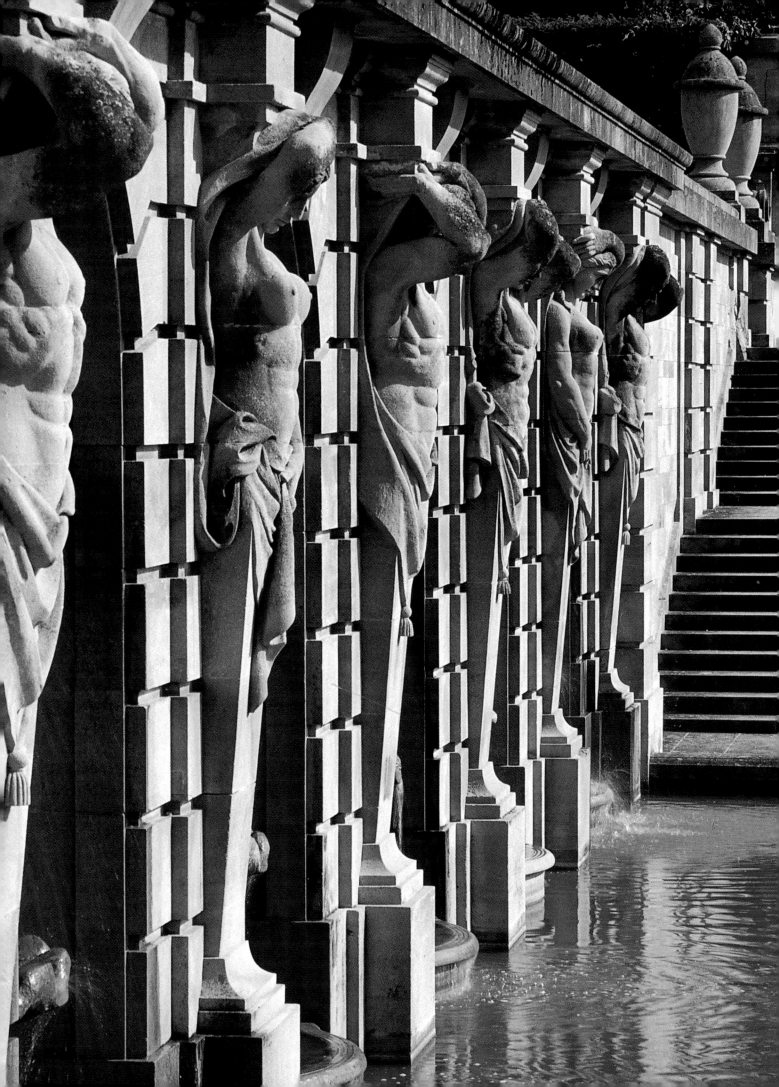

ZOOM LENSES

Zoom lenses differ from wide-angle, telephoto and standard lenses in that they have variable focal lengths. Once the subject is in focus, the lens can be pulled in or out so that the subject in the viewfinder appears larger or smaller, making it possible to shoot several different compositions of that subject from a fixed viewpoint. Time is not wasted on changing from one lens to another, an important factor in garden photography where the light falling on a photogenic subject can change in the space of just a few seconds.

Because of their complex optical design, zoom lenses are bulkier, heavier and more expensive than any comparable lens of fixed focal length. Their widest aperture also tends to be smaller than on 'prime' lenses in the same range, so the viewfinder image is not as bright. However, thanks to recent improvements in lens technology, most zooms are now perfectly capable of delivering images which are of equal quality to those produced by many fixed focal-length lenses. Like telephoto lenses, they are also prone to camera shake, so should always be used with a tripod. Their advantage, though, is that one zoom lens can do the same job as several 'prime' lenses. For example, rather than carry three separate lenses (say, a 28mm wide-angle, 50mm standard and 80mm telephoto) in your camera-bag, it is possible to obtain similar results with a single zoom lens in the 28–80mm range.

Overall, zoom lenses offer many benefits which outweigh their drawbacks. It is not surprising, therefore, that they have become increasingly popular among both amateur and professional horticultural photographers.

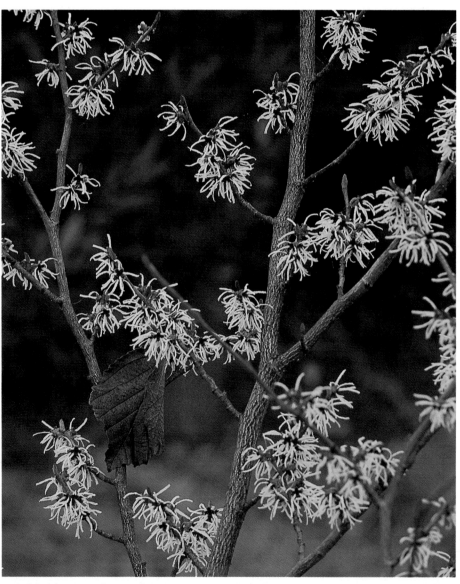

❧ I used a zoom lens and an aperture of f8 to isolate these hamamelis flowers from a distracting background.

(Olympus OM2, 80–200mm zoom lens, Fujichrome Velvia, f8, tripod.)

These two pictures of this glorious autumnal border illustrate perfectly how a zoom lens can be used to shoot different compositions from a fixed viewpoint.

(Olympus OM2, 80–200mm zoom lens, Fujichrome Velvia, f32, tripod. Waterperry Gardens, near Oxford.)

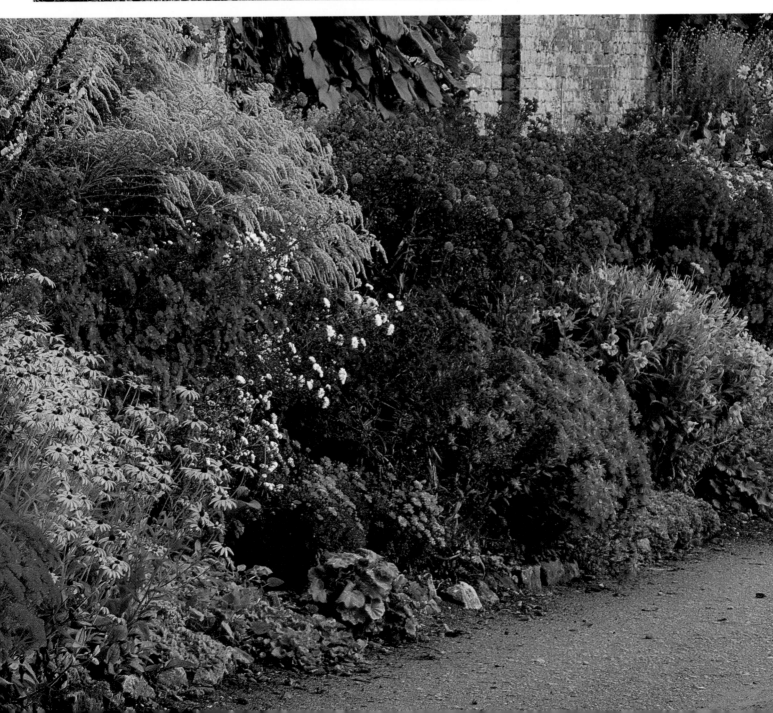

MACRO LENSES

Macro lenses are optically designed to be at their sharpest when focused on objects at very close range. For this reason they are ideal for close-up work in garden photography. They come in focal lengths from 55mm to 200mm, but unlike other lenses of comparable focal length, they have built-in extensions which allow the lens to be moved further away from the film plane and closer to the subject being photographed.

When fully extended, most macro lenses are capable of producing an image which is at least half life-size. In other words, a single poppy flower which is 5cm (2in) in diameter, in reality will be recorded as an image 2.5cm (1in) in diameter on the negative or transparency. However, some models are capable of life-size reproduction, so subjects are recorded the same size on film as they are in reality.

Doubling the focal length of the macro lens in use will double the working distance from the subject being photographed. For example, at full extension a 55mm macro lens produces a half life-size image on film 25cm (10in) from the subject. The 100mm macro lens will record the subject as half life-size at twice that distance – 50cm (20in).

Macro lenses can also be used to obtain extreme close-ups with magnifications greater than half life-size by adding hollow metal rings known as extension tubes between the lens and the camera body. Extension tubes are covered in more detail in the section on plant portraits on p 136.

Most macro lenses have a dual role. As well as producing superior close-ups, they are capable of delivering sharp pictures at longer range, making them a viable alternative to comparable focal length lenses. The 55mm macro lens, for example, can double as a standard lens and I would strongly advise anyone who is thinking of purchasing a 35mm SLR for the first time to consider buying a 55mm macro lens with the camera body instead of the usual standard lens.

In many ways, macro lenses are the most difficult lenses to use in garden photography. A great deal of patience and concentration is often required in setting up an outdoor macro close-up.

A tripod and cable release is a must, as the slightest movement of the camera during the exposure will simply record the subject as a large blur on the negative or transparency. Getting in close enough to a floral subject can often be a problem, too. It may be impossible, for example, to take a close-up image of a flower that is growing at the back of a deep border without physically damaging neighbouring plants.

Because macro lenses move the lens further away from the film plane, the amount of light reaching the film is reduced and longer exposures are therefore required, further increasing the risk of camera and subject movement. Working out the correct exposure is no problem if you are using a through-the-lens meter (see p 16), but with a hand-held meter this will have to be done manually.

Finally, depth of field is severely limited at close focusing distances, so when using a macro lens you should work at a small aperture of f11 or f16, and focus carefully on your main subject to ensure as much of it as possible is sharply recorded.

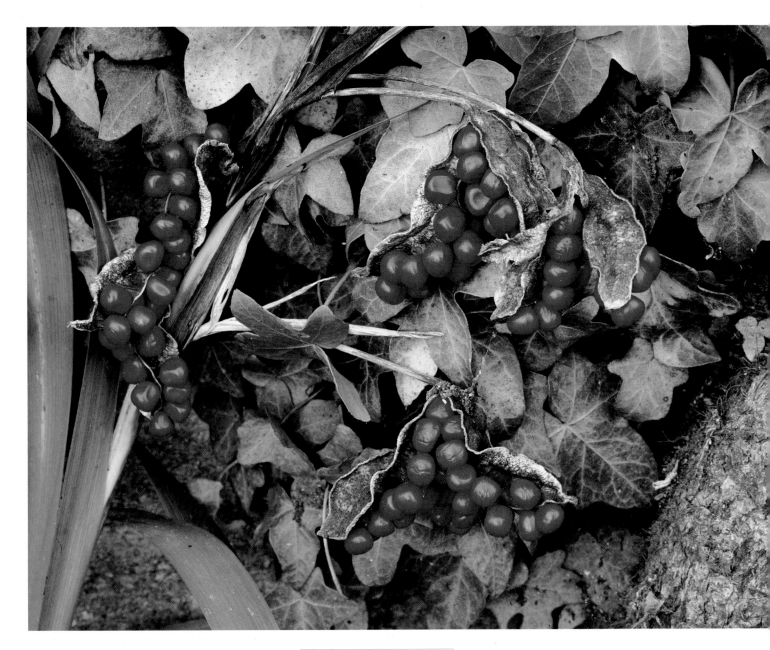

A low viewpoint and macro lens capture an unusual view of these fritillaries.

(Olympus OM2, 90mm macro lens, Fujichrome Velvia, f11, tripod. Keukenhof Gardens, Holland.)

PROFESSIONAL·TIPS

LENSES IN BRIEF

Use the standard lens for general scenes, and with extension tubes for close-ups.

Wide-angle lenses encompass a broader view and convey a feeling of depth.

Use the telephoto lens to emphasise selective areas, and when you cannot get close to the subject.

The zoom lens has variable focal lengths and can do the same job as several prime lenses.

Macro lenses are ideal for close-up work, also for sharp pictures at longer range.

The seed heads of *Iris foetidissima* ripen during the summer and split open in the autumn to reveal brilliant scarlet fruits which last for most of the winter. I used a macro lens and gave the picture a stop less exposure than indicated by my hand-held meter in order to deepen the colour of the berries.

(Pentax 6 × 7, 135mm macro lens, Fujichrome Velvia, f32, tripod. East Lambrook Manor, Somerset.)

Film

Given that colour plays such an important role in the visual beauty and appeal of flowers, it is hardly surprising that the vast majority of garden photographers working today prefer to use colour film in preference to black-and-white film to capture their favourite subjects. If you are a newcomer to this field of photography, though, you must first decide which films are most suitable for the kinds of pictures you want to take. This is by no means a straight-forward task, as the range of colour films now on sale in camera stores is vast, and all are capable of producing subtly different results.

What you intend to use your photographs for should dictate your choice of film. If you want colour prints to frame on the wall or to place in a photo album for casual viewing, then colour negative film is the ideal medium. If, on the other hand, your aim is to produce photographs for pro-jection, or for publication in printed media such as books, magazines or cal-endars, then colour slide film (also known as transparency film) is your best bet. All the pictures in this book were taken on colour slide film.

These two pictures were shot to illustrate an article on the antique collection of garden artefacts held by the Tradescant Trust. Both pictures were lit primarily by tungsten lights, but the first was taken with tungsten-balanced film,

thereby rendering the colours accurately, whereas the one below was taken with daylight-balanced film which has reproduced the tungsten lighting as an orange cast.

Above and below (Bronica 6 × 6, 80mm standard lens, f22, tripod. Church of St Mary-at-Lambeth, London.)

For pin-sharp images with rich, vibrant colours, there is nothing to match Fuji's Velvia film, as these two pictures of lavatera and sedums (right) and salpiglossis (left) demonstrate.

(Pentax 6 × 7, 135mm macro lens, Fujichrome Velvia, f22, tripod. Eluned Price's garden, Oxford.)
(Olympus OM10, 90mm macro lens, Fujichrome Velvia, f22, tripod. Harewood, Buckinghamshire.)

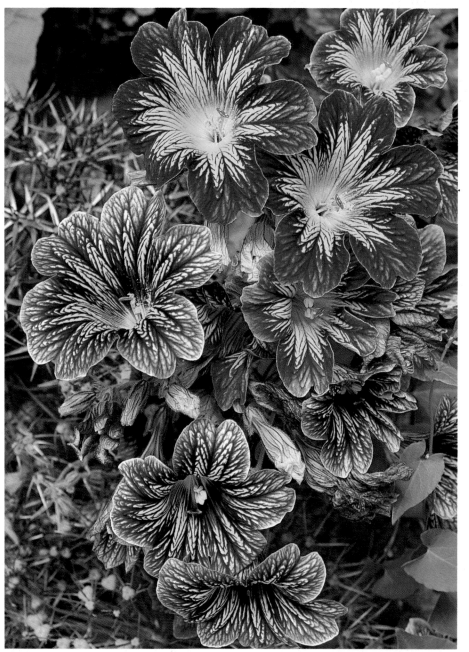

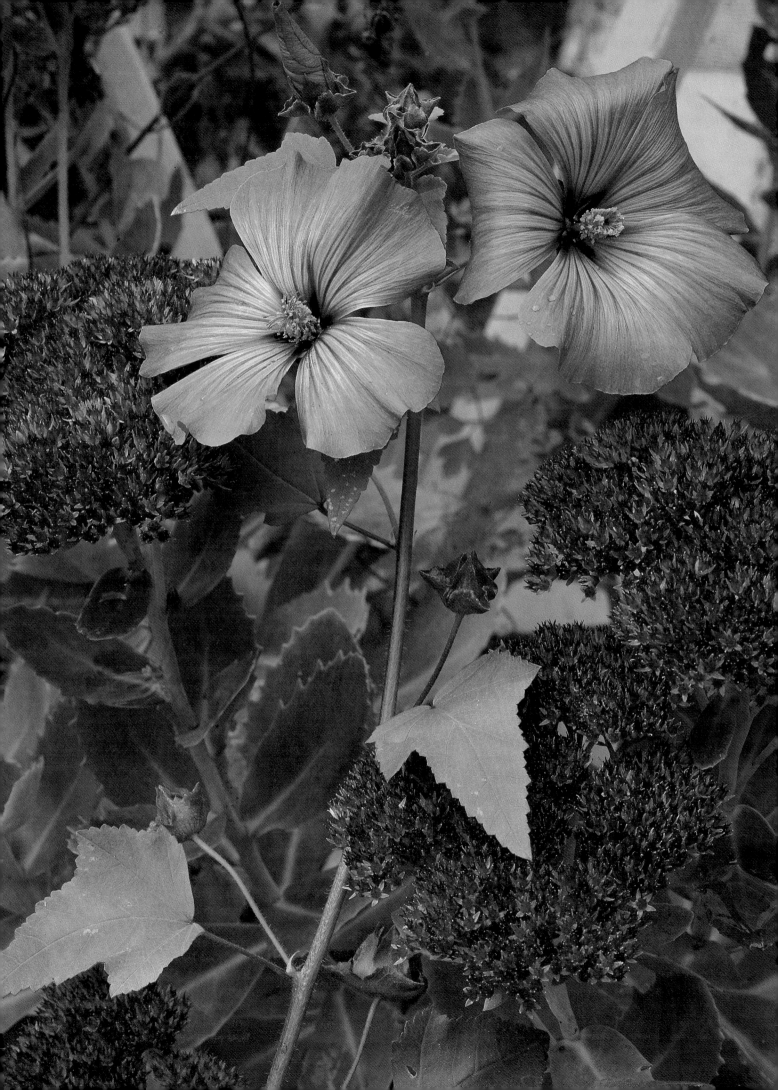

FILM SPEED

All modern colour films have a flexible plastic base which is coated with a triple layer of gelatin emulsion in which light-sensitive silver halide crystals are embedded. The size of these crystals or grains determines how sensitive a film is to light and this sensitivity is referred to as the speed of a film. 'Slow' films have finer grain structures and are less sensitive to light than 'fast' films which have coarser grain structures. The speed of a film is quoted as an ISO (International Standard Organisation) number. As a general rule-of-thumb, films in the range ISO 25 – ISO 100 are referred to as slow films, and those in the range ISO 400 and greater as fast.

As the ISO speed doubles, so does the film's sensitivity to light. Thus, ISO 100 film is twice as sensitive to light as ISO 50 film and therefore only requires half as much light for correct exposure.

It is important to understand that film speed and image quality are linked. Slower, fine-grained films are sharper and give more accurate colour rendition than faster, coarser-grained films. When an enlargement is made from a 35mm or 120 negative, the effects of grain size will show up even more and faster films will exhibit a marked deterioration in image quality because of their 'graininess'. Slow, fine-grained films, however, will retain their sharpness and rich colour saturation.

While it might seem preferable in terms of image quality to use the slowest film there is all the time, in practice it is often impossible to use slow film in plant and garden photography without obtaining a blurred image. Slow films need longer exposure and if maximum depth of field is required in a photograph, then a slow shutter speed, often of one second or more, may be needed. At such a slow speed, even a light breeze during the exposure will move a flower stalk enough to render the subject as a blur. In such conditions the photographer can either wait for the wind to drop, use flash to freeze subject movement, or revert to a faster film in order to obtain a higher shutter speed. Just how fast is a matter of personal taste and depends on the aesthetic

✤ These two still-life photographs of pumpkins and chrysanthemums were both lit by window light from the left. The picture below was taken on Fuji's Velvia film (ISO 50) and shows the rich colours, fine grain and pin-sharp

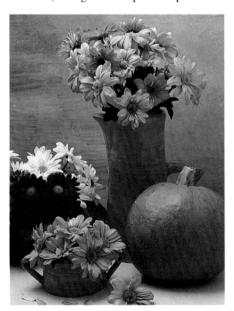

definition for which this film is renowned. For the picture on the right I switched to a faster film with an ISO rating of 400 and then asked my processing laboratory to 'push' the film 1 stop to ISO 800. Uprating has increased the grainy quality of the faster film, producing a strongly impressionistic feel.

(Olympus OM2, 80–200mm zoom lens, left: Fujichrome Velvia; right Fujichrome RSP; f32, tripod).

effect which the photographer wishes to portray.

An artistic photographer can create a impressionistic masterpiece by enhancing the grainy effect of a fast film using a procedure known as 'pushing' or 'up-rating'. This is done by rating the film at a higher ISO level – for example, ISO 400 film can be rated at ISO 800 or even ISO 1600. Because this has the effect of under-exposing the film, it must receive extra development during processing to compensate, and doing this causes a dramatic increase in grain size.

FILM MAKE

Deciding on which make of film to use for any given situation is also a matter of personal preference. Films made by different manufacturers will record colours in a different way, even if they are of the same type and speed. Each make has its own strengths and weaknesses. As a general rule, differences in colour negative films are less marked than colour slide films, because today's printing machines tend to standardise print tones by using filters.

Fujichrome slide film, especially Velvia (ISO 50), is noted for its punchy, vibrant colours and biting definition. In poor light or on a dull, overcast day, this can be a real boon to the garden photographer, but in bright sunshine, the colours of flowers and foliage are enhanced to the point where they can appear brash. Kodachrome slide films such as Kodachrome 64 and Kodachrome 25 are famous for their sharpness and natural, well-balanced colour rendition. For this very reason, though, they often give poor, dull-looking results on overcast days or in failing light.

Alternatively, beautiful images can be produced by using a super-fast film with a recommended ISO rating of 1000, 1600 or 3200. This approach is preferable if you are shooting colour negative film, as it does not give good results when up-rated.

Your best bet is to experiment with a range of different films to discover how they perform in different conditions. Specific brands can then be chosen for different jobs to produce the best possible results.

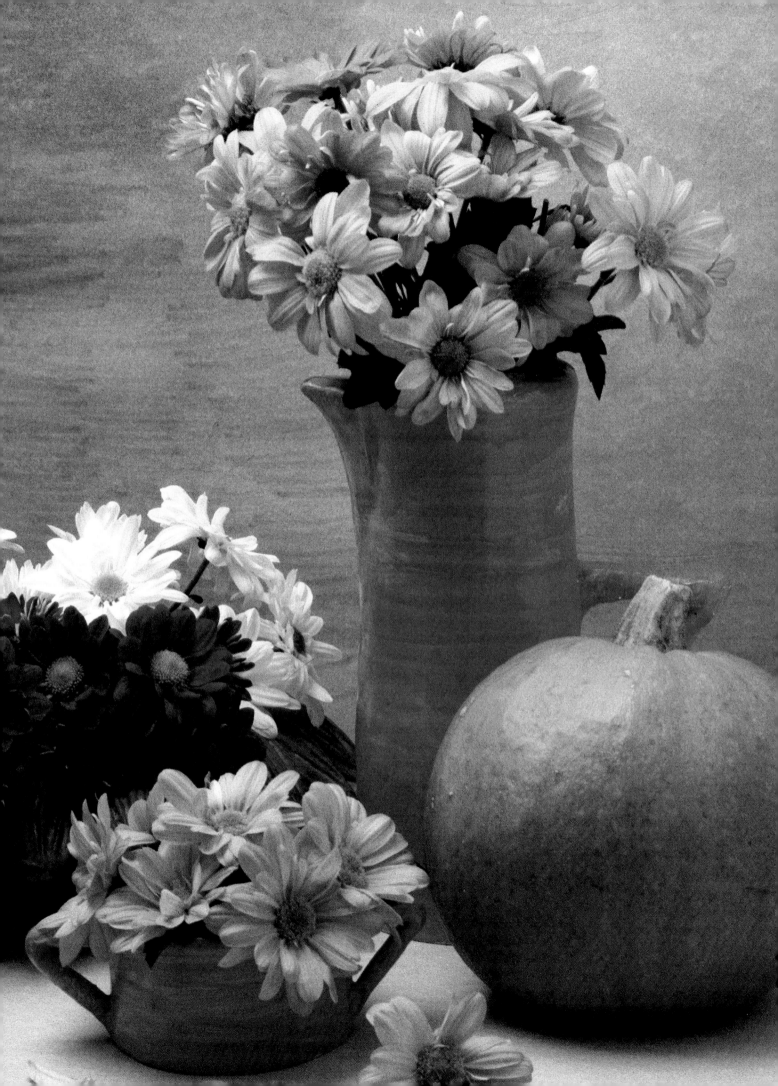

Tripods

🍂 A stunning association of asters, dendranthemas and anemones.

(Bronica 6 × 6, 80mm standard lens, Fujichrome Velvia, f22, tripod, RHS Garden, Wisley, Surrey.)

Tripods are an essential tool for the garden photographer. Every single image in this book, with the noticeable exception of the aerial shot on p 53, was taken with the camera mounted on a tripod. Tripods hold the key to obtaining pin-sharp, well-composed photographs in the garden. They help you to frame the picture in exactly the way you want and eliminate the risk of camera shake during exposure. Once the camera is firmly screwed down on to the tripod and carefully focused, you are free to concentrate on selecting exactly the right moment to press the shutter.

I am not saying that you cannot take hand-held shots of plants and gardens, just that wherever possible you should try to use a sturdy tripod. Cameras fitted with wide-angle and standard lenses can be hand-held at speeds of around 1/30th second or faster without the effects of camera shake being discernible in the finished photograph. Using faster films and setting the camera at a large aperture will help to keep shutter speeds high and eliminate camera shake, although image quality will suffer because of the increased grain size of the film.

When purchasing a tripod for the first time, try to choose the strongest one that you feel comfortable with. Be careful not to buy one that is so heavy that it becomes a burden to carry around – remember that on location you will also have your camera-bag with you. Some photographers get around the problem of bulky equipment by loading their tripod and camera-bag on to a pull-along trolley. Unfortunately, these have to be custom-built and although they may be suitable for locations such as landscape gardens, they can become a hazard in more confined situations.

The best tripods for garden photography are those with enclosed tubular legs and screw-thread release collars. They tend to be more sturdy and reliable than those with U-shaped legs and quick-release clamps. For photographing close-ups of low-level plants such as cyclamen and anemones and subjects such as alpines or fallen leaves, you need a tripod that can suspend the camera close to the ground. One make – the Benbo – is perfect for such situations, because the legs and centre column can be independently locked into any position required.

Two different types of head are available to fit your tripod: ball and socket, and pan and tilt. In practice, pan and tilt heads are of greater use to the garden photographer as they tend to lock up more tightly and have a larger base for the camera to screw into, thereby minimising the effects of camera movement. Pan and tilt heads are a must when using the heavier medium- and large-format cameras.

When using a tripod, be sure to use a cable release, rather than your finger, to fire the camera's shutter. Mechanical cable releases are flexible cables which screw into a socket on either the camera body, the shutter-release button or the lens. The end of the cable has a plunger which, when pressed gently, pushes down a metal rod that in turn fires the camera's shutter. Electronic cable releases, which are used with cameras that have electronically controlled shutters, are attached to the camera via electrical contacts on the camera body. Using a cable release further reduces the chances of camera shake during the exposure.

A less expensive alternative to a tripod is available in the form of a monopod. As its name implies, a monopod has just one leg instead of three. Although more portable than a tripod, it is less stable and therefore of limited use to the plant and garden photographer.

🍂 These alliums, wisteria and wooden seat were photographed in light rain.

(Bronica 6 × 6, 80mm standard lens, Fujichrome Velvia, f22, tripod. Barnsley House Garden, Gloucestershire.)

🍂 Decorative cabbages in the great ornamental potager at Villandry, in France.

(Olympus OM2, 80–200mm zoom lens, Fujichrome Velvia, f32, tripod. Château de Villandry, Loire Valley, France.)

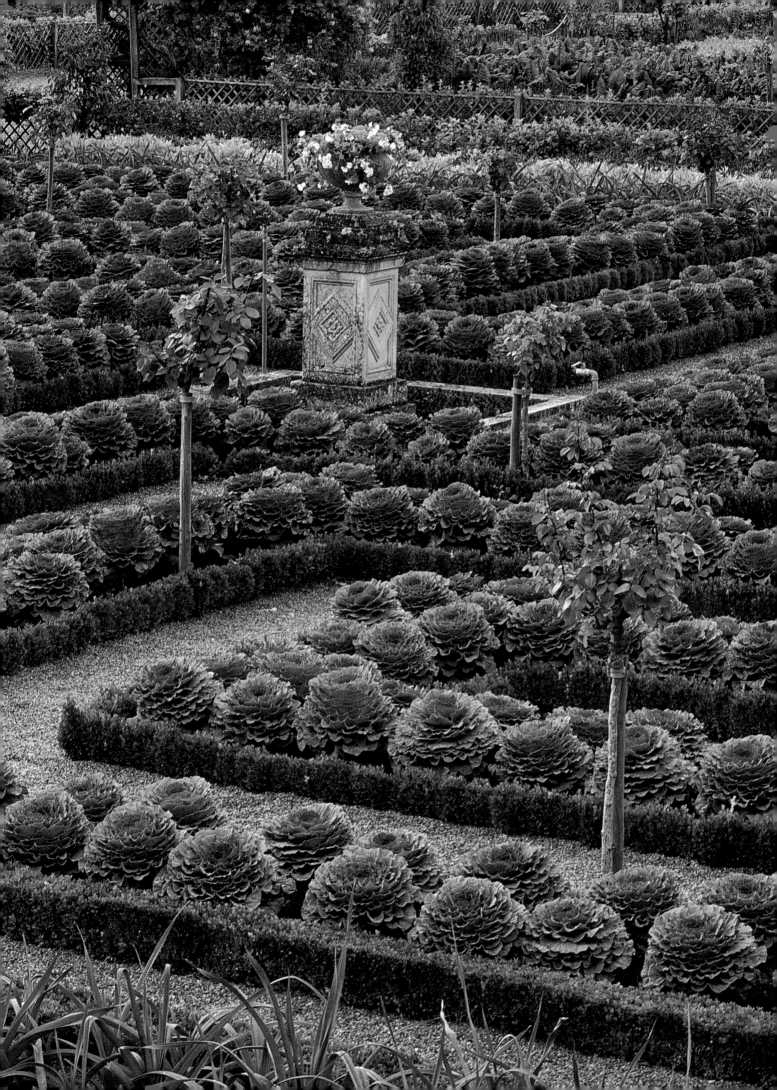

Filters

Filters are usually transparent or translucent pieces of glass or gelatin which are placed in front of the lens to alter the nature, colour or amount of light passing through the lens. Used carefully and in the right conditions, filters can make the difference between ordinary and outstanding photographs of plants and garden scenes.

In my opinion, polarising filters are the most useful filters available to the plant and garden photographer because they are able to create several different effects. Properly used, polarising filters can enrich the colours of flowers and foliage, remove glare from reflective surfaces, such as leaves and water, and deepen the blue of the sky in garden vistas.

A polarising filter is actually made of two pieces of glass. Once the filter has been screwed to the front of the camera lens, the outer piece of glass is rotated manually by the photographer until the desired effect is achieved. Thankfully, the exact results can be seen through the lens as the filter is rotated. In garden scenes with lots of blue sky, polarisation is most marked when the sun is at right angles to the camera.

The one drawback with a polarising filter is that it operates by refracting light and in so doing reduces the amount of light reaching the film by up to two f-stops. In practice, this means that considerably longer exposures may be necessary when using a polarising filter. This may not be a great loss in very brightly lit scenes, but it can lead to unsharp pictures on a windy day, especially if you are also using a slow film.

Because colour film does not always record colour as we see it, it is sometimes necessary to use filters in order to record the 'true' colours of a flower or garden scene. In overcast or shady situations, for example, certain colour films exhibit a cool, bluish cast. To restore proper colour balance, attach a pale amber-coloured filter (81A or 81B), which has the effect of 'warming up' the picture. In contrast to the 'cool' colours in shade, the orange-magenta light at sunset may give a wonderful 'warm' glow to architectural features in the garden, but it will completely change the 'true' colours of flowers. Fitting a pale blue filter (82A or 82B) will effectively cool things down and help to restore the natural colours of the flowers.

Certain blue flowers such as bluebells, ageratum and morning glory always seem to turn out pink on colour film. This is because their flowers contain pigments which reflect infra-red light, invisible to the naked eye but picked up as red by the film's emulsion. The effect is most noticeable in sunlight, so shooting these flowers in diffused light will reduce the pink cast. Another option is to use a pale blue colour-compensating filter (CC20B or CC30B), which will help to increase the blueness of the flowers. The drawback with using this filter is that it also imparts a blue cast to the rest of the image and is therefore only satisfactory if the whole of the frame is filled with blue flowers.

These colourful fall leaves in a pool in Vermont caught my eye. By using a polarising filter and Fuji Velvia film I was able to remove unwanted glare from the surface of the pool and make the water appear jet black, as if the leaves had been laid on a sheet of velvet. The picture was taken from directly overhead.

(Pentax 6 × 6, 55mm wide-angle lens, Fujichrome Velvia, f22, tripod.)

PROFESSIONAL·TIPS

FILTER TIPS

- To enrich colours and remove unwanted glare, use a polarising filter.
- Longer exposures may be necessary when using a filter: on a windy or dull day this can lead to unsharp pictures.
- Colour film sometimes records colour inaccurately: to prevent a bluish cast in shady situations use an amber-coloured filter; in strong light (sunset), restore the 'true' colours of flowers with a pale blue one.
- Certain blue flowers appear pink on film: to reduce this effect, use a pale blue filter.

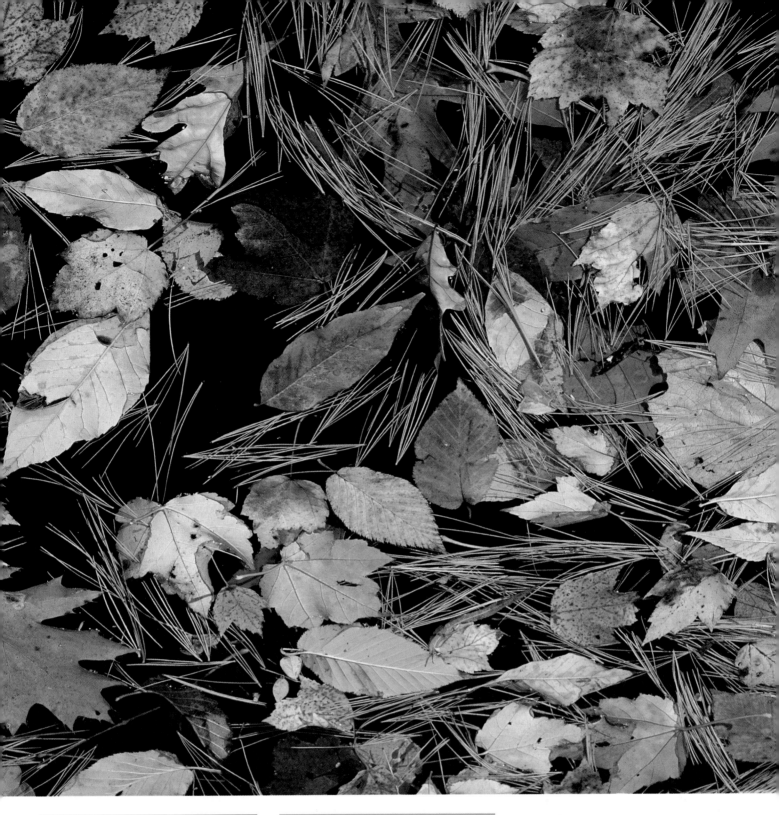

 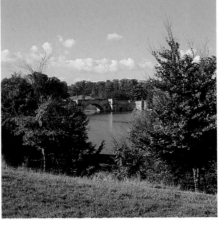

🍂 These photographs of Vanbrugh's Bridge seen from across Capability Brown's Lake at Blenheim Palace clearly demonstrate the effect of using a polarising filter. The left-hand picture was taken with a polarising filter and required a longer exposure. The polariser has deepened the blue of the sky and increased the colour saturation in the leaves.

(Bronica 6 × 6, 80mm standard lens, Fujichrome Velvia, left: 1/30 sec f22; right: 1/125 sec f22; tripod. Blenheim Palace, Oxfordshire.)

Reflectors

Reflectors are inexpensive accessories which can be purchased as solid boards or as flexible, circular white nylon diffusers which fold away neatly into a bag and spring open when needed. Alternatively, they can be home-made by wrapping material like paper or aluminium cooking-foil around a piece of card or cardboard. A very good portable diffuser can also be made by stretching a sheet of muslin over a wire frame.

Reflectors are invaluable for bouncing light back into shaded areas ('fill in') or for diffusing strong or contrasty light falling on flowers and foliage (achieved by positioning the reflector between the sun and the subject). Reflectors can be hand-held or propped against a nearby object.

Unlike the short duration of flash, their effects are visible, so they can be moved carefully into position so that only the desired degree of 'fill in' or diffusion is achieved. Having a companion with you to hold a reflector is very useful, as it is sometimes difficult to fire the camera's shutter at the same time as trying to hold a reflector in position.

Reflectors are usually sold with white, silver or gold surfaces and the colour of the reflector determines the colour of the light that is reflected back on to the subject being photographed. White surfaces tend to reflect a soft light into the shadows. Silver surfaces reflect a harder, cooler light. Gold surfaces give a similar quality of light as silver, but with a warmer glow.

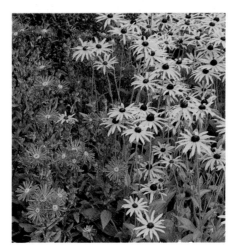

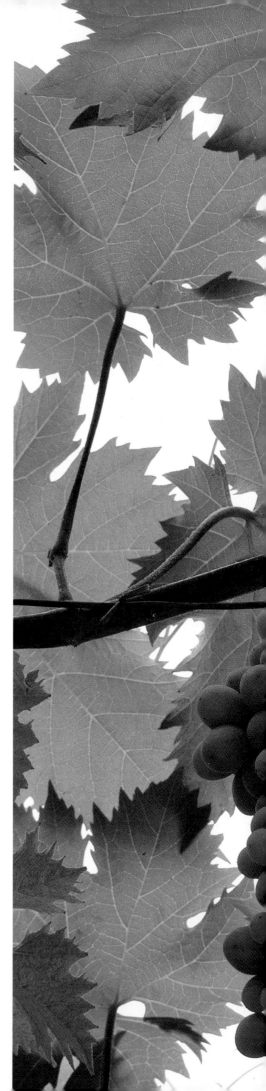

✿ The bright sunlight falling on these asters and rudbeckias made for a contrasty picture (left), so to soften the light for a more flattering portrait I used a sheet of muslin stretched over a wire frame to diffuse the sun's rays. The effect can be seen in the right-hand picture which I find much more pleasing.

(Bronica 6 × 6, 80mm standard lens, Fujichrome Velvia, f22, tripod. Waterperry Gardens, Oxfordshire.)

✿ I photographed these back-lit grapes growing in a glasshouse from directly below. In order to increase the illumination on the grapes I asked a friend to 'fill in' some of the shadow on the underside of the grapes with a large sheet of white card, leaving me free to concentrate on taking the picture.

(Bronica 6 × 6, 80mm standard lens, Fujichrome Velvia, f11, tripod. RHS Garden, Wisley, Surrey.)

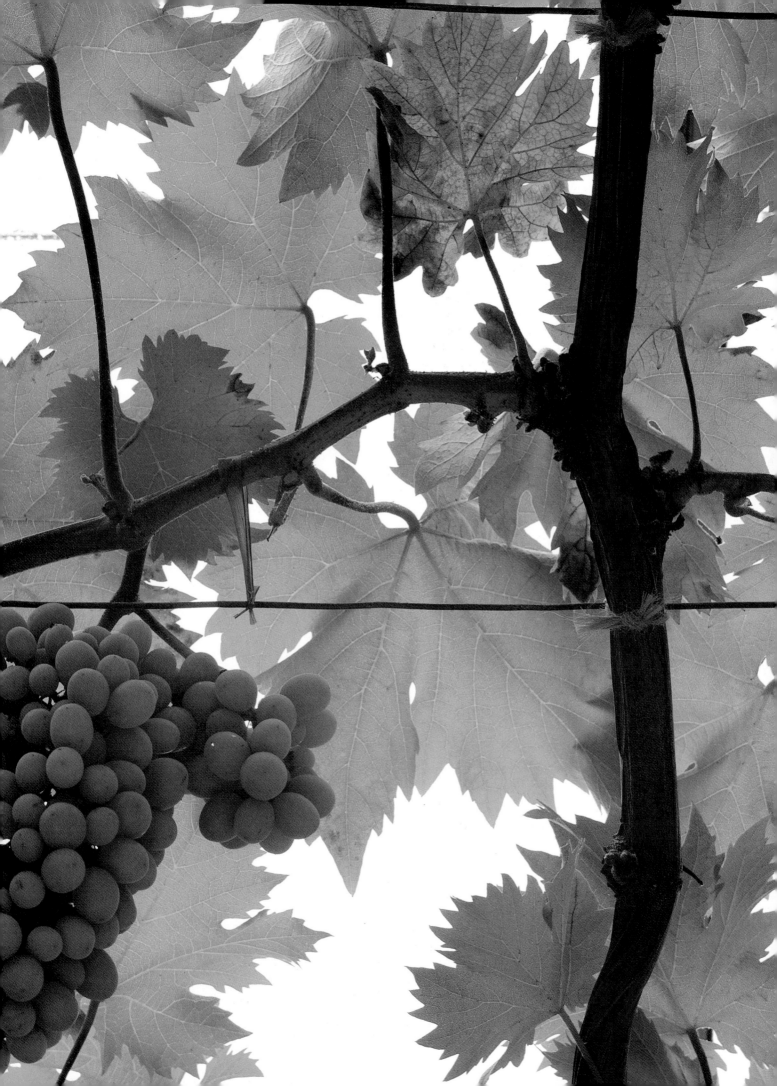

Lens Hood

A lens hood or shade is an important and often overlooked accessory for the garden photographer. Lens hoods are invaluable for shading the lens, thereby reducing the risk of flare from extraneous light, particularly when photographing against the light. If you are using through-the-lens metering (see p 16), then a lens hood will also help to give a more accurate meter reading. Most important of all, however, is the protection which lens hoods offer to lenses themselves. Without hoods, lens fronts can easily become badly scratched through contact with other lenses and cameras in your bag and these scratches will soon show up on your photographs.

Make sure when purchasing a lens shade that you use a size made specially for each lens. The wrong lens shade may result in photographs with black corners where the lens hood has encroached into the frame. This effect, known as 'vignetting', is especially noticeable when extension tubes are fitted between the lens and camera body.

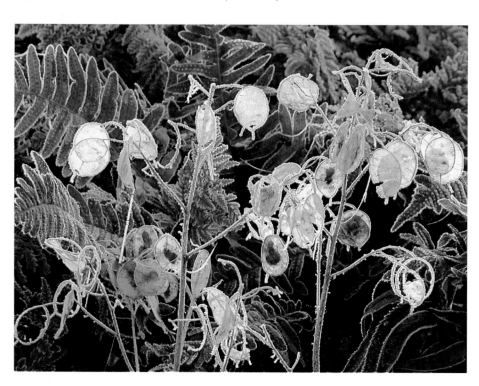

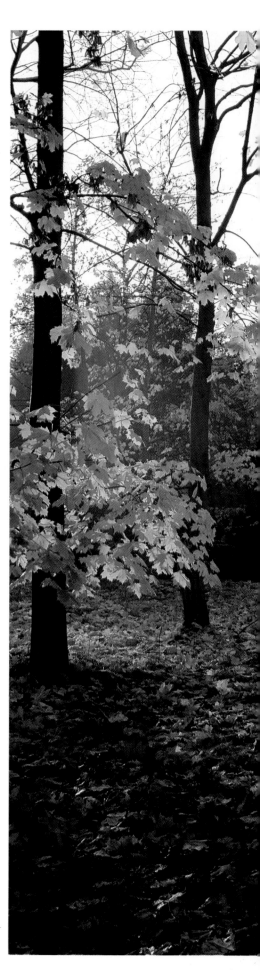

❀ A lens hood has prevented any flare from entering the lens in this frosty, back-lit portrait of honesty seed heads.

(Olympus OM2, 90mm macro lens, Fujichrome Velvia, f22, tripod.)

❀ I used a lens hood on my wide-angle lens to record this autumnal scene.

(Pentax 6 × 7, 55mm wide-angle lens, Fujichrome Velvia, f16, tripod.)

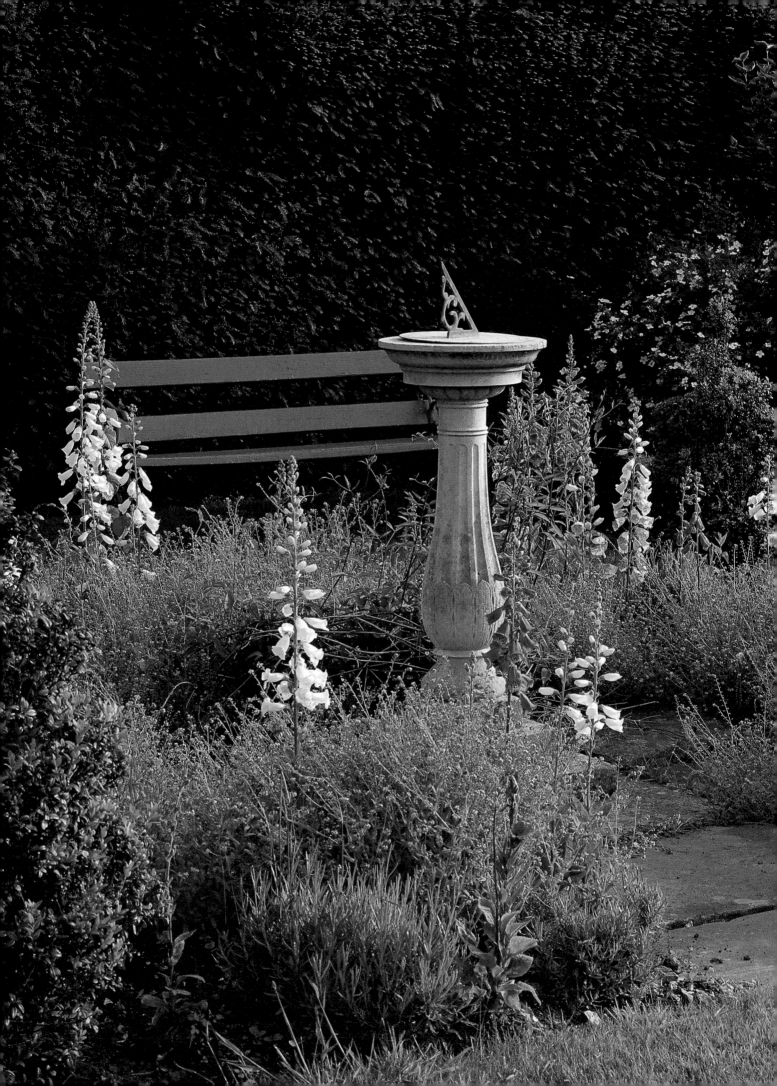

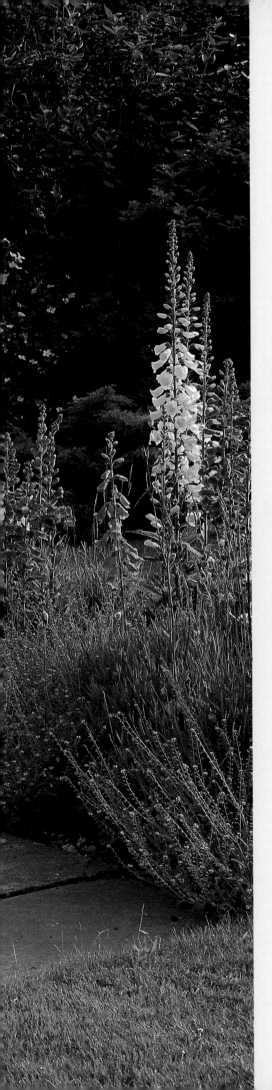

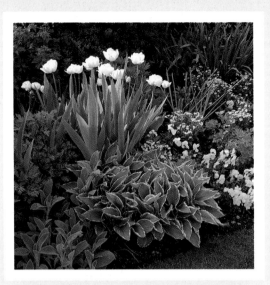

TECHNIQUES

❧ (Top) For this early-morning high-contrast shot of tulips and
hostas I under-exposed by 1½ f-stops to retain detail.

**(Bronica 6 × 6, 80mm standard lens, Fujichrome Velvia, f16, tripod. Chenies
Manor, Buckinghamshire.)**

❧ (Above) I used an aperture of f22 to obtain this pin-sharp
composition of alliums and poppies.

**(Bronica 6 × 6, 150mm short telephoto lens, Fujichrome Velvia, tripod. 40 Osler
Road, Oxford.)**

❧ (Left) Shooting just before sunset has added warmth to this
sundial.

**(Pentax 6 × 7, 135mm short telephoto lens, Fujichrome Velvia, f22, tripod.
Redenham Park, Hampshire.)**

Composition

Composition is simply the way in which we arrange and organise subject matter from a given scene within the picture. Generally, a successful composition will be one in which the disparate elements of the scene come together in a way that is aesthetically pleasing to the viewer.

For the plant and garden photographer, producing compositions that capture the attention of the viewer should not pose too much of a problem. For a start, to a certain extent the gardener seems to have done some of the hard work already. Good garden designers are artists working with living and man-made materials. As such, they know how to arrange plants and hard structural elements in an artistic way which is pleasing to the eye and hence at the same time to our cameras. Indeed, many of the most photogenic gardens are those in which the designer

has created a series of pictures or vistas for the viewer to admire and linger over. In a well-designed flower border, flowers will be juxtaposed in such a way that they complement rather than clash with each other, making the task of recording a photogenic composition more straightforward.

Nature also plays its part. Many floral subjects seem to possess their own 'natural' rhythm and symmetry which observant photographers can use to strengthen the impact of their compositions. Think, for example, of the 'chequerboard' pattern on the petals of the snake's head fritillary (*Fritillaria meleagris*), or the way in which the delicate petals of a rose radiate in a 'pinwheel' outward from the flower's centre. Learning to discover and isolate the 'natural' harmony and order contained within flowers and gardens will vastly improve your chances of producing satisfying compositions.

What you choose to exclude from a composition can often be as important as what you decide to leave in. So many garden pictures turn out to be a failure because the photographer has included too much of a scene and has not noticed distracting elements within the frame. The reason for this is that our eyes 'see' what they want to see, whereas the camera is not nearly as subjective and will faithfully record everything that is contained within the viewfinder. We may point our cameras at a border stacked full of beautiful blooms, only to discover when we examine our processed films that the picture has been spoiled by a distracting plant label in the foreground or people in the background.

One way to avoid making this kind of mistake when composing is to ask yourself the simple question 'What do I want to show in this photograph?'. In the example above, it may have been a particular combination of plants within the border that made you stop and set

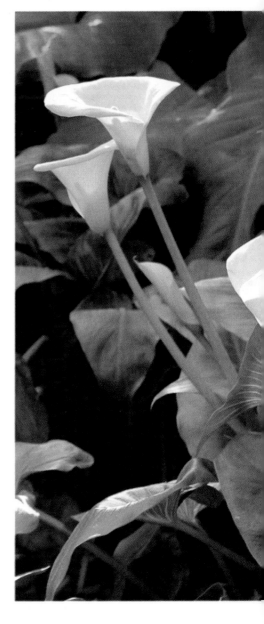

⚘ This necklace of scarlet *Tropaeolum speciosum* flowers forms a simple but effective composition.

(Olympus OM2, 90mm macro lens, Fujichrome Velvia, f11, tripod.)

up your camera. So rather than just use a wide-angle lens that takes in the whole of the border, it may be better to get in close with a telephoto lens so that the picture includes *only* those plants that first caught your eye and nothing else. By choosing to use a telephoto rather than a wide-angle lens,

PROFESSIONAL·TIPS

COMPOSITION

⚘ Successful composition exists where the diverse elements of a scene are presented to create a particular effect: peace and harmony, drama, discord.

⚘ Learn to recognise the 'natural' harmony contained in flowers and gardens: this will help you produce more satisfying compositions.

⚘ Check for plant labels, passers-by or other distractions.

⚘ Set up your camera on a tripod so you depict only what you want to include.

⚘ Consider a subject from unusual angles to create a more original or striking composition.

⚘ Ensure your photographs have a clear centre of interest; use mass, colour or contrast to achieve this.

⚘ Use natural garden features or paths and avenues to create scale and perspective and a sense of depth.

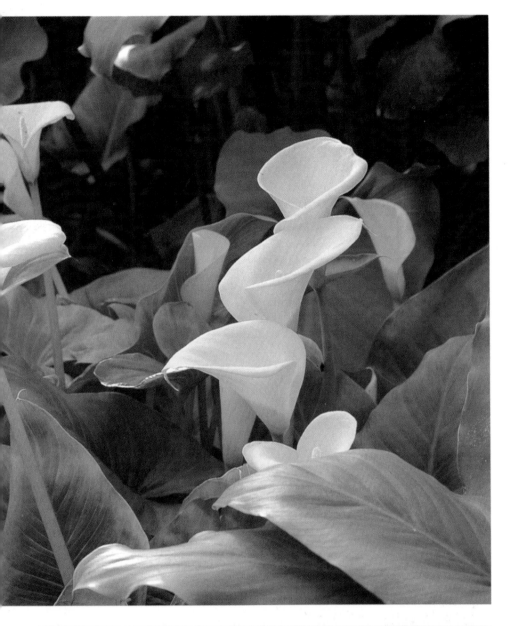

❀ These zantedeschias growing in a glasshouse seem to form their own 'ideal' natural composition. Delicate back-lighting has further enhanced the image.

(Pentax 6 × 7, 135mm short telephoto lens, Fujichrome Velvia, f16, tripod. RHS Garden, Wisley, Surrey.)

❀ A telephoto lens concentrates the brilliant autumnal hues of this maple. The tree's slender trunk adds strength to the composition.

(Olympus OM2, 300mm telephoto lens, Fujichrome Velvia, f22, tripod.)

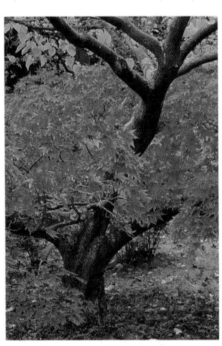

parts of the scene which do not contribute to the finished picture can be easily excluded, making the composition more photogenic.

There is no doubt in my mind that the best way to improve your eye for composition is to study the work of great photographers – and not just great garden photographers. Personally, I have been influenced just as much by the work of famous American landscape photographers such as Ansel Adams, Eliot Porter and David Muench as I have by any horticultural photographer, past or present. Indeed, I purchase regularly beautifully illustrated books on travel or sport or natural history in order to gain inspiration and learn new ways of composing pictures.

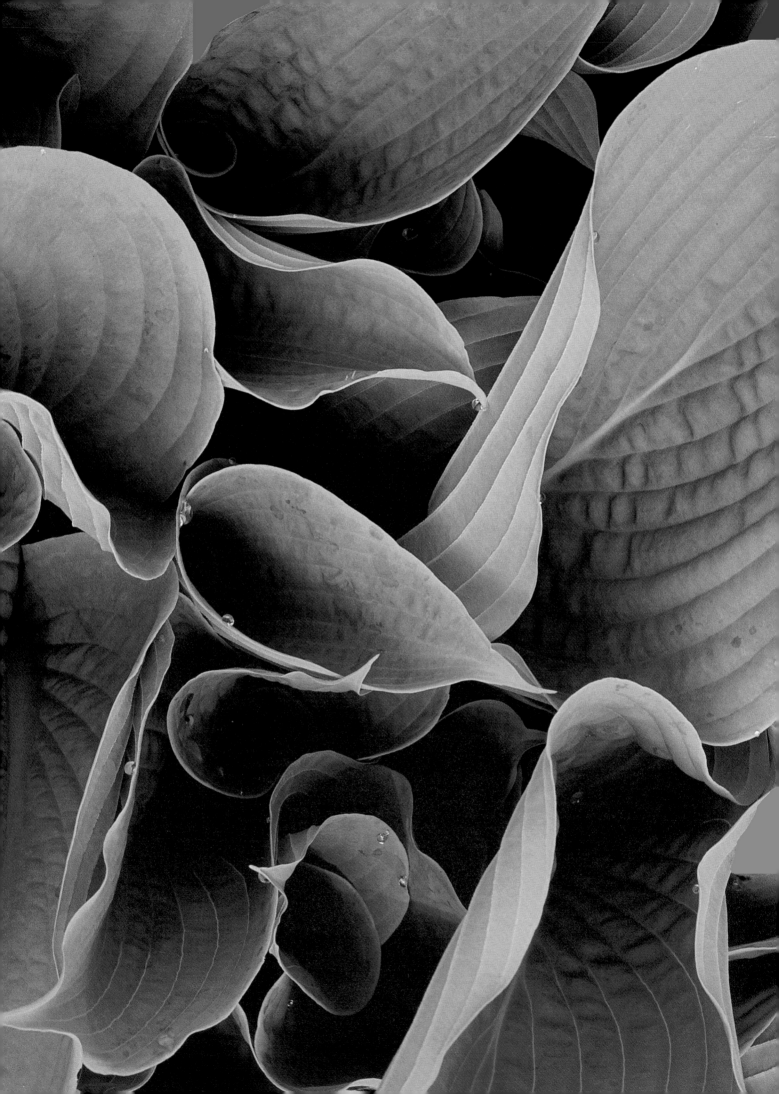

I picked out these pumpkins with a zoom lens. The two leaves at the top of the picture are important because compositionally they balance the two pumpkins below. If you block out the two leaves with your thumb the picture becomes bottom-heavy.

(Olympus OM2, 80–200mm zoom lens, Fujichrome Velvia, f22, tripod. Château de Villandry, Loire Valley, France.)

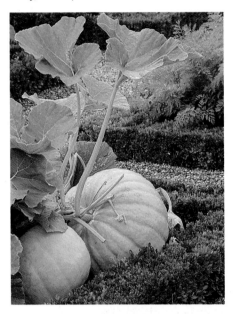

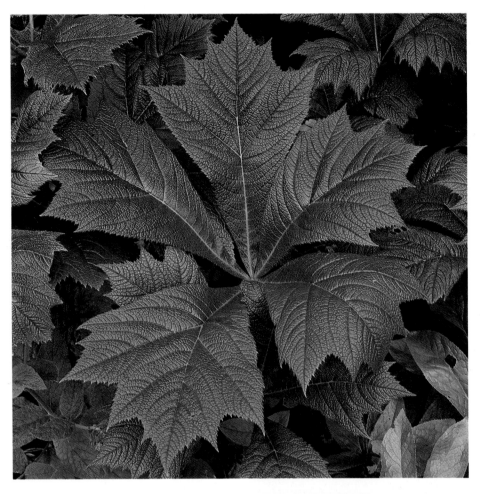

(Above) Bright overcast lighting shows off the thick, leathery foliage of *Rodgersia podophylla*. The shape of the leaves dictated my choice of camera format.

(Bronica 6 × 6, 80mm standard, Fujichrome Velvia, f16, tripod.)

(Left) The uniformity of colour and elegant curves of these hosta leaves create a striking composition when photographed from directly above.

(Olympus OM2, 90mm macro lens, Fujichrome Velvia, f22, tripod.)

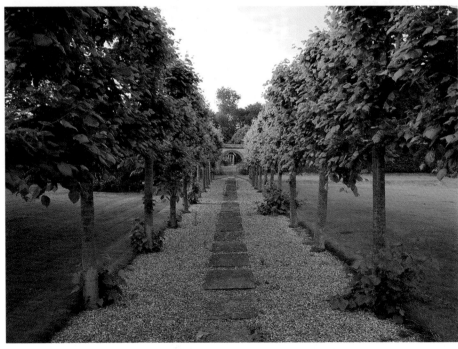

A wide-angle lens was used for this view of the pleached lime walk at Redenham Park. The converging lines of the central path and diminishing scale of the lime trees help to create a sense of depth in this composition.

(Pentax 6 × 7, 55mm wide-angle lens, Fujichrome Velvia, f22, tripod. Redenham Park, Hampshire.)

Choosing the Viewpoint

Choosing a suitable viewpoint from which to record a particular floral subject or garden scene is one of the most important decisions that must be made before you press the camera's shutter. Even the slightest change in viewpoint can often make the difference between a disappointing garden photograph and one which catches the attention of the viewer.

Having chosen a suitable subject that you wish to record, avoid the temptation simply to lift the camera to your eye and shoot it. Instead, take time to walk around the subject, looking through the viewfinder all the time to see how different angles of view can present an entirely different image of the subject through the viewfinder. Train yourself to look behind, in front of and to the sides of the subject.

Sometimes a higher viewpoint can improve a garden shot. If the garden is adjacent to the house, then shooting through an upstairs window can be the best way to show the garden's overall framework and design. For working over obstacles such as low hedges, fences or gates, a step-ladder has often proved invaluable. Steps, balconies and flat roofs are other vantage points which can be utilised whenever they are present in a garden.

Certain subjects demand to be photographed from a low viewpoint. Hanging-baskets, for example, are often photographed from below simply because they tend to be located in places where it is difficult or impossible to gain enough height to photograph them straight on. Similarly, the saucer-shaped flowers of the Lenten rose (*Helleborus orientalis*) are best photographed from ground level, because their faces hang downwards and so can only be recorded properly from such a low viewpoint. With tall subjects like trees and statuary, dramatic pictures can sometimes be created by pointing the camera upwards so that the subject is set off against a background of sky.

Once you have established what you think is a suitable viewpoint, check carefully to make sure that there is nothing in the scene which will spoil the photograph. Depress the depth-of-field button if you have one and look at everything in the viewfinder, paying special attention to the edges and the corners of the frame. Sometimes it may be necessary to remove distracting plant material such as dead-heads or leaf litter in order to improve the composition – indeed, this is a common practice among garden photographers and is often referred to as 'gardening'! Remember, though, that if you are working in a garden which is not your own, you should not remove *any* plant material, no matter how unsightly, without the garden owner's permission.

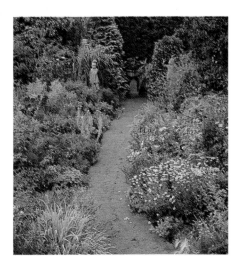

❧ I climbed on to the kitchen roof in order to photograph the full extent of these twin borders at Red Gables in Worcestershire.

(Bronica 6 × 6, 150mm short telephoto lens, Fujichrome Velvia, f22, tripod. Red Gables, Worcestershire.)

❧ A very low viewpoint was chosen to photograph this delicate hellebore flower.

(Olympus OM10, 50mm standard lens, Fujichrome Velvia, f11, tripod. The Old Rectory, Burghfield, Berkshire.)

❧ This aerial view of designer David Hicks' garden was taken from a helicopter. I leant out of one of the windows and hand-held the shot using a wide-angle lens. Because of the amount

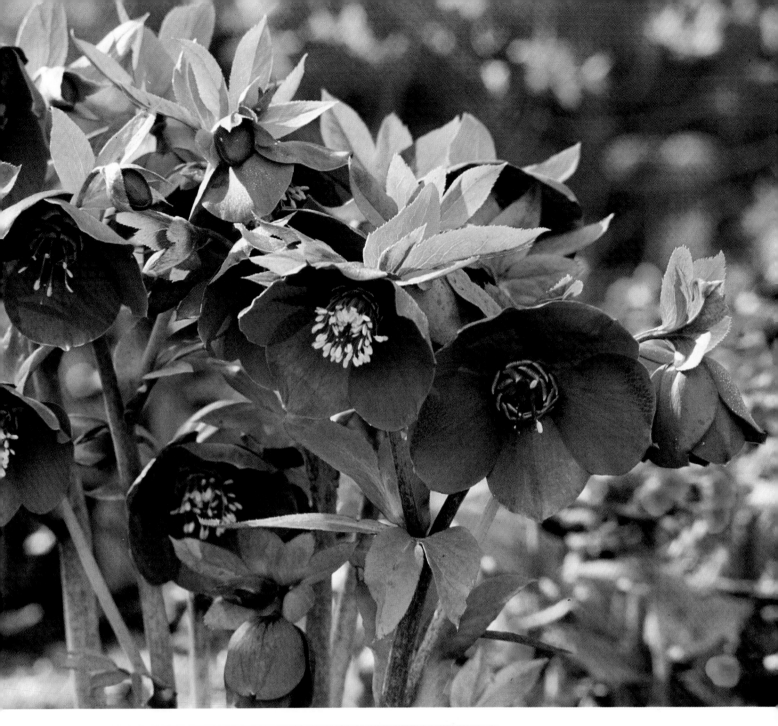

of vibration from the helicopter and also because I was hand-holding the camera, I set a large aperture which allowed me to use a very fast shutter speed, thus eliminating any possibility of camera shake.

(Olympus OM2, 28mm wide-angle lens, Fujichrome Velvia, 1/500 sec f4, tripod. David Hicks' garden, Oxfordshire.)

❀ (Overleaf) A high viewpoint reveals the pattern of hedges and topiary of the great parterre at Villandry. The picture was taken from the walls of the château.

(Bronica 6 × 6, 150mm telephoto lens, Fujichrome Velvia, f22, tripod. Château de Villandry, Loire Valley, France.)

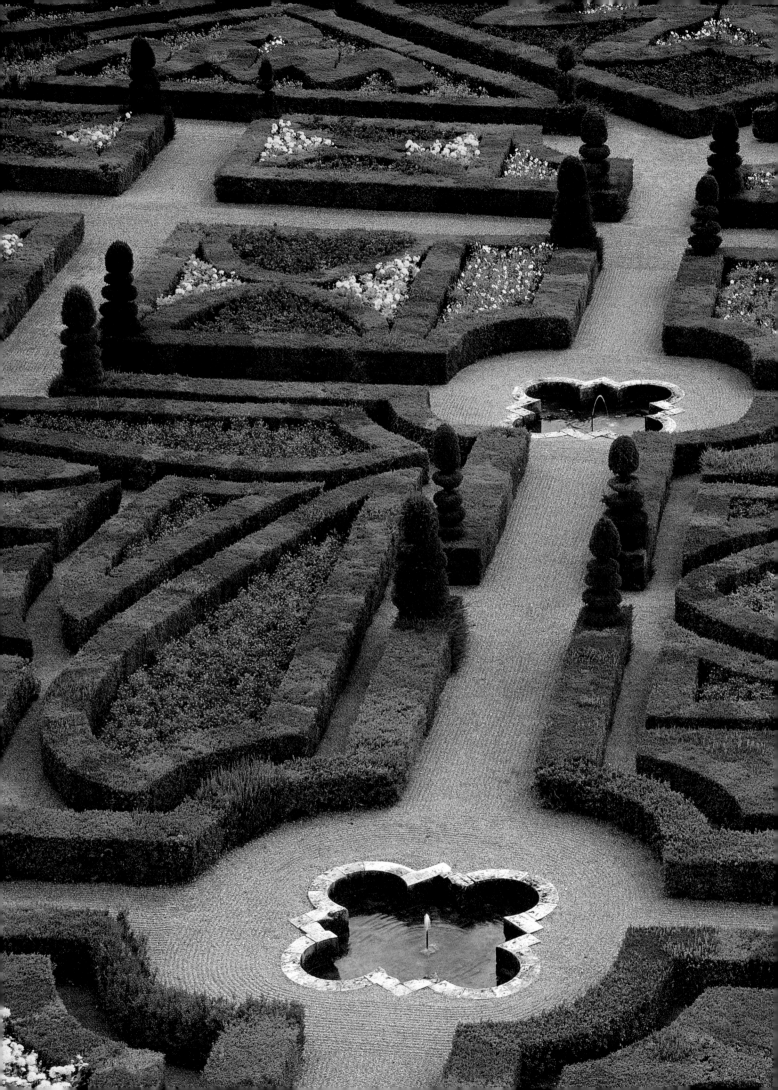

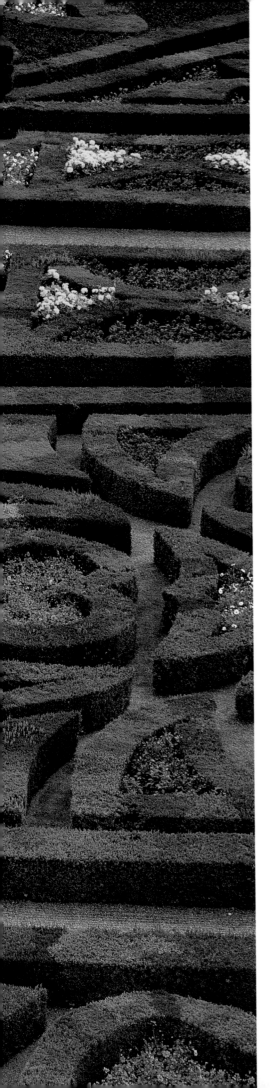

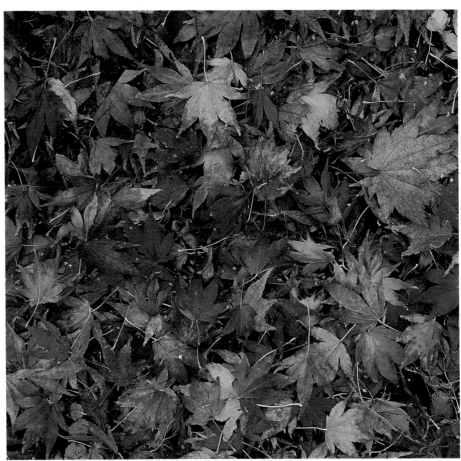

❀ These Japanese maple leaves were photographed directly overhead.

(Bronica 6 × 6, 80mm standard lens, Fujichrome Velvia, f22, tripod. Batsford Arboretum, Gloucestershire.)

❀ A low viewpoint was chosen to photograph the drooping flowers of this *Crinum* x *powellii* 'Album'.

(Olympus OM2, 90mm macro lens, Fujichrome Velvia, f16, tripod. Myddelton House, Hertfordshire.)

Focusing and Depth of Field

Having chosen a suitable viewpoint from which to photograph a subject, a decision must be made as to how much, if any, of that subject should be reproduced in sharp focus. Sometimes it is desirable to show just a small portion of a flower or garden detail as pin-sharp, while recording the rest of the scene as an out-of-focus blur. With other subjects you may want to have the whole scene sharp from front to back, so that all the details are crystal clear. Understanding precisely how to create the right degree of sharpness for different garden subjects is a difficult and time-consuming matter and is only possible once the concept of depth of field has been understood fully.

Depth of field refers to the section of any scene, before and beyond the point of focus, which appears sharp in the finished photograph. This plane of optimum definition is dependent on three factors, all of which the photographer can control.

1 The size of the lens aperture. The smaller the aperture, the greater the depth of field will be. The larger the aperture, the smaller the depth of field. On the camera, the smaller apertures are denoted by higher f-numbers – f22 and f16 and the larger apertures by lower f-numbers – f4 and f5.6.

2 The point of focus. The greater the distance between the camera and the subject that the lens is focused on, the greater the depth of field will be.

3 The focal length of the lens. The shorter the focal length of the lens, the greater the depth of field will be. Hence, wide-angle lenses have greater depth of field than standard lenses which in turn have greater depth of field than telephoto lenses.

To complicate the issue further, depth of field is not distributed equally on both sides of the plane of focus. It is approximately one-third in front and two-thirds behind the point at which the lens is focused. Hence, to achieve maximum sharpness in a garden image you should choose the smallest possible aperture and focus on a spot which is roughly one-third of the distance into the scene. Depressing the camera's depth-of-field button (if your camera has one) will show which elements of the composition are sharp and which are unsharp (see also p 20). Alternatively, you can use the scale on the focusing mount of your lens to read off the extent of the depth of field against the aperture that you intend to use.

When working at very close distances, the depth of field decreases dramatically, making precision focusing imperative. At high magnifications, it may not even be possible for all parts of a flower or garden detail to be sharp. Using the smallest aperture possible and keeping the back of the camera parallel with the subject will ensure that depth of field is maximised.

❧ Precise focusing and a small aperture of f22 enabled me to produce this bitingly sharp picture of a 'Bird of Paradise' tulip.

(Olympus OM2, 90mm macro lens, Fujichrome Velvia, f22, tripod. Chenies Manor, Buckinghamshire.)

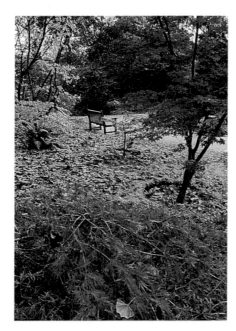

❧ These photographs show how different lens apertures can affect the depth of field. In both instances a 28mm wide-angle lens was mounted on a tripod and focused on to the green leaf in the foreground. The left-hand photograph was taken with the lens opened up to its maximum aperture of f2.8. For maximum depth of field, the right-hand picture was taken with the lens closed right down to its minimum aperture of f22.

(Olympus OM2, 28mm wide-angle lens, Fujichrome Velvia, left: f2.8; right: f22; tripod. City of Bath Botanical Gardens.)

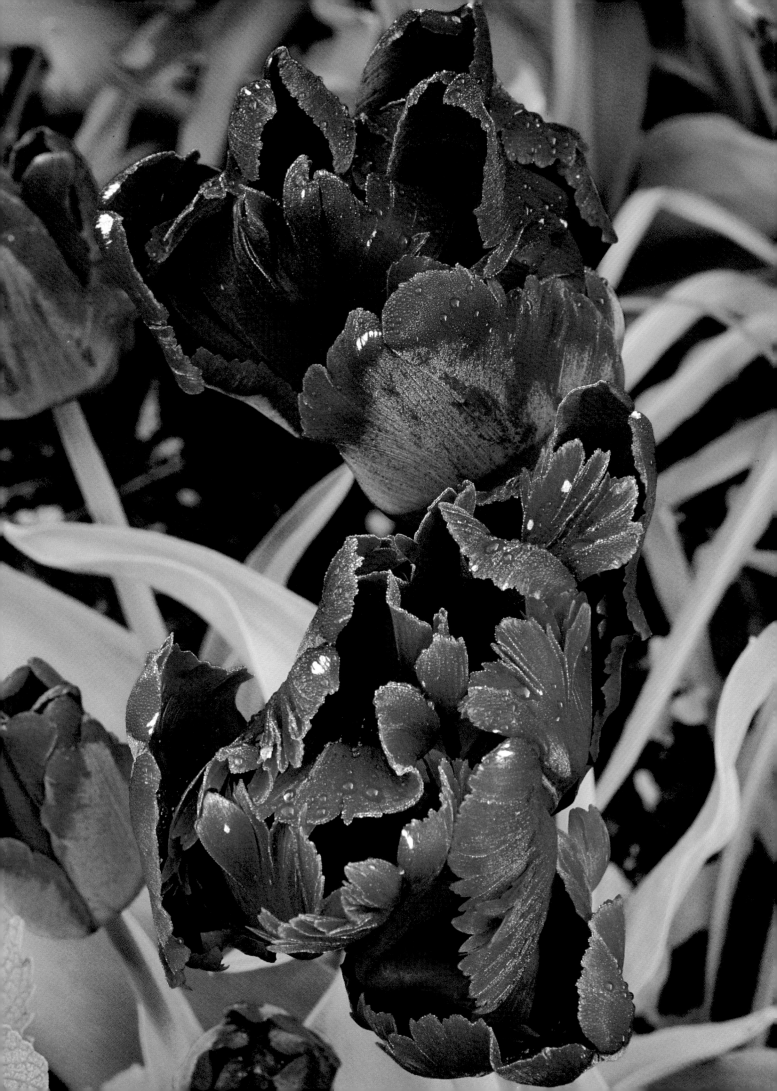

Exposure

The term exposure refers to the amount of light which is allowed to reach the surface of the film inside the camera body when a photograph is being taken. If insufficient light reaches the film during an exposure, the picture will appear dark and will be under-exposed, whereas if too much light is allowed to strike the film, the image will appear washed out and will be over-exposed.

Exposure is controlled by two basic camera settings: lens apertures and shutter speeds. Lens apertures or 'f-stops' determine the intensity of light reaching the film by altering the size of the aperture opening inside the lens. On most lenses they appear as a series of numbers starting at, for example, f2.8 (a large aperture) and ending at f22 (a small aperture). Shutter speeds control the length of exposure time and are measured in seconds and fractions of a second. Most cameras have shutter speeds ranging from a slow speed of 1 second through to a fast speed of 1/1000th second. For exposures longer than 1 second, there may be a 'B' setting which allows the shutter to remain open for as long as the shutter release button is depressed.

Each incremental setting on the shutter speed and lens aperture scales is called a 'stop'. Selecting each higher 'stop' or setting on either scale (for example, changing from f16 to f22 or from 1/60th second to 1/125th second) will halve the amount of light reaching the film. Conversely, selecting each lower setting on either scale (for example, changing from f16 to f11 or changing from 1/60th second to 1/30th second) will double the amount of light reaching the film.

Because lens aperture and shutter speed work in a reciprocal 'one stop' relationship, it is possible to allow the same amount of light to reach the film using a series of different settings. Choosing a higher setting on one scale means that the next lowest setting must be used on the other scale if the same exposure is to be achieved. For example, an exposure of 1/30th second at f8 would be the same as 1/15th second at f11 or 1/60th second at f5.6 since all three combinations let in the same amount of light on to the film.

It follows from this that for virtually any subject, there is a whole range of different shutter speed and f-stop combinations that can be used to achieve correct exposure. Deciding on which combination to use for any given subject is a matter of personal preference, since both settings control not just the amount of light that reaches the film, but also the appearance of the final photograph. Apertures determine the depth of field (see p 56), while shutter speeds control both camera and subject movement.

✿ Deliberate under-exposure by 1½ stops helps to set these brilliant white 'Mount Tacoma' tulips off against a dark, velvety background, adding drama to the picture.

(Bronica 6 × 6, 80mm standard lens, Fujichrome Velvia, f22, tripod.)

✿ A slight over-exposure of ½ stop helps to bring out the delicate tonalities in these buttery yellow and rich red heleniums.

(Olympus OM2, 90mm macro lens, Fujichrome Velvia, f22, tripod. Manor House, Upton Grey, Berkshire.)

Using the Light Meter

A light meter is the tool that photo-graphers use to measure exposure. All light meters gauge the intensity of light and work out the possible lens aperture and shutter-speed combinations that will give proper exposure for any given film speed.

While some light meters are hand-held, many modern cameras now have their own built-in light-metering systems. Most SLR cameras use through-the-lens (TTL) light meters, which measure the intensity of light reflected from the subject via the camera's reflex viewing system (see also p 16).

Multi-pattern metering systems are designed to overcome exposure error in tricky lighting. They work by taking light readings in different parts of the camera's viewfinder, then processing them using an on-board microchip computer to determine the ideal exposure based on 'model' lighting situations programmed into the computer's memory.

Most TTL meter systems are either averaging, centre-weighted or spot systems, and some modern cameras offer a choice of all three. Centre-weighted meters gauge the light levels across the whole picture area, but bias the reading towards the central 60 per cent or so, as it is assumed that this is where the most important subject matter will be. Spot systems take a reading from a very small area of the scene (usually 1–5 per cent of the total image area) and are most useful in situations where some parts of the subject are illuminated with bright light while other parts are in shade.

Exposure readings given by TTL meters are generally fairly reliable when the subject being photographed is of neutral tone and is illuminated by flat, even lighting. However, there are occasions when the meter cannot always be trusted to give an accurate exposure reading. TTL meters that take centre-weighted readings, for example, are biased towards the bright-ness of the scene in the centre of the frame. This assumes that the pho-tographer has composed the picture in such a way that the main subject is in the centre – clearly not always the case.

Because TTL meters take readings based upon the light being reflected back towards the camera from the sub-ject, the tone of the subject will influ-ence the reading of the meter. If the meter sees a very light-coloured sub-ject, such as a garden covered with a mantle of fresh snow, it will try to cut down the exposure because of the amount of light which is being reflected and the result will be an under-exposed picture with the snow appearing grey instead of white. To 'whiten' and lighten the subject it is necessary to increase the exposure by selecting either a larger lens aperture or a slower shutter speed than that rec-ommended by the meter. The opposite effect can occur when metering a very dark-coloured subject, as the meter will try to increase exposure because the amount of light being reflected back to the camera is so low. If the reading indicated by the meter were used, the picture would appear over-exposed, so it is necessary to decrease exposure by choosing either a smaller lens aperture or a faster shutter speed.

✿ I used a hand-held meter to work out the correct exposure for this shot of the Praeneste terrace at Rousham Landscape Garden. I decided that a slight degree of over-exposure was needed in order to show some detail in the shadow areas.

(Pentax 6 × 7, 90mm standard lens, Fujichrome Velvia, 2 sec f22, tripod. Rousham Landscape Garden, Oxfordshire.)

✤ This balcony required very careful metering. Over-exposure would have resulted had I not taken into account the large area of dark decking and fencing. I took a reflected light reading from the cream-coloured hyacinths on the left using a hand-held meter and then under-exposed by ½ stop in order to saturate the colours even more.

(Pentax 6 × 7, 55mm wide-angle lens, Fujichrome Velvia, ½ sec f22, tripod. Keukenhof, Holland.)

✤ I decided to over-expose this shot of aquilegias by about 1 stop in order to brighten the whole picture. I was able to 'fool' the camera's through-the-lens-metering system by changing the ISO speed dial from ISO 50 to ISO 25.

(Olympus OM10, 90mm macro lens, Fujichrome Velvia, f16, tripod.)

Metering for Very Contrasty Light

In situations where there is a mixture of intense sunlight and inky black shadows within a composition, such as on a sunny day when a border of brightly lit flowers is set against a dark yew hedge which is in deep shadow, a decision must be made about which part of the scene should be properly exposed. Since no film can record the range of tones from highlights to deep shadows in such high-contrast conditions, the photographer must choose to expose either for the highlights or for the shadows. If the brightly lit area of the composition is the most important element in the photograph, then a reading should be taken from that section, allowing the deeply shaded area to turn even darker. The photographer should then try to make the most of the situation by composing the picture in such a way that the highlighted area is enhanced by the darker backdrop.

If, on the other hand, the shady portion of the image is the main subject of the picture, then an exposure value that will record detail in that part only should be chosen. The section of the composition which is in full sunlight will consequently appear overexposed and burnt out, but provided it is of secondary importance to the composition, it should not distract too much from the finished photograph.

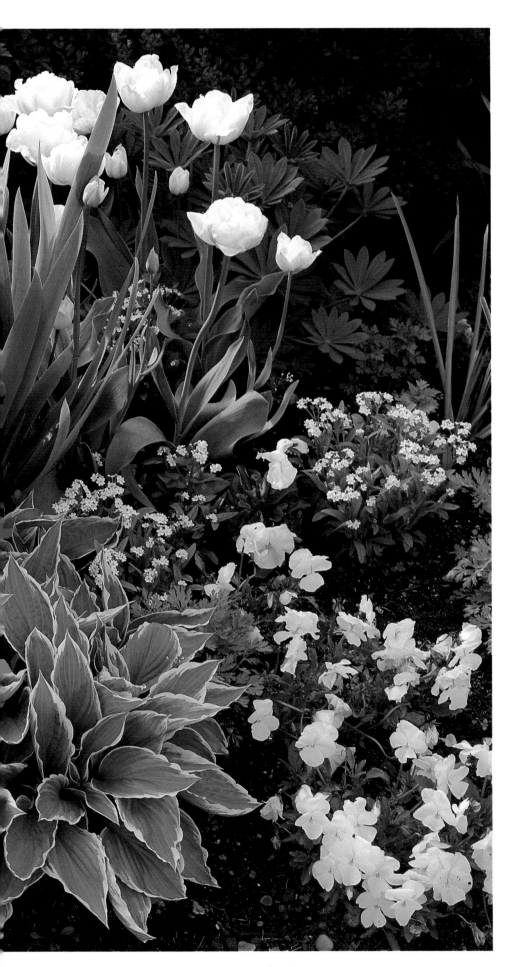

 In this early morning photograph I was faced with very contrasty lighting. I took a general reading of the scene using the camera's through-the-lens meter and then under-exposed by 1½ stops to prevent the white tulips from burning out.

(Bronica 6 × 6, 80mm standard lens, Fujichrome Velvia, f22, tripod. The White Garden, Chenies Manor, Buckinghamsnire.)

Bracketing

One way to make certain that you have at least one perfectly exposed picture every time you shoot a different garden subject is to use a technique known as 'bracketing'. To do this, take one shot of the subject using the exposure reading suggested by your meter, then take one or two additional frames above and below that reading. You will end up with a bracketed series of photographs like the ones shown on this page and the 'perfect' exposure can then be selected for printing, projection or reproduction.

Bracketing exposures is especially important when using transparency films, because they have less exposure latitude than negative films. With negative films it is usually necessary to over- or under-expose by at least one whole stop from the suggested meter reading before there is a noticeable difference, whereas with transparencies I would suggest bracketing in $\frac{1}{2}$-stop increments.

To bracket exposures, you can change either the lens aperture (f-stop) or the shutter speed. If depth of field is important in the photograph, then you will want the aperture setting (f-stop) to remain unchanged, so simply adjust the shutter speed. If, on the other hand, you wish to keep the shutter speed constant (for example, if you wanted to freeze the wind-tossed movement of a flower), simply vary the aperture setting instead.

With some cameras you can bracket by using the exposure compensation dial which has settings marked with a plus sign (+) for over-exposure and a minus (−) for under-exposure. On automatic cameras which do not have manual override facilities or a compensation dial, you may be able to bracket by altering the film-speed dial, setting a faster film speed to under-expose and a slower film speed to over-expose. For example, if you are using ISO 100 film, set the film-speed dial to ISO 200 in order to obtain 1 stop under-exposure; to over-expose by 1 stop, set it to ISO 50.

One way to make certain that you have at least one perfectly exposed image is to take a bracketed series of photographs. You will then be able to select the ideal exposure (shown opposite).

(Olympus OM2, 80–200mm telephoto lens, Fujichrome Velvia, f32, tripod. The pots were planted by Caroline Cordy.)

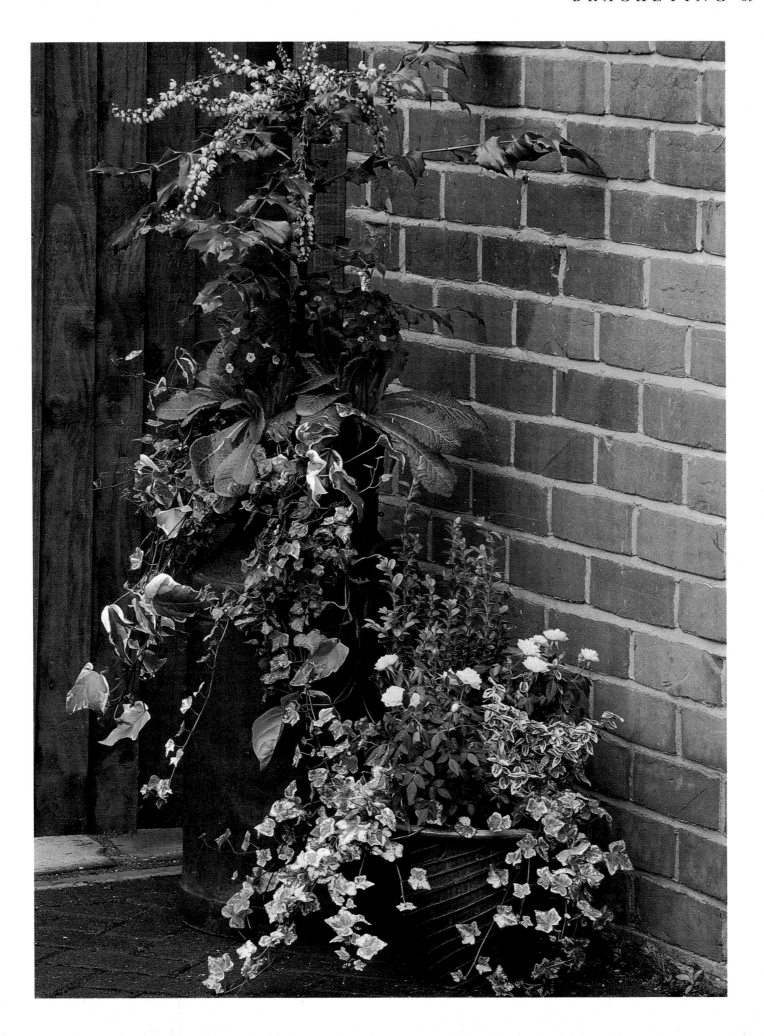

Movement

Flowers and foliage outdoors are rarely perfectly still. Most of the time they are being tossed around by the wind. While this can be a source of great frustration to the photographer who wants to produce sharp pictures of these floral subjects, with a little imagination still images can be amazingly effective in portraying the beauty of this movement. The motion of wind-tossed flowers and foliage can be 'frozen' by using a fast shutter speed or electronic flash, or it can be deliberately reproduced on film as a blur by using a slow shutter speed with the camera mounted on a tripod.

Water is another potential source of movement in a garden. Streams, cascades, waterfalls and fountains are the music of a garden and all make good subjects for photography. If you want to freeze the movement of water from fountains you will have to use a shutter speed of around 1/250th second or higher. To render it as a milky blur, on the other hand, requires an exposure of around $1/2$ second or longer, depending on how fast the water is flowing.

Accidental camera shake is probably the main cause of blurred pictures among amateur photographers. As a general rule, cameras can be hand-held at shutter speeds that are equal to or faster than the focal length of the lens that is being used, without camera shake being discernible in the finished photograph. For example, a standard 50mm lens can be hand-held at a shutter speed of 1/60th second or faster, whereas a longer focal length lens such as a 200mm telephoto lens would require a shutter speed of around 1/250th second or faster to eliminate the effects of camera vibration.

❀ The movement of the water in this magnificent fountain was recorded as a milky blur by using an exposure of 1 second. In order to achieve such a slow shutter speed I set the smallest aperture possible (f32) on my zoom lens.

(Olympus OM2, 80–200mm zoom lens, Fujichrome Velvia, f32, Tripod. Château de Versailles, France.)

Light

Light is the dominant element in any garden photograph. More than any other factor, it is the quality of light within a composition that can make the difference between a picture that works and one that does not. An awareness and understanding of the subtle, yet elusive, qualities of light and how they can be used to enhance or create atmosphere in your garden pictures is something that can only be learnt through experience.

PROFESSIONAL·TIPS

WORKING WITH LIGHT

❧ **L**ens apertures and shutter speeds together control exposure; which combination to use for a subject is up to you.

❧ **E**arly morning or late afternoon light often produces the most effective garden pictures, especially in summer.

❧ **I**n very contrasty light you must expose either for the highlight or the shadow.

❧ **T**TL meters will under-expose a very light subject and over-expose a very dark one: compensate by increasing or decreasing exposure.

❧ **L**earn how to exploit the positive qualities of intense sunlight.

❧ **U**se side-lighting to emphasise depth and the 3-dimensional; diffused lighting the detail.

❧ **U**sed carefully, back-lighting can create dramatic images.

The majority of garden photographs are taken outside, using the natural light emitted by the sun. Even throughout the course of a single day, this natural light can vary dramatically, not just in direction and quantity, but also in colour. A sudden change in lighting conditions can turn an uninspiring garden scene into a dramatic one within the space of a few minutes. Conversely, an exciting picture can disappear in a flash. If the light is not right for a garden photograph, then rather than take a poor picture, it may be better to sit and wait for the light to improve, or to put the camera away and return at a later date when the lighting conditions are more favourable. It is the unpredictable nature of natural light that makes plant and garden photography such a difficult and challenging occupation.

Many garden photographers prefer to work in the early morning or late afternoon when the sun is at a tangent to the earth and low in the sky. At such times the sun's rays are weaker because they have to pass through an extra layer of the earth's atmosphere. As a consequence, contrast is reduced between highlights and shadows. The low-angled lighting at dawn and dusk also produces raking shadows which reveal texture and accentuate the three-dimensional quality of a garden. In addition, the dense atmospheric layer absorbs much of the ultra-violet and blue light, so that garden scenes photographed at dawn and dusk are washed in a rich, warm light which is highly flattering to garden subjects.

❧ I arrived at Chastleton Glebe Garden at dawn to find this incredible scene. The mist was just thick enough to allow me to shoot straight at the sun without any danger of flare, and the lake was so still that perfect reflections were produced on its surface, even with a 4 second exposure. Ten minutes later the sun had burnt through the mist and the scene had lost all its magic and drama.

(Bronica 6 × 6, 80mm standard lens, Fujichrome Velvia, f22, tripod. Chastleton Glebe Garden, Gloucestershire.)

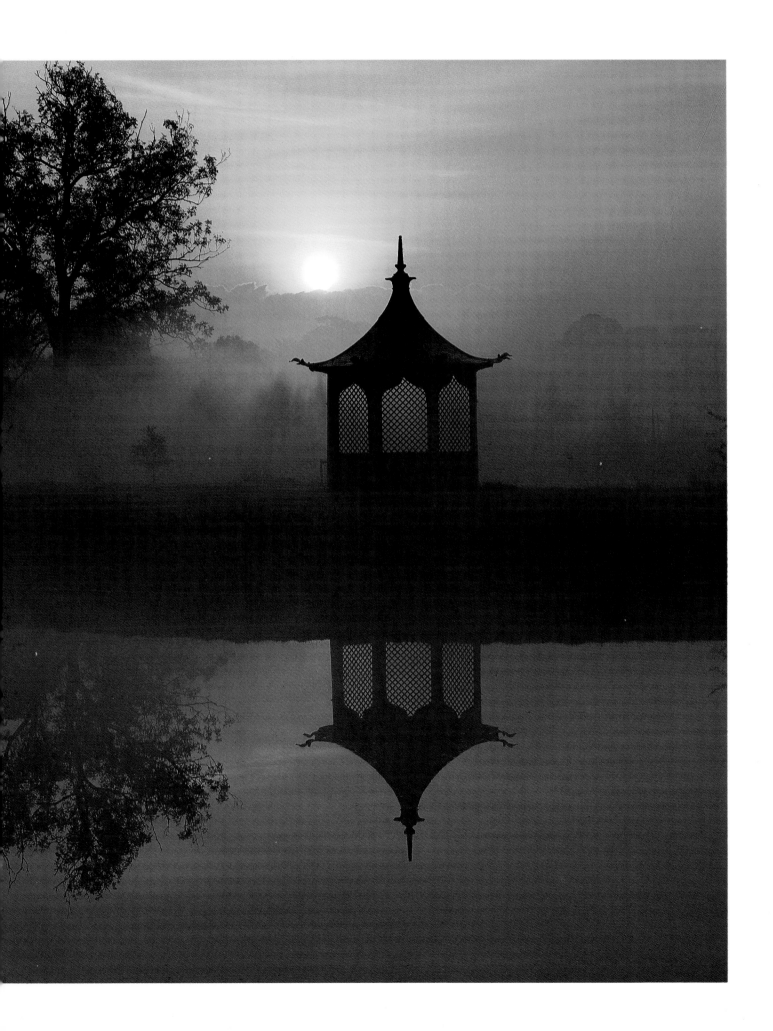

Intense Sunlight

Intense sunlight is often thought to be the best light for garden photography. Personally, I think this has something to do with the fact that most of us get maximum enjoyment from our gardens when the sun is shining brightly and the colour of flowers and foliage seems most intense. Brilliant sunshine makes us feel happy, so out come our cameras to record a piece of this happiness. In practice, photographs taken in such conditions can often be a disappointment. The reason for this is that no film is able to record the extremes of contrast which harsh sunlight creates. The result is that pictures are often marred by the presence of washed-out highlights or cavernous, inky-black shadows.

Wonderful garden pictures can be taken in intense daylight, provided that its positive qualities are recognised and fully exploited. Solid objects – buildings, trees and statuary, for example – can look dramatic in bright, direct sunlight, particularly when set against a brilliant blue sky with scudding white clouds. Subjects which are deep red or orange in colour, such as a maple tree in autumn or a border of red flowers and foliage, can also be very photogenic in bright sunlight because of their strong colours. Pictures taken in intense sunlight can be further enhanced by using a polarising filter, which has the effect of reducing haze, enriching colours and cutting down distracting glare.

The strong shadows cast by intense sunlight can be incorporated into the picture in such a way as to enhance a garden photograph. For example, they can create a dark background to set off a brightly lit foreground subject, or they can be used to accentuate the form and texture of certain subjects. Another option is to omit deep shadows altogether from the photograph by including in the frame only those parts of the scene which are in strong sunlight.

When working close to subjects like flowers and foliage which are half in deep shade and half in brilliant sunshine, it may be possible to reduce the high-contrast situation, either by adding light to the shady areas using a reflector or a burst of electronic flash, or by softening the harsh sunlight and shadows using a diffusing screen.

This view of the great topiary garden at Levens Hall was taken in bright sunlight. A polarising filter saturates the colours of the foreground flowers and deepens the blue of the sky.

(Bronica 6 × 6, 50mm wide-angle lens, Fujichrome 50, f22, tripod. Levens Hall, Cumbria.)

overleaf

Intense midday sunlight adds to the feeling of Mediterranean opulence in this view of the pink and white Villa Ile-de-France and its gardens in the Côte d'Azur. I used a polarising filter to deepen all the colours, particularly the blue of the sky.

(Pentax 6 × 7, 135mm short telephoto lens, Fujichrome Velvia, f32, tripod. Villa Ile-de-France, Côte d'Azur, France.)

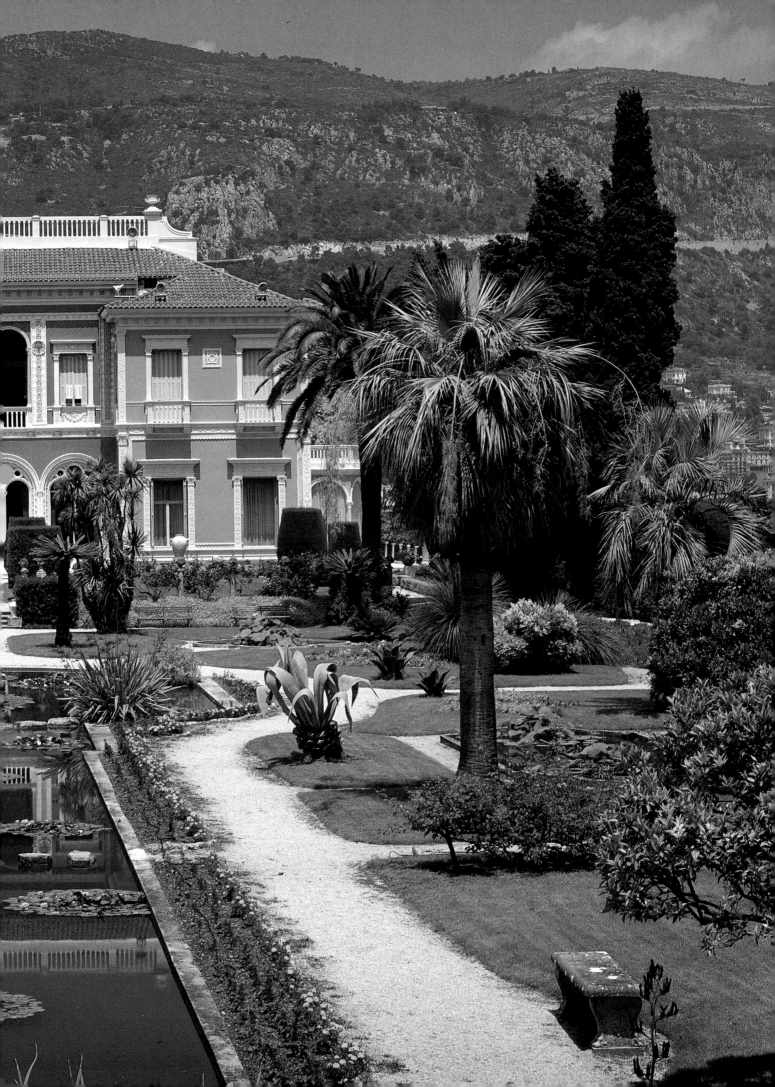

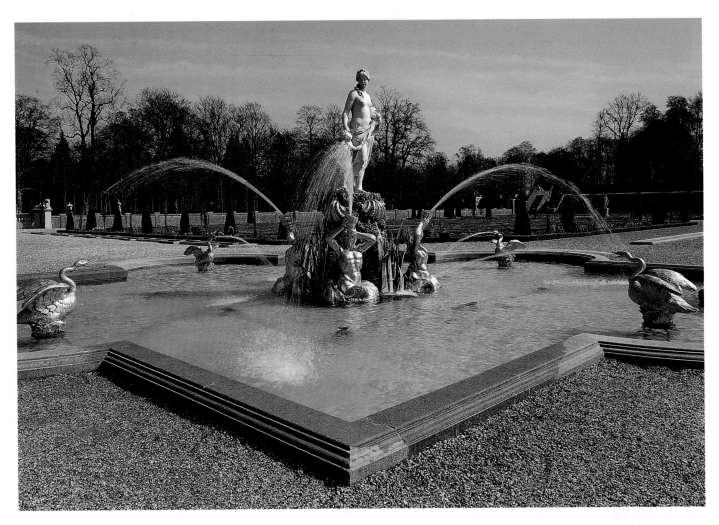

❦ A polarising filter has enriched the gold of the statues, cut down reflections from the pool and deepened the blue of the sky in this brightly lit picture of a fountain. The V-shape of the pool's edge in the foreground holds the whole composition together.

(Pentax 6 × 7, 55mm wide-angle lens, Fujichrome Velvia, f22, tripod. Het Loo, Holland.)

❦ Mediterranean gardens invariably photograph well in intense light as is shown in this picture of the villa of La Mortola, Ventimiglia, taken from the cactus garden. I used a polarising filter to saturate the colours and the smallest aperture of f22 to obtain maximum depth of field.

(Pentax 6 × 7, 105mm standard lens, Fujichrome Velvia, f22, tripod. La Mortola, Ventimiglia, Italy.)

❦ A strong shaft of sunlight illuminated these flowers of *Tulipa neustreuvae* growing in an alpine house. I decided not to try to diffuse the light, choosing instead to set off the brightly lit flowers against a dark, velvety backdrop.

(Olympus OM2, 90mm macro lens, Fujichrome Velvia, f11, tripod. RHS Garden, Wisley, Surrey.)

Back-lighting

With back-light, the camera is pointed towards the sun so that the sun's rays are shining towards the lens and from behind the subject. Handled properly, back-lighting or *contre-jour* can transform even the most mundane scene into one of great beauty and drama. If the light source is strong, then shadows will extend towards the camera, enhancing the three-dimensional quality of a scene. If the subject is translucent then strong back-light can make it glow like a light-bulb.

There are, however, several problems with this kind of light. Pointing a camera directly at the sun in the middle of the day may actually damage the camera's shutter, as well as your own eyes. Because the camera is pointed directly towards the light source, there is also a danger that some stray, non-image-forming light will strike the lens, causing internal reflections and flare. Internal reflection produces spots of light on the finished photograph, sometimes reproducing the shape of the lens's iris diaphragm. Flare will fog the image, reducing contrast. Obviously, if the sun is to be shown in the picture,

then there is no means of protecting the lens from its effects, which will therefore be reproduced in the finished photograph. In strong sunlight, flare and internal reflection may be unacceptable, but if the intensity of the sun's rays is reduced by mist, fog, atmospheric haze or when it is rising or setting, then flare may actually enhance the photograph.

If the sun is not actually included in the frame, then flare can be reduced or eliminated altogether either by using a suitable lens hood, by shading the lens with your hand, by casting your own shadow over the lens, or by selecting a viewpoint which is in the shadow of an object such as a tree.

Fortunately, if you are using an SLR camera, it is easy to see how much, if any, flare exists, simply by looking in the viewfinder and stopping down the lens to the desired aperture by pressing in the depth-of-field button (see also p 20). If you are using your hand to shade the lens, be careful that it is not visible in the picture.

Back-lighting also requires careful exposure. Because of the great range in contrast between dark shadows and brilliant highlights, you must decide whether to expose for the shadows or for the highlights. For example, if the

intention is to have the main subject reproduced as a silhouette, then an exposure based on the sky will suffice. In fact, if there is colour in the sky, such as at sunrise and sunset, a slight degree of under-exposure will saturate the colours of the sky even more. If, on the other hand, the intention is to show detail in the shadow side of the subject, then over-exposure by around two f-stops from the meter reading of the sky is required to record detail in the shadow areas. With small subjects such as individual flowers, a reflector can be used close to the lens to bounce light back into the shadows, and reduce contrast so that a greater range of detail can be recorded by the film.

❦ (Right) This shot of *Canna indica* was taken late in the afternoon using a 90mm macro lens. As I was shooting almost directly into the sun, a lens hood was needed in order to avoid unwanted flare.

(Olympus OM10, 90mm macro, Fujichrome Velvia, f16, tripod. Overbecks (National Trust) Devon.)

❦ Delicate back-light illuminates this magnolia flower.

(Olympus OM2, 90mm macro lens, Fujichrome Velvia, f16, tripod.)

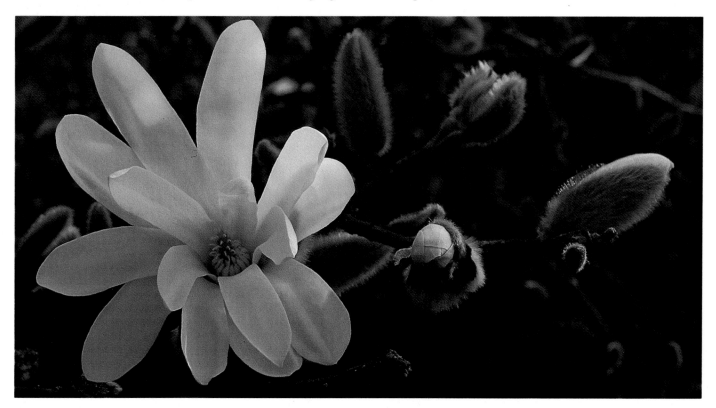

Frontal Lighting

Frontal lighting has the photographer between the light source and the subject. With the sun directly behind the camera, only the front of the scene is lit, so shadows fall directly behind the subject and are therefore not visible in the picture. As a result, frontally lit pictures tend to lack creativity as they have a rather two-dimensional look, conveying little information about the depth and form of the subject being photographed.

It is a little surprising, therefore, that many people consider frontal lighting to be the best form of lighting to work with outdoors. This may have something to do with the fact that it is the light most often encountered outside during daylight hours. Also, frontal lighting gives the most even illumination and is therefore easy to meter. It is, for want of a better word, a 'safe' light to work with.

✿ Strong frontal light is ideal for this view of the Mediterranean.

(Bronica 6 × 6, 80mm standard lens, Fujichrome Velvia, f22, tripod. Villa Ile-de-France, Côte d'Azur, France.)

✿ Flat front-light and a telephoto lens enabled me to photograph this pleasing association of *Allium aflatunense* and *Persicaria bistorta* 'Superba'.

(Olympus OM2, 300mm telephoto lens, Fujichrome Velvia, f22, tripod. Barnsley House, Gloucestershire.)

✿ I used a macro lens and a low viewpoint to record this frontally-lit Christmas rose flower (*Helleborus niger*).

(Olympus OM2, 90mm macro lens, Fujichrome Velvia, f8, tripod. RHS Garden, Wisley, Surrey.)

✿ Strong but diffused front-light brings out the rich colours of these chrysanthemums.

(Olympus OM2, 90mm macro lens, Fujichrome Velvia, f22, tripod. Dorothy Clive Garden, Shropshire.)

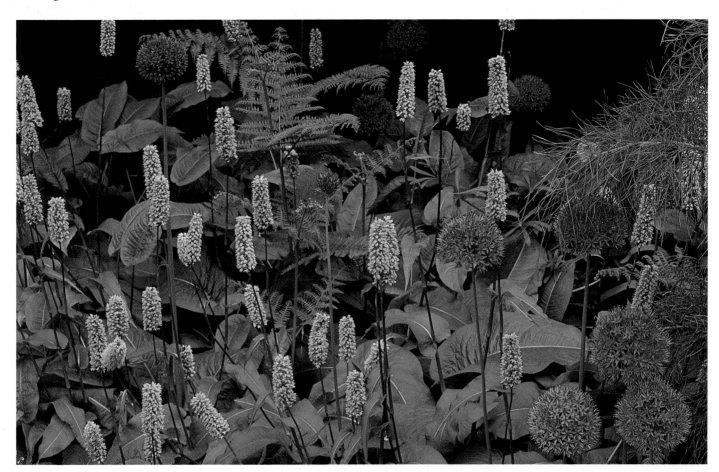

Side-lighting

Side-lighting or cross-lighting can create spectacular garden pictures and is the best light for emphasising depth and the three-dimensional nature of gardens. With the sun's rays shining from the left or right of the camera, the form and texture of flowers, trees, ornaments and buildings is enhanced, with shadows being cast across the photograph.

By using a polarising filter, side-lit compositions with blue sky, water or other reflective surfaces can be enhanced, especially if the side-light is strong. With the sun at an angle of 90° to the camera, the polarising filter will have maximum effect, deepening the blue of the sky and the greenery, and removing distracting reflections and glare.

One problem with harsh side-light is that contrast levels often become unmanageable, with the lit side of the subject having bright highlights, leaving the dark side in deep shadow. If the subject is small – say, a single flower or a cluster of berries – then a reflector or an electronic flash may be used to add light to the shadows, thus reducing contrast. With garden vistas, though, the only option available to the photographer in such instances is to expose for the lighter side of the subject at the expense of the dark side.

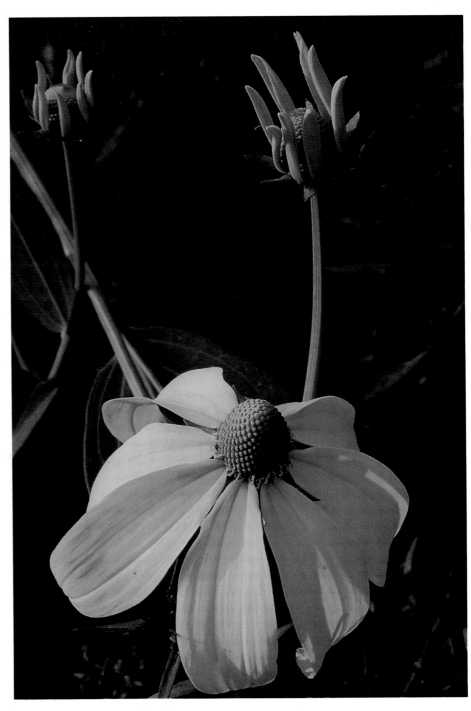

🌱 Early morning side-light bathes the Praeneste terrace at Rousham Landscape Garden in an orangey glow, giving a strong three-dimensional quality to the scene. I used a polarising filter to enrich the colours further.

(Bronica 6 × 6, 80mm standard lens, Fujichrome Velvia, 3 sec f22, tripod. Rousham Landscape Garden, Oxfordshire.)

🌱 This shot of *Rudbeckia* 'Herbstsonne' was taken half an hour before sunset. Slight under-exposure of the flower has darkened the background.

(Olympus OM2, 90mm macro lens, Fujichrome Velvia, f11, tripod.)

❧ Weak, early-morning side-light complements the cool planting in and around this elegant terracotta urn in Anthony Noel's London garden.

(Pentax 6 × 7, 135mm short telephoto lens, Fujichrome Velvia, f32, tripod. Anthony Noel's garden, London.)

❧ Strong side-light highlights this lavender and sweet pea pyramid in the formal potager at The Old Rectory, Sudborough. The picture was taken an hour after sunrise.

(Pentax 6 × 7, 135mm short telephoto lens, Fujichrome Velvia, f32, tripod. The Old Rectory, Sudborough, Northamptonshire.)

Diffused Lighting

Diffused lighting is probably the most under-estimated type of natural lighting that exists. It is often thought of as being a poor light for outdoor photography because it is associated with dull and overcast weather. In reality, however, diffused light can provide a beautifully soft, shadowless lighting which is ideal for capturing the fine details and subtle hues of garden scenes, flowers and plants.

Because diffused light is even and uniform, contrasts are less emphatic and glare is either minimised or eliminated altogether. Under such conditions, metering becomes easier and the colours of flowers and foliage often appear richer and more saturated, even without deliberate under-exposure. Light subjects, such as snowdrops and 'Iceberg' roses, photograph well in this kind of light because they do not 'burn out' as they would do in a harsher, more direct light.

Diffused lighting is especially suitable for photographing close-ups of flowers and plants, as the lack of contrast combined with the softness of the light allows the maximum amount of detail to be recorded. Using a slow, fine-grained film in the range ISO 50–100 will help to keep these details pin-sharp, as well as maximising colour saturation.

Strong but diffused lighting has brought out the rich colours and velvety texture of *Clematis* 'Niobe' growing on a wall. To obtain maximum sharpness in the portrait I stopped down to f32.

(Pentax 6 × 7, 135mm macro lens, Fujichrome Velvia, f32, tripod.)

These hostas and poppies growing together were photographed on a dull, overcast morning. The softness of the light has actually enhanced the clarity of detail in the scene.

(Bronica 6 × 6, 80mm standard lens, Fujichrome Velvia, f22, tripod. Longacre Garden, Kent.)

✿ This shot of a reclining nymph and
tile panels in the gardens of the Palacio
de Estoi was lit by the soft light of open
shade. The delicate colours and fine
detail of the tile painting would have
been lost if the scene had been lit with
strong sunlight.

(Bronica, 6 × 6, 150mm telephoto lens,
Fujichrome Velvia, f22, tripod. Palacio de Estoi,
Algarve, Portugal.)

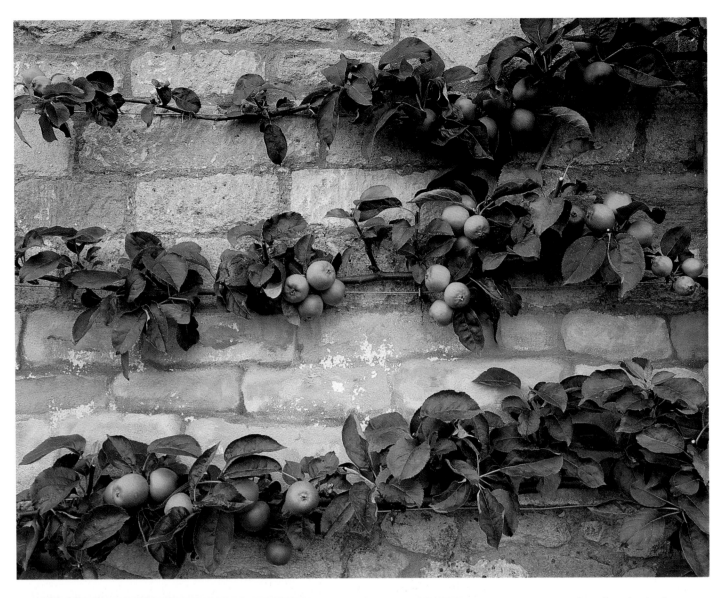

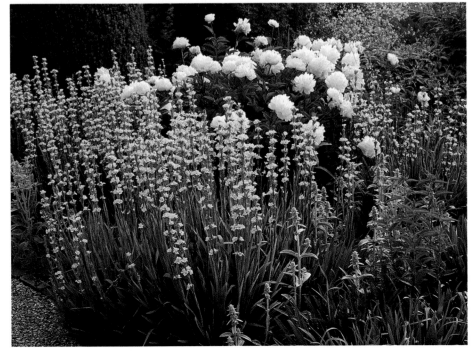

✿ These espaliered apples in the potager at Bourton House garden in Gloucestershire were lit by the soft light of open shade. The mellow Cotswold stone wall provides a sympathetic background for the apples and foliage.

(Pentax 6 × 7, 55mm wide-angle lens, Fujichrome Velvia, f22, tripod. Bourton House, Gloucestershire.)

✿ I prefer to photograph white or cream-coloured flowers and foliage in diffused light as they tend to burn out in harsh sunlight. To capture these *Paeonia* 'Duchesse de Nemours' and *Sisyrinchium striatum*, I waited for a cloud to diffuse the sun before taking the picture.

(Bronica 6 × 6, 80mm standard lens, Fujichrome Velvia, f16, tripod. Mottisfont Abbey (National Trust), Hampshire.)

Flash

When light levels are low in a garden, you may be tempted to reach into your camera-bag for a flashgun. However, because a burst of electronic flash is so brief, its effects cannot be seen by the naked eye. For this reason, flash is a particularly difficult kind of light to control when working outdoors, and a great deal of care and experience is needed to take successful plant and garden photographs using this form of lighting.

Many inexperienced garden photographers are unaware of the fact that flash is useless for lighting a whole garden scene. However, at distances of less than about 5m (15ft), the short duration and high intensity of electronic flash can improve garden details, plant portraits and extreme close-ups. Even on a bright day, a burst of flash can arrest the movement of wind-tossed plants, soften shadows cast by harsh sunlight, foliage and man-made structures, and boost the level of ambient light so that a smaller aperture can be used for greater depth of field.

Before taking a flash photograph in the garden, always ask yourself the question 'Do I really need to use flash for this picture?' Even in poor lighting conditions, provided the subject you are shooting is relatively still, a long exposure using the available light, perhaps boosted by a reflector, is often preferable to the more unpredictable light of electronic flash.

BALANCING FLASH WITH DAYLIGHT

The most successful flash pictures are usually those in which the flash has been used in such a way that the viewer is unaware of its presence and the photograph looks as if it has been taken only with natural, available light. In order to achieve such an effect, the flash should never be stronger than the primary light source (daylight). The flash thus acts simply as a fill-in light, in much the same way as a reflector.

To take a fill-in flash photograph, first take an exposure reading in the normal way, making sure that you select a shutter speed which synchronises with the electronic flash (usually 1/60th, 1/125th or 1/250th second and marked in red on the shutter-speed dial). Next, in order to ensure that the ambient light dominates the flash, select an aperture setting that is one f-stop smaller than the one recommended on the flash unit, or set on the flash if you are using an automatic unit with auto exposure settings.

In practice, there are other ways of lowering the power output of the flash unit so that the required degree of under-exposure is obtained. A low-power setting can be used with flash units that have such settings, but even with constant-power flash units, the intensity of the fill light can be reduced by placing a diffuser over the flash head. Alternatively, the flash can simply be moved further away from the camera and subject.

SOFT LIGHT WITH FLASH

It is usually advisable to diffuse flash in some way, as using a single direct flash will cast harsh shadows on the subject. In addition, when photographing subjects that have shiny surfaces, such as the colourful fruits of pyracantha or *Skimmia japonica*, distracting bright highlights will appear on each fruit if direct flash is used. Diffusion can be achieved simply by placing a white handkerchief or lens tissue over the front of the flash, or by bouncing the flash-light on to a piece of white card or umbrella. Shadows will be softened, but unfortunately the light output will be considerably reduced. Automatic flashes will automatically take this into account, but with a manual flash you will have to compensate by using a larger lens aperture.

If you have a flash gun that is not built in to your camera, you can improve the lighting quality on a subject by placing the flash to the left or right of the subject, rather than using it straight on. This is because light coming from the side creates a three-dimensional image by revealing more detail in the subject.

CLOSE-UPS USING FLASH

In certain instances it may be impossible to take a close-up photograph without adding light by means of a burst of electronic flash. On a windy day, for example, it may only be possible to obtain a shutter speed fast enough to arrest the swaying movement of a flower by using fill-in flash. A different problem can arise when attempting to photograph the interior structures of deep-throated flowers such as orchids and lilies. Because the lens must be moved in very close to the subject, there is unlikely to be enough light reaching the inside of the flower's throat. In such a situation the only option is to use a special piece of equipment known as a ring flash. This is simply a circular electronic flash-tube which is fitted into a mount and screwed on to the filter ring on the front of the camera lens. The ring flash is powered by a separate power pack which sits on top of the camera, and because the light source surrounds the lens, it can be moved in extremely close to the subject being photographed, giving a very high-intensity light even for extreme close-ups. Furthermore, because the light emitted by a ring flash is frontal and virtually shadowless, the maximum amount of detail in the subject can be recorded.

This cymbidium orchid, growing in the orchid house at the Royal Horticultural Society's Garden at Wisley, was lit from behind with soft, diffused sunlight. The orchid appeared too dark on film when photographed from the front (far right), so I fitted a ring flash on to the lens and used a burst of electronic flash to increase illumination on the front of the flower (right). In order to retain a natural look in the flash shot I used the same shutter speed ($1/4$ sec) and aperture (f11) as in the non-flash picture. The burst of electronic flash has thus acted only as a 'fill-in' light.

(Olympus OM2, 90mm macro lens with ring flash; without ring flash; Fujichrome Velvia, $1/4$ sec f11, tripod. RHS Garden, Wisley, Surrey.)

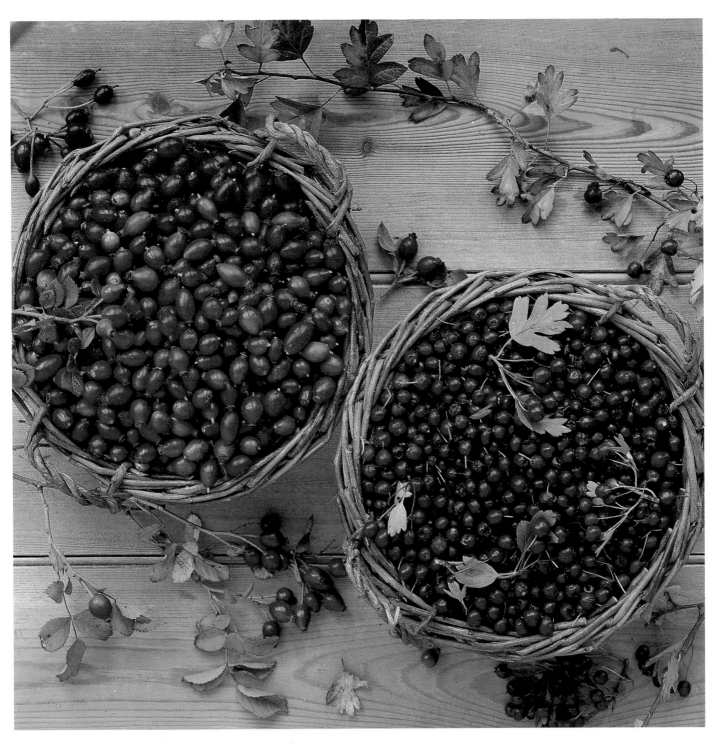

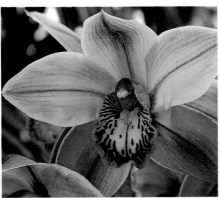

❀ For this still-life shot I filled two wicker baskets with hips and haws. I positioned several planks of wood side by side, placed the baskets on top and photographed the arrangement from directly above using a standard lens. A soft box placed to one side of the baskets provided diffused light while a large sheet of white polystyrene positioned on the opposite side added fill in.

(Bronica 6 × 6, 80mm standard lens, Fujichrome Velvia, f22, tripod, flash.)

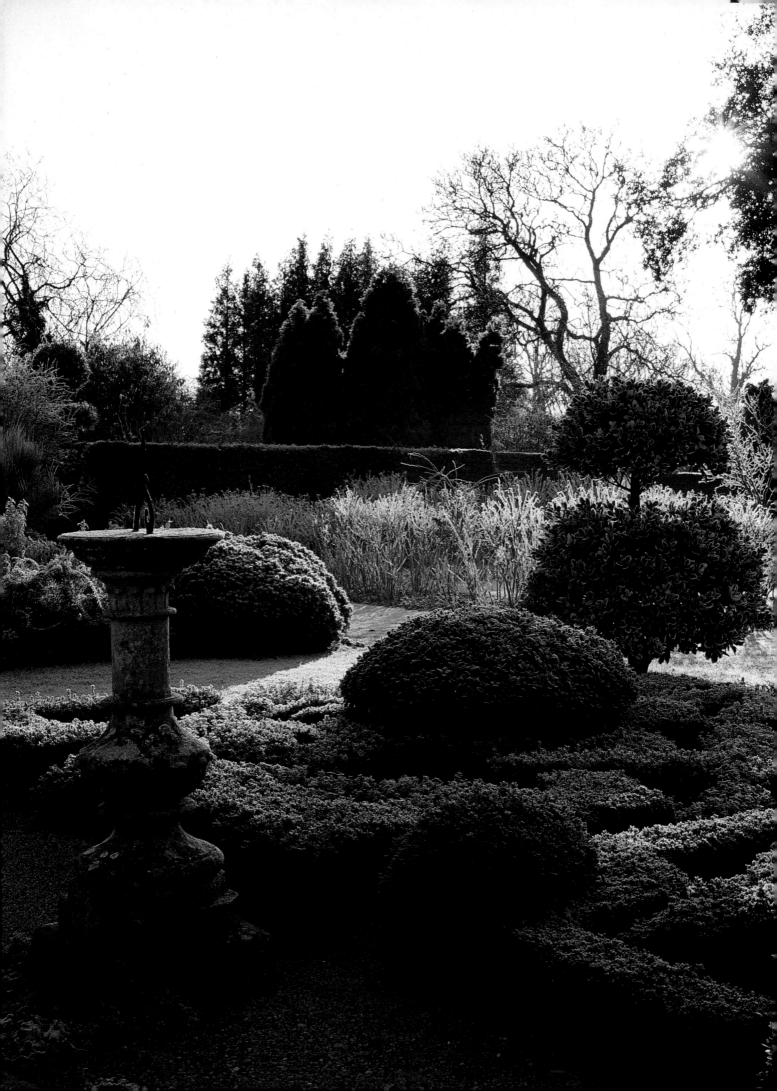

WEATHER

🍃 (Top) These herbaceous borders looked sensational coated with a thick layer of hoar frost. I have picked out a back-lit section with a wide-angle lens.

(Pentax 6 × 7, 55mm wide-angle lens, Fujichrome Velvia, tripod. The Old Rectory, Burghfield, Berkshire.)

🍃 (Above) Although it was pouring when I took this shot, the light was perfect, and the rain brightened up the autumnal colours.

(Bronica 6 × 6, 80mm standard lens, Fujichrome Velvia, f22, tripod. The Dingle, Wales.)

🍃 (Left) The formal knot at Barnsley House has been transformed into a magical stage-set by early morning back-light and a thick layer of hoar frost.

(Bronica 6 × 6, 50mm wide-angle lens, Fujichrome Velvia, f22, tripod. Barnsley House, Gloucestershire.)

Rain

Garden owners often express surprise when they are shown photographs of their garden which have been taken during a light downpour. They find it difficult to believe that pictures taken in such 'rotten' weather can reveal such clarity of detail and rich colours in their beds and borders. One reason for this is that wet weather is often associated with 'dull' light and poor visibility, but on those occasions when drizzle sets in and the cloud cover seals in the available light, gardens can take on a wonderful luminescence which shows up beautifully on film.

Light rain or drizzle can be perfect for shooting portraits of flowers, especially when there is little or no breeze. Petals become speckled with tiny beads of moisture and every detail of the flower and its surrounding foliage can be recorded with great clarity. The same effect can be achieved with a spray bottle filled with water and many flower photographers regularly carry these with them on location in order to create their own artificial 'raindrops'.

Make sure when photographing in the rain that water does not get into your camera or on to film when it is loaded and unloaded. Most modern cameras can withstand brief exposure to rain or drizzle, but for prolonged periods it is advisable to cover the camera when you are not actually taking a photograph – a plastic bag or handkerchief usually does the trick. Remember also to keep your camera-bag out of the wet, if possible.

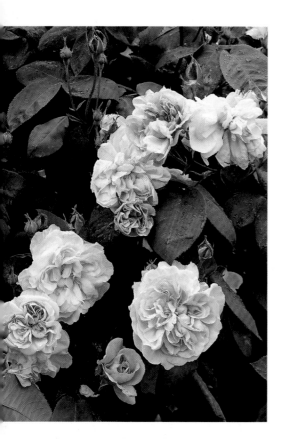

I took this picture of *Rosa* 'Fantin-Latour' just minutes after a light rainfall. The lack of wind enabled me to use a long exposure and stop down to f32 in order to obtain a pin-sharp portrait of the rose.

(Pentax 6 × 7, 135mm macro lens, Fujichrome Velvia, f32, tripod. The Anchorage, Kent.)

This photograph was taken seconds before a torrential downpour. I used a polarising filter to darken the brooding sky and saturate the glorious autumnal foliage of the trees and shrubs.

(Bronica 6 × 6, 150mm telephoto lens, Fujichrome Velvia, f22, tripod. City of Bath Botanical Gardens.)

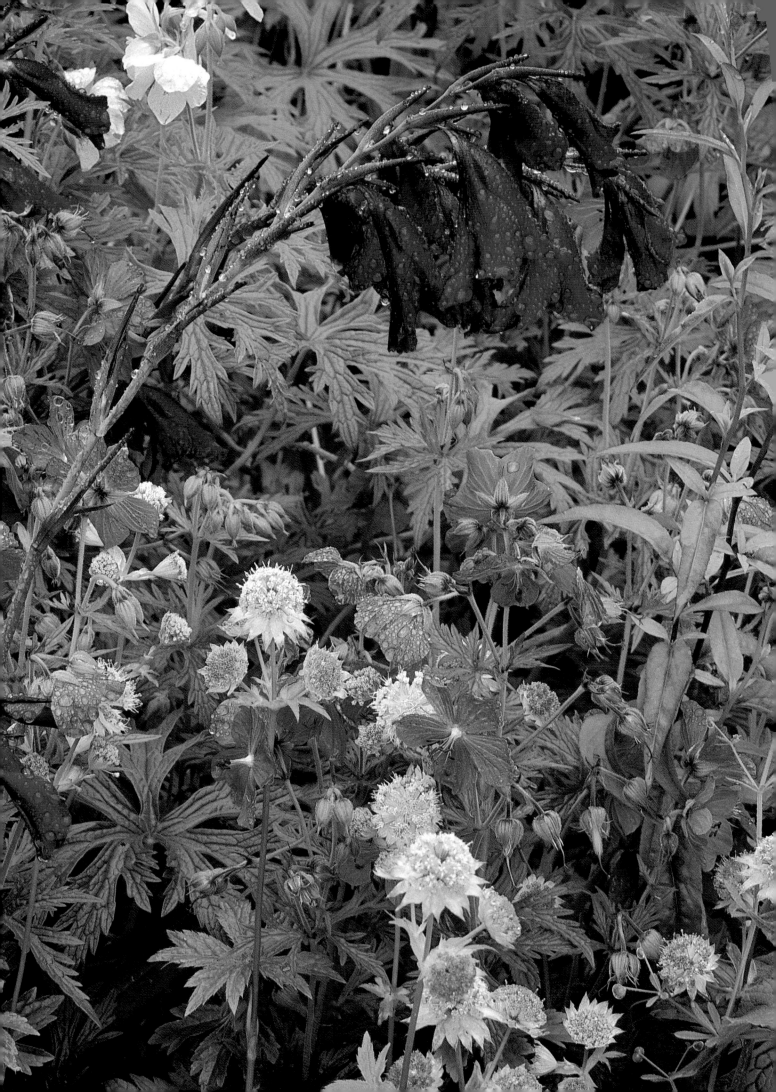

✿ Light rain was falling when I took this picture of gladioli, astrantias and geraniums. I used a lens tissue to remove raindrops that had landed on the lens before making the exposure.

(Olympus OM2, 80–200mm zoom lens, Fujichrome Velvia, f32, tripod. East Lambrook Manor, Somerset.)

✿ These bluebells and azaleas were photographed in heavy rain. The brilliant orange of the azalea contrasts strongly with the rich blue of the bluebells, giving the composition form and impact.

(Bronica 6 × 6, 80mm standard lens, Fujichrome Velvia, f22, tripod. Duckyls, West Sussex.)

✿ Raindrops and bright, overcast light bring out the rich colour and fine detail in this *Pelargonium* 'Lord Bute' flower. I used the depth-of-field previous button to select an aperture that would render only the flower in sharp focus.

(Olympus OM2, 90mm macro lens, Fujichrome Velvia, f8, tripod. Anthony Noel's garden, London.)

Mist and Fog

Mist and fog can add a touch of atmosphere and mystery to your garden pictures. Moisture in the air diffuses the light so that depth and form are reduced and colours and contrasts become muted. Although most people think of mist and fog as being white, in reality it can pick up a grey, blue, orange or reddish cast.

In thick fog that the sun's rays cannot penetrate, there is a tendency for the light to pick up a slightly bluish hue. Over-exposing by $1/2$ to 1 stop will help to lighten and 'whiten' the scene and penetrate the dense fog.

Rising mist on a clear autumnal morning can add great drama to even the most mundane garden scene. If the mist is thick, it will diffuse the sun's rays sufficiently to allow the camera to be pointed directly at the sun without the danger of flare creeping into the lens. Bodies of water such as ponds and lakes are ideal places to take this kind of photograph because mist often rises slowly off their surfaces. The best pictures taken under these conditions have something interesting in the foreground such as a pergola, bridge or tree. If there is still some colour left in the rising sun, under-exposing by $1/2$ to 1 stop will dramatise the scene by enriching the orange glow of the sunlight through the veil of mist.

Early morning fog has added an air of mystery to this view of the Gothic temple at Stowe Landscape Garden. To show some detail in the temple, I over-exposed by 1 stop. This in turn has 'whitened' the fog and 'lightened' the whole scene.

(Bronica 6 × 6, 55mm wide-angle lens, Fujichrome Velvia, f22, tripod. Stowe Landscape Garden, Buckinghamshire.)

Mist rising from this lake has diffused the rays of the rising sun. The reflections in the water balance the composition perfectly.

(Bronica 6 × 6, 80mm standard lens, Fujichrome Velvia, f22, tripod. Chastleton Glebe, Gloucestershire.)

Snow and Frost

Snow and frost bring moments of rare beauty to a garden and provide a wonderful opportunity to capture the garden's more unusual guise. Frost can soon disappear once the sun gets to work and snow can also be very transient, melting soon after it has fallen, so be prepared to grab your camera and venture outside, however cold the weather, at a moment's notice.

Gardens which photograph well under a blanket of white snow or a coating of silvery frost are those which have good permanent structural features. Trees, hedges, walls, paths, steps, topiary, sculpture, statuary, urns, pergolas, arbours and gazebos are the 'bones' of the garden and become the most dominant elements in the winter garden, stripped of its lush summer foliage and flowers. Snow and frost serve to accentuate the form and shape of these architectural elements, clinging like icing-sugar and transforming the garden into a stage set.

On a more intimate scale, snow and frost can invest flowers, stems, fruits and foliage with a magical quality which can be captured beautifully on film. Slender bulbs like snowdrops and crocus make glorious splashes of colour as they poke through a sprinkling of snow. Frozen catkins of the shrub *Garrya elliptica* dangle gracefully like icicles, and clusters of brilliant red, orange and yellow berries of cotoneasters, pyracanthas, skimmias and hollies look wonderful when dusted with hoar frost, sparkling like champagne in the watery sunshine.

When working in a garden which is covered in a fresh mantle of frost, avoid walking across lawns unless you absolutely have to. Not only will your footprints detract from your finished photographs, but they will also leave a brown mark on the grass afterwards. It is always better to shoot general vistas of the garden first before closing in to record the smaller details.

One of the biggest problems with shooting snowy garden scenes is calculating the correct exposure. Under bright skies, reflected light from snow can play havoc with your camera's light meter. The intensity of the light in these conditions often results in meter readings that are too high, so shots will appear under-exposed (too dark) unless extra exposure of $^1/_2$ to 1 f-stop over that recommended by the light meter is given.

This picture was taken after a heavy snowstorm and is interesting because it relies on the juxtaposition of basic geometric shapes – circles, triangles and squares – for its impact. Flat winter light on the freshly fallen snow has created a monochromatic image.

(Olympus OM2, 80–200mm zoom lens, Fujichrome Velvia, f32, tripod. Ham House, London.)

Strong back-lighting has given these snow-covered steps and pool at Cornwell Manor a distinct sparkle. The snow has given the picture an overall blue cast, which I feel enhances the shot, so I decided not to try and filter it out. A telephoto lens compresses perspective, making the steps look as if they are literally on top of the pool.

(Olympus OM2, 300mm telephoto lens, Fujichrome Velvia, f32, tripod. Cornwell Manor, Oxfordshire.)

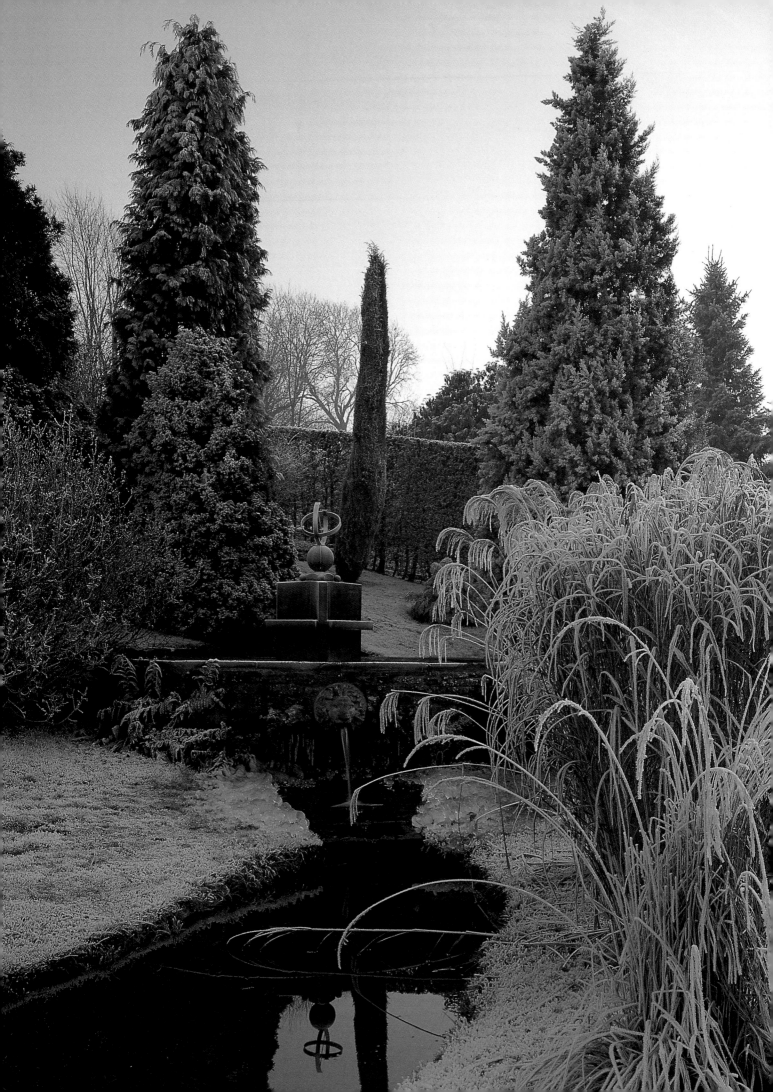

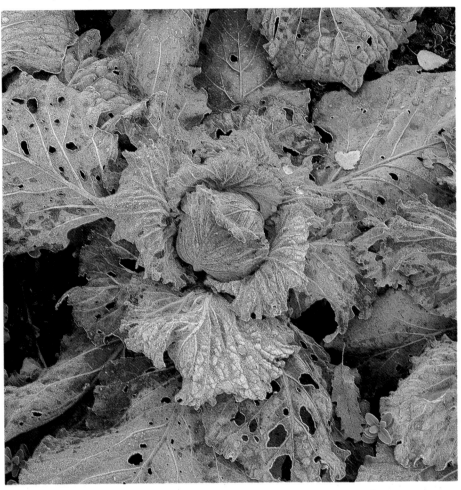

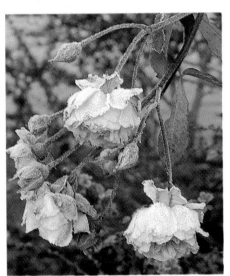

⚜ This frosted cabbage in the potager at Barnsley House was photographed from directly overhead using just a standard lens. To get everything pin-sharp I stopped down to f22.

(Bronica 6 × 6, 80mm standard lens, Fujichrome Velvia, f22, tripod. Barnsley House, Gloucestershire.)

⚜ These Hybrid Musk roses look marvellous with a dusting of hoar frost.

(Olympus OM2, 90mm macro lens, Fujichrome Velvia, f11, tripod. Heale House, Wiltshire.)

⚜ (Overleaf) In this lovely spring scene, brilliant pink azaleas contrast with the fresh green foliage of ferns and *Gunnera manicata*.

(Olympus OM2, 80–200mm zoom lens, Fujichrome Velvia, f32, tripod. Exbury Gardens, Hampshire.)

⚜ Early morning sunlight has melted some of the frost on the foreground grasses and beech hedge in this winter view of the water garden at Brook Cottage.

(Bronica 6 × 6, 50mm wide-angle lens, Fujichrome Velvia, f22, tripod. Brook Cottage, Oxfordshire.)

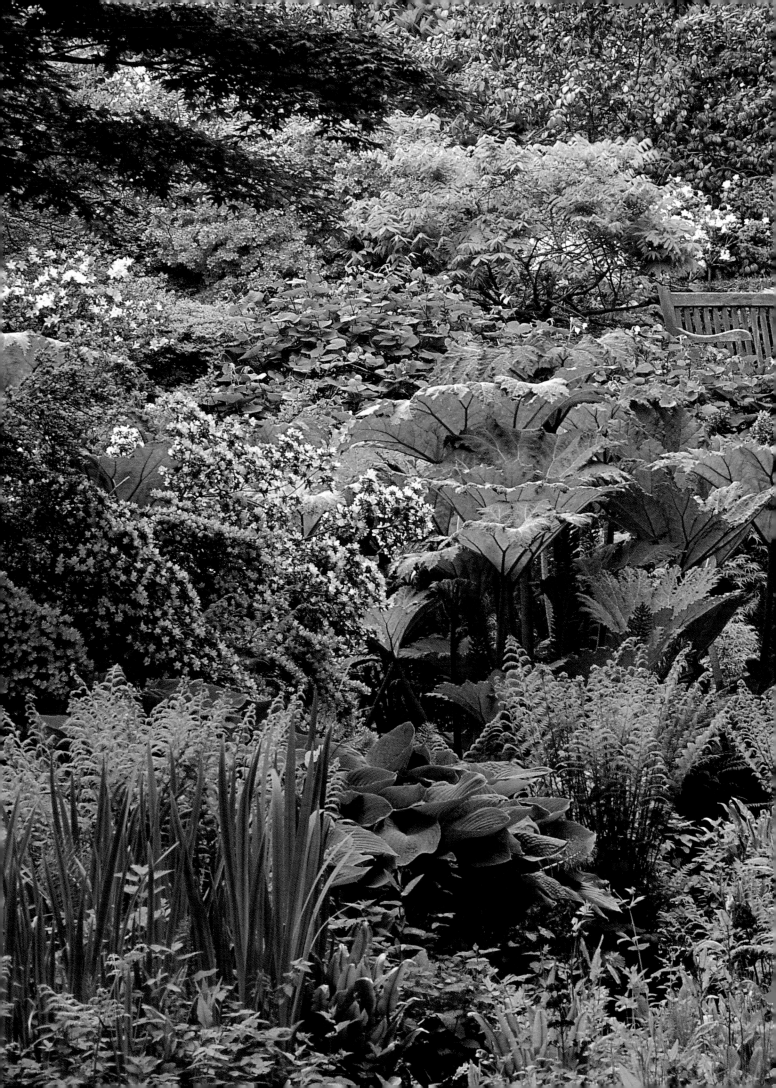

THE FOUR SEASONS

🍃 (Top) Autumnal fruits of *Sorbus devoniensis*.

(Olympus OM2, 90mm macro lens, Fujichrome Velvia, f16, tripod.)

🍃 (Above) Soft, autumnal light highlights the pastel hues of these sedums and asters.

(Bronica 6 × 6, 150mm short telephoto lens, Fujichrome Velvia, f22, tripod. Picton Garden, Worcestershire.)

(Left, see page 101)

Spring

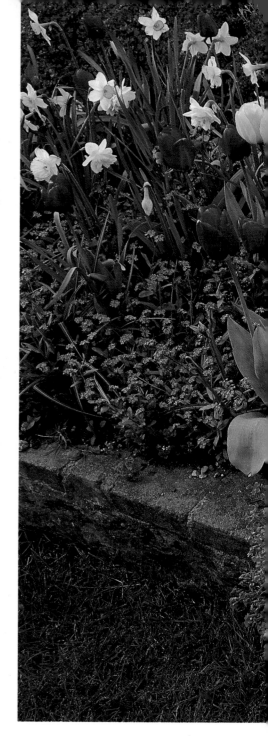

Spring is the season of renewal and regeneration, as the garden reawakens after months of virtual dormancy. As if by magic, in an astonishing burst of new life, the garden erupts with an explosion of flowers, buds, blossom, foliage and bright green grass, refreshing the senses and lifting the spirits.

As the weather warms, the brilliant yellow trumpets of daffodils (narcissi) grace the garden, reflecting the gentle spring sunshine. Illuminating the feet of shrubs and trees, they also create cheerful highlights to rock gardens, containers and window-boxes. They are wonderfully photogenic when planted in association with blue-flowering bulbs such as *Chionodoxa luciliae*, *Muscari armeniacum* and *Scilla siberica*.

Tulips, too, with their delicious colours, luxurious satin-petalled blooms and elegant form make an outstanding contribution to the spring garden. They are probably the most photographed flowers at this time of year. Because of their tall, stark stems, they are usually best when grouped together, or underplanted with a sea of forget-me-nots (myosotis) or wall-flowers (*Erysimum cheiri*).

The beauty of spring bulbs is matched by the profusion of flowering shrubs. In early spring, *Daphne mezereum*, forsythia and camellias hold centre-stage, soon to be followed by choisya, kerria, laburnum, lilac, *Magnolia stellata*, viburnums and tree peonies. Woodland gardens are soon awash with great banks of multi-coloured azaleas and rhododendrons.

Alpines have their showiest moments in the spring. Rock gardens, raised beds, paths, walls, sinks and troughs all provide a suitable setting for a multitude of these jewel-like plants to be seen and photographed at their best. As alpine photography usually involves close-up work, sinks and troughs tend to be the easiest of environments to take pictures because they are often raised off the ground and provide all-round access.

Flowering trees, heavily laden with blossom, are striking focal points in the spring garden and always make lovely subjects for photography. In Japanese gardens, the spring flowering of ornamental cherry and plum trees is so amazing that viewing the blossom has become an important national pastime. In the maritime states of America, a similar effect is created by the flowering dogwoods (*Cornus florida*). Other trees with stunning spring flowers include the ornamental crabs (*Malus* species), snowy mespilus (*Amelanchier lamarckii*) and the tree magnolias.

As the majority of spring-flowering trees have white, cream or pale-pink flowers, they are best photographed against a rich blue sky or against a dark or contrasting background. Soft morning or afternoon side-light will emphasise the form of trees and bring out the subtle shades of the flowers.

Pergolas, arbours and house walls, bare during the winter months, suddenly acquire a colourful dress in the spring. The fragile, creamy-white flowers of *Clematis armandii* are delightful, wafting their vanilla scent on the warm breeze and creating a gentle backdrop to garden views. *Clematis montana* has a similar fragrance and looks wonderful intertwined with the buttery-yellow flowers of the spring-flowering rose, *Rosa banksiae* 'Lutea'. Most striking of all are the fragrant purple and white trusses of wisteria, cascading like waterfalls that have been frozen in time.

Spring is obviously a wonderful time to take photographs of plants and gardens, but you can be sure that the photographer's greatest enemy – the weather – will try its hardest to frustrate your activities. A sudden, violent rain- or hail-storm can flatten a lovely group of tulips and damage their delicate, goblet-shaped flowers. A late frost is even worse. One spring I remember driving to Hampshire to photograph the magnificent 250-acre woodland garden at Exbury, only to discover on my arrival that every single azalea and rhododendron flower had been wiped out by a lick of early frost.

❧ I waited until half an hour before sunset to photograph this wonderful spring planting of tulips, wallflowers, and forget-me-nots in a neighbour's front garden.

(Pentax 6 × 7, 55mm wide-angle lens, Fujichrome Velvia, f22, tripod.)

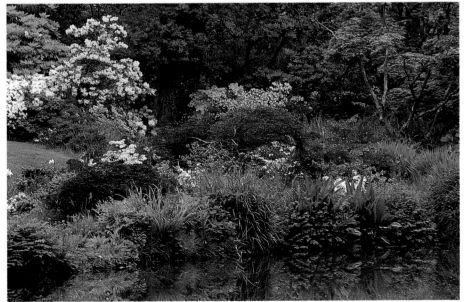

🌺 The only way that I could effectively record these maples and azaleas growing beside a pond was to use a long lens.

(Olympus OM2, 80–200mm zoom lens, Fujichrome Velvia, f32, tripod. Exbury Gardens, Hampshire.)

🌺 (Overleaf) The colours of these parrot tulips create harmony and rhythm in this composition. I used the compressed perspective of a telephoto lens to make the flowers appear closer together.

(Olympus OM2, 300mm telephoto lens, Fujichrome Velvia, f22, tripod. Chenies Manor, Buckinghamshire.)

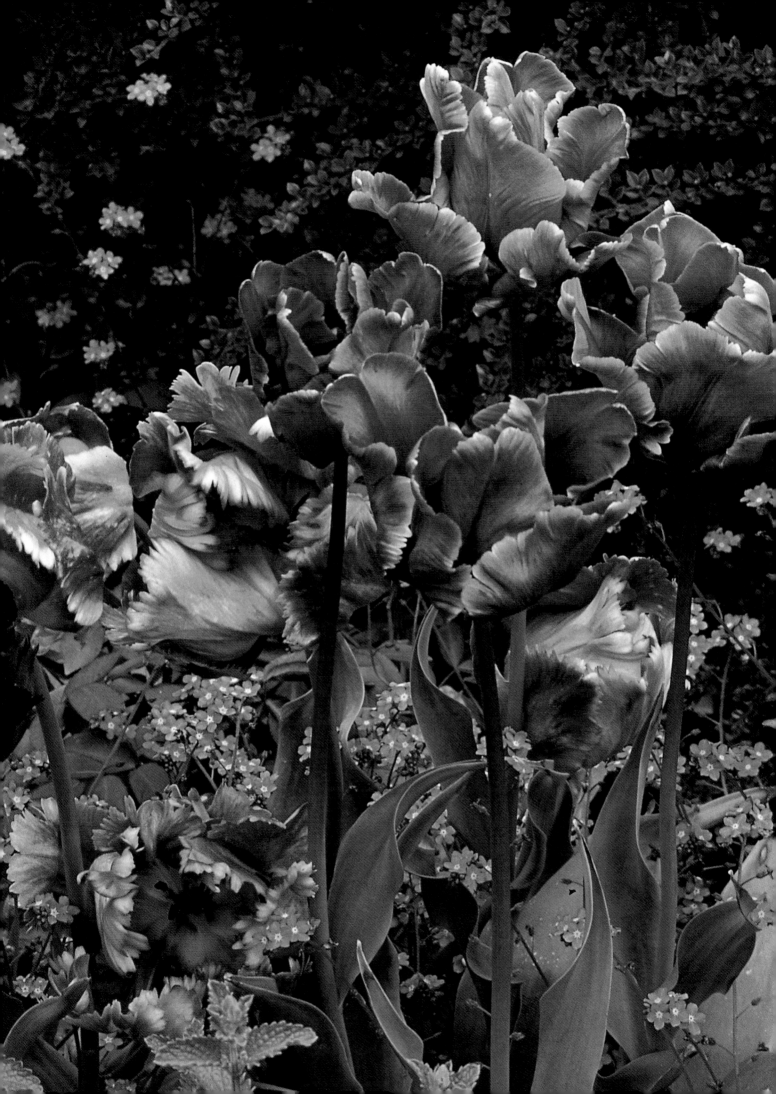

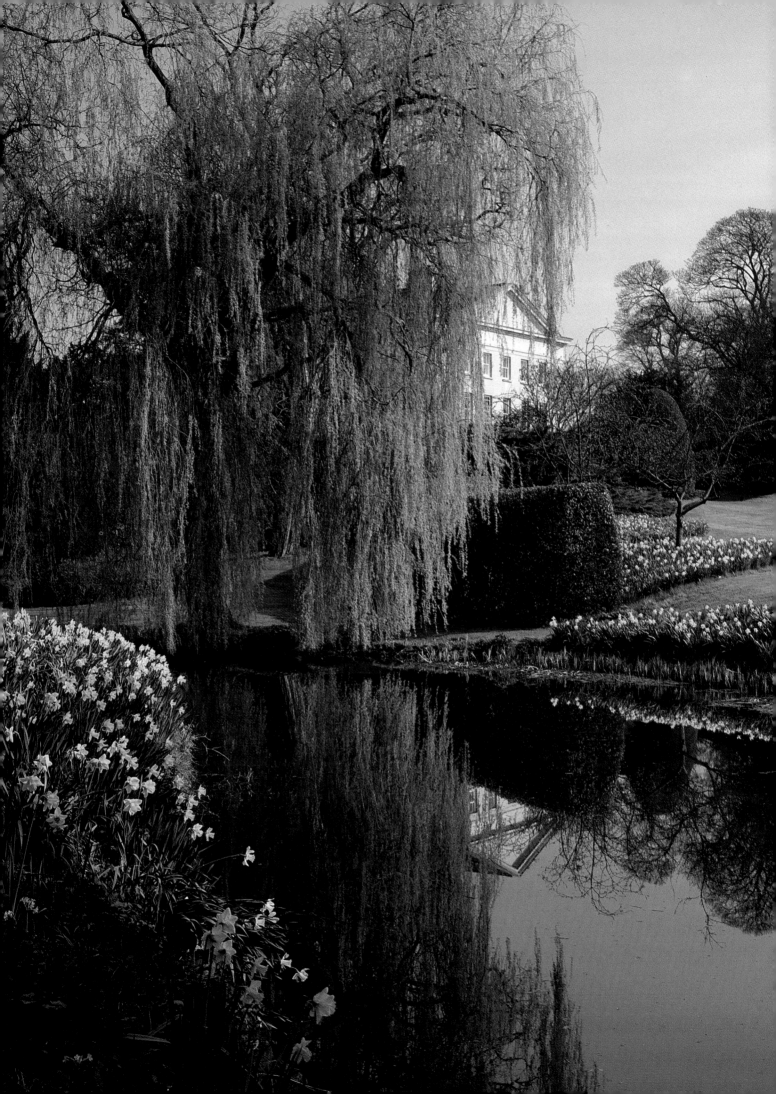

🍃 Bright, overcast lighting and the quality of the film have combined to bring out the provocative colours of these azaleas. I under-exposed by 1 stop in order to saturate the colours and used a short telephoto lens to ensure that the flowers filled the frame.

(Bronica 6 × 6, 150mm short telephoto lens, Fujichrome Velvia, f22, tripod. Exbury Gardens, Hampshire.)

🍃 I used a polarising filter to increase the colour saturation in this spring scene. I focused on the daffodils in the foreground and stopped down to f22 to obtain a pin-sharp image.

(Bronica 6 × 6, 50mm wide-angle, Fujichrome Velvia, f22, tripod. Great Thurlow Hall, Essex.)

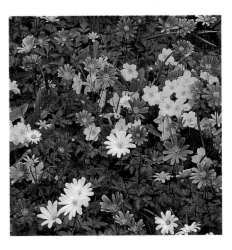

🍃 The gardens at Dartington Hall are delightful to photograph in early spring. I used a zoom lens to pick out this group of anemones and primroses growing in the soft light of open shade.

(Olympus OM2, 80–200mm zoom lens, Fujichrome Velvia, f32, tripod. Dartington Hall, Devon.)

Summer

Summer is the season of exuberance in the garden, with a luxuriance of vegetation and an opulence of blooms. As days grow longer and nights warmer, the choice of photogenic subjects becomes overwhelming. Perennial gardens come into their own, changing from week to week as the season unfolds. The succession of blooms begins with splashes of colour from such beauties as irises, multi-coloured aquilegias and blowsy peonies, quickly followed by lilies, daylilies, and the stately spires of delphiniums and hollyhocks. For the photographer, there are endless opportunities for capturing plant close-ups, plant associations and borders packed with blooms.

From late-spring to autumn, clematis and roses flower prolifically as they run riot through mixed borders and adorn trellises, fences, pergolas and walls. As summer progresses, hanging-baskets, window-boxes and containers make charming focal points for photography, as the miniature gardens they contain overflow with flowers and foliage in a kaleidoscope of colours.

But the flower garden is not the only attraction: in high summer, water gardens bring an air of tranquillity to the garden, their coolness contrasting with the intense heat of the sun. Not surprisingly, waterlilies are the most photographed aquatic plants, their decorative, saucer-shaped blooms adding a touch of magic to even the tiniest of ponds and pools.

Don't neglect the vegetable garden, either. Remember the humble allotment can look as good as the well-designed potager with runner beans in scarlet, white and salmon pink, rows of plump cabbages and feathery wands of fennel – all are exciting for the photographer's palette.

Catching flowers at their peak is important now, as fierce heat or pelting rain can wreak havoc in no time. How many times have I turned up at a garden only to be told, 'If only you'd been here yesterday, the roses were wonderful. But we had very heavy rain in the night and they're not quite as good as they were.' Not quite as good? The poor things have been battered out of existence, half their petals on the ground, the other half bruised beyond recognition. Being roses, of course, they'll be back – but next year.

Another problem is the light. In high summer under cloudless blue skies, the main part of the day is best forgotten. The light is too intense, the contrast too high for film to cope with. Summer gardens therefore are better shot on overcast days or in the very early morning while the light is still soft and almost pliable and against which all blooms from shell-pinks to wine-reds will return their delicacies and strengths. Evening light in the summer is good, too, infusing your composition with a mellow aura. All this means, however, that you will have to get up very early in the morning if you want to be there by first light and hang around until late in the day if you want to capture the evening magic.

PROFESSIONAL·TIPS

SPRING/SUMMER

- ❧ **B**rilliant colours are the hallmark of the spring garden: daffodils, tulips, shrubs, alpines. Flowering trees are always striking, particularly against a rich blue sky or a dark background.
- ❧ **S**oft morning or evening side-lighting will emphasise form and colour.
- ❧ **T**he summer flower garden runs riot, with endless opportunities for close-ups and plant associations.
- ❧ **W**ater and vegetable gardens deserve attention, too.
- ❧ **B**eware fierce summer heat; the light can be too intense, so shoot gardens in early morning or late afternoons, or on cloudy days.

❧ At Ashtree Cottage, Wendy Lauderdale has created a garden bursting with summer blooms. I captured this side-on view of the rose-smothered pergola on a bright but overcast day with a short telephoto lens.

(Pentax 6 × 7, 135mm short telephoto lens. Fujichrome Velvia, f22, tripod. Ashtree Cottage, Wiltshire.)

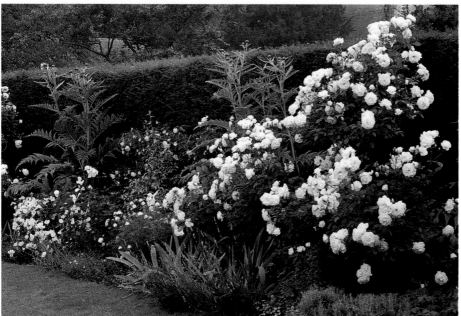

White borders can be difficult to photograph on a very sunny day as contrast levels are very high, resulting in either washed-out, almost metallic highlights or deep, inky shadows. For this reason I chose to shoot the white border at Lower Hall in Shropshire on a cloudy day so that the subtle hues of flowers and foliage could be seen.

(Pentax 6 × 7, 135mm short telephoto lens, Fujichrome Velvia, f22, tripod. Lower Hall, Shropshire.)

This photograph of the twin herbaceous borders at The Old Rectory, near Reading, was taken in the middle of the afternoon in late summer. I decided not to use a polarising filter as this would have made the image too dark. Instead, I under-exposed by 1 stop to maintain colour saturation in the picture.

(Pentax 6 × 7, 55mm wide-angle lens, Fujichrome Velvia, f22, tripod. The Old Rectory, Burghfield, Berkshire.)

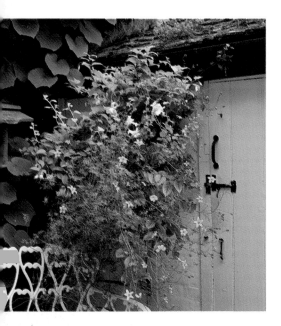

I used a step-ladder to gain extra height when photographing this hanging basket. The basket was in a small, enclosed courtyard and would have been difficult to photograph on a very sunny day, so I waited for a bright, overcast morning before taking the picture.

(Bronica 6 × 6, 50mm wide-angle lens, Fujichrome Velvia, f16, tripod. Vale End, Surrey.)

Autumn

Cooler nights and shorter days signal the arrival of autumn in the garden. As the light softens, shadows lengthen. The fierce heat of the summer sun is absent as the garden takes on an altogether more gentle, mellower mood. Days dawn with crisp frosts and golden mists, providing marvellous opportunities for outdoor colour photography.

Deciduous trees and shrubs become the dominant focal points in the autumn garden, as their foliage turns from a rather uninspiring cloak of green to a blaze of reds, oranges, golds and browns. Walls and fences are transformed by the vivid red foliage of climbers like Virginia creeper (*Parthenocissus quinquefolia*), Boston ivy (*Parthenocissus tricuspidata*) and the Japanese crimson glory vine (*Vitis coignetiae*). Gardens, parks and arboretums show off magnificent specimens of tupelo (*Nyssa sylvatica*), winged spindle (*Euonymus alatus*), Persian ironwood (*Parrotia persica*), stag's horn sumach (*Rhus typhina*), *Amelanchier lamarckii*, sweet gum (*Liquidambar styraciflua*) and *Stewartia pseudocamellia*. Perhaps the most photographed group of trees are the acers (maples), whose glorious leaves glow like fire even in the dullest of weather.

The intensity of autumn colours can vary from year to year, depending on the weather. The most vibrant leaf colours appear when sunny days combine with cold nights. Excessively hot, dry summers, however, can lead to disappointing autumn tints, as the leaves shrivel and fall before turning colour. Strong winds can also make autumn colour disappointingly fleeting, so you will need to be prepared to make the most of any still weather that occurs at this time of year.

The decorative fruits of shrubs and trees are in abundance now and add another dimension of interest for the photographer. Those of holly (ilex), crab apples (malus), whitebeam or mountain ash (sorbus), berberis, cotoneaster, pyracantha, *Skimmia japonica* and *Viburnum davidii* are obvious targets for photography, but look out for more unusual ones, too, like the tiny, almost fluorescent turquoise berries of *Clerodendrum trichotomum var. fargesii* and the amazing purple fruits of *Callicarpa bodinieri var. giraldii*. Because all shiny fruits reflect sunlight as bright highlights, they are best photographed in diffused lighting. A still, overcast morning is ideal.

Large ornamental fruits like pumpkins are easier to photograph than smaller fruits because they lie on the ground and are not subject to movement by the wind. Pumpkins nearly always look great in photographs because of their deep orange colour and their lovely shape and texture.

Flowers can still catch the eye at this time of year, so look out for exciting autumnal borders to photograph. Splashes of yellow are provided by heleniums, *Helianthus* x *multiflorus*, *Rudbeckia fulgida* 'Goldsturm' and the daisy-like *Rudbeckia* 'Herbstsonne'. There are the rich reds of dahlias and *Helenium* 'Moerheim Beauty', and the tall orange spikes of kniphofias (red-hot pokers, torch lilies). Softer hues come from Japanese anemones (*Anemone* x *hybrida*), chrysanthemums (dendranthema) and asters (Michaelmas daisies) in shades of pink, mauve and purple.

The colours of asters are echoed by many of the bulbs which start to pop out of the soil at this time of year. Autumn bulbs are poorly represented in our gardens, which is a pity because they make wonderful photographic subjects. *Amaryllis belladonna* add an exotic touch to the autumn garden, with their fragrant, salmon-pink trumpets held high above the ground by long, leafless stems. Nerines create a similar effect, especially when massed against the base of a wall. There are colchicums, cyclamen, crocuses and zephyranthes. Most striking of all, though, must be *Sternbergia lutea*, whose butter-yellow flowers open out through a dense mass of narrow, bottle-green leaves.

On the look-out for slightly unusual compositions, I photographed this lovely example of parrotia leaves on steps – an outdoor still life as perfect as any studio set-up. Luckily there was no wind at all and this combined with bright, overcast lighting enabled me to bring out every detail in the steps and leaves.

(Bronica 6 × 6, 80mm standard lens, Fujichrome 50 Velvia, f22, tripod. Pyrford Court, Surrey.)

The saturated colour of these autumn colchicums was produced by a combination of soft, diffused light, slight under-exposure and Fuji's Velvia film. The dark, shadowy background makes the flowers jump out of the picture.

(Olympus OM2, 90mm macro lens, Fujichrome Velvia, f22, tripod. The Savill Garden, Surrey.)

 Arboretums are great places to shoot autumnal photographs. In this picture of a Japanese maple I was attracted by the graceful shape of the tree's trunk. A dark background has helped give the picture more impact.

(Olympus OM10, 50mm standard lens, Fujichrome 50 Velvia, f11, tripod. Westonbirt Arboretum, Gloucestershire.)

 I am constantly attracted by the colour red and this Boston ivy growing against a wall was no exception. For this shot I closed in on a section of the wall and this has given the picture a graphic quality.

(Bronica 6 × 6, 150mm short telephoto lens, Fujichrome 50 Velvia, f16, tripod. Lower House Farm, Wales.)

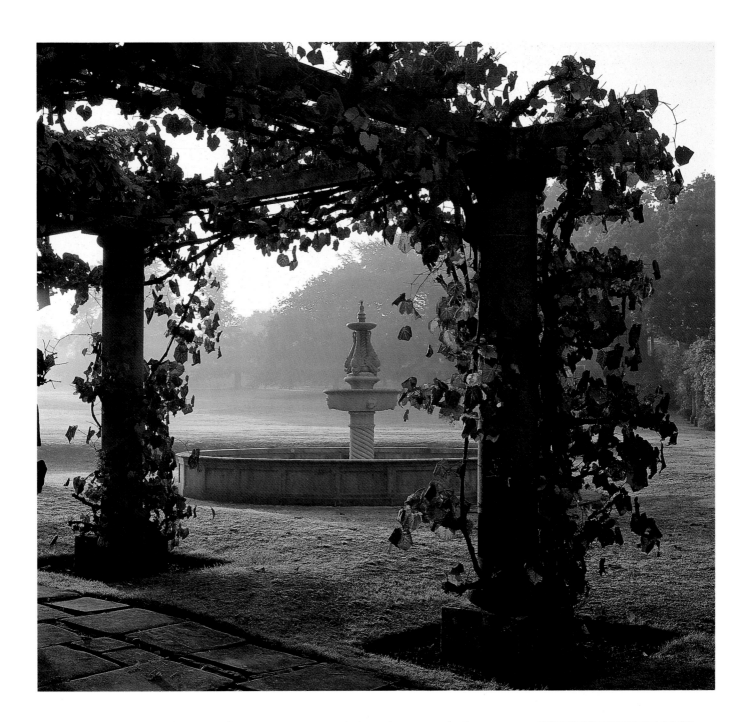

These three pictures of the Pergola Walk at Pyrford Court were taken in the space of just two minutes early one morning in late autumn. I had to drive to the garden through quite thick fog but as I arrived I noticed the sun was beginning to burn through very quickly; I ran to the pergola and pointed the camera towards the sun, being careful to ensure that the rays were masked by part of the pergola. Back-lighting of the vine leaves had added great drama to the scene and the result is a memorable photograph. Turning my back to the sun, I photographed a single column of the pergola. The early morning light,

together with slight under-exposure of the film, enriched the autumnal reds of the vine leaves.

(Bronica 6 × 6, 80mm standard lens, Fujichrome 50 Velvia, f22, tripod. Pyrford Court, Surrey.)

PROFESSIONAL TIPS

AUTUMN/WINTER

Enjoy the blaze of colours displayed by deciduous trees, shrubs, autumn fruits.

Make the most of still weather – sunny days, cold nights – when leaf colours will be most vibrant.

In winter there are fewer subjects, so spend time on composition.

Look for winter-flowering bulbs, trees and shrubs; also remember evergreen foliage and striking bark/stems.

Winter

On several occasions I have been asked the question 'What do you do in the winter when there is nothing to photograph in the garden?' My answer is always the same: 'I take photographs of gardens and flowers', for the truth is that gardens can be as colourful and as photogenic in winter as they are during the rest of the year. Summer spoils the garden photographer. In winter you have to look harder.

In addition to the delights that snow and frost can bring to the garden in winter (see pp 98–99), there are the fragrant flowers of several choice trees and shrubs, the blues, greens and golds of evergreens, many winter-flowering bulbs and vibrant splashes of colour from the stems and bark of deciduous shrubs and trees, clothed with leaves in summer but naked in the depths of winter. To my mind though, the most beautiful sight in the winter garden are the delicate flowers of the hellebores, in shades of white, cream, mint-green, pink and purple.

The brilliant-red stems of *Cornus alba* 'Sibirica' and *Salix alba* var. *vitellina* 'Britzensis' will stop you in your tracks and make striking subjects for photography, especially when set against a dark background, such as yew hedging, or beside a pool or lake. Evergreen foliage is also a lovely foil for yellow-stemmed shrubs like *Cornus stolonifera* 'Flaviramea' and *Salix alba* var. *vitellina*. Then there are the snow-white trunks of birches, gorgeous when photographed against a brilliant blue sky, and the ghostly wands of the winter bramble, *Rubus cockburnianus*, arching up from the bare earth.

Several choice trees and shrubs can also be relied upon to flower during milder spells. The winter-flowering cherry, *Prunus* x *subhirtella* 'Autumnalis', produces pale-pink blossom. The honeysuckles *Lonicera* x *purpusii* and *Lonicera fragrantissima* waft their heady fragrance from creamy-white flowers, and witch hazels (hamamelis) display their spidery yellow and orange flowers on bare stems. The flowers of camel-

lias, daphnes, viburnums, winter sweet (*Chimonanthus praecox*), winter jasmine (*Jasminum nudiflorum*), *Mahonia japonica*, and the Cornelian cherry (*Cornus mas*) all make great subjects for macro photography.

At ground level, a multitude of flowering bulbs spring to life, creating exciting carpets of colour to record on film. First come drifts of brilliant white snowdrops, butter-yellow aconites (*Eranthis hyemalis*) and pink, carmine and cream *Cyclamen coum*, followed by anemones, crocuses, reticulata iris and golden miniature narcissi.

Curiously, I actually find photographing plants and gardens easier in the winter months than at any other time of year. Everything seems so much more straightforward. If you walk into a cottage garden in midsummer, the beds and borders will overflow with a multitude of floral subjects which will make it difficult to decide where or what to photograph first. In winter, the same garden may be empty save for a few snowdrops or hellebores, so these plants are obvious targets for photography. Because there are generally fewer subjects to choose from, it is often possible to spend more time on a composition without worrying about other photogenic subjects you might be missing. The weather, too, can be more predictable and stable, especially on frosty mornings when wind is rare.

❧ Winter bulbs always make great subjects for photography. I used a macro lens and an aperture of f32 to obtain maximum sharpness in this straightforward portrait of a Reticulata iris.

(Pentax 6 × 7, 135mm macro lens, Fujichrome Velvia, f32, tripod.)

❧ The brilliant candy-pink bark of this *Acer pensylvanicum* 'Erythrocladum' caught my eye. The bark contrasts perfectly with the rich, green background.

(Pentax 6 × 7, 135mm short telephoto lens, Fujichrome Velvia, f16, tripod. Sir Harold Hillier Gardens and Arboretum, Hampshire.)

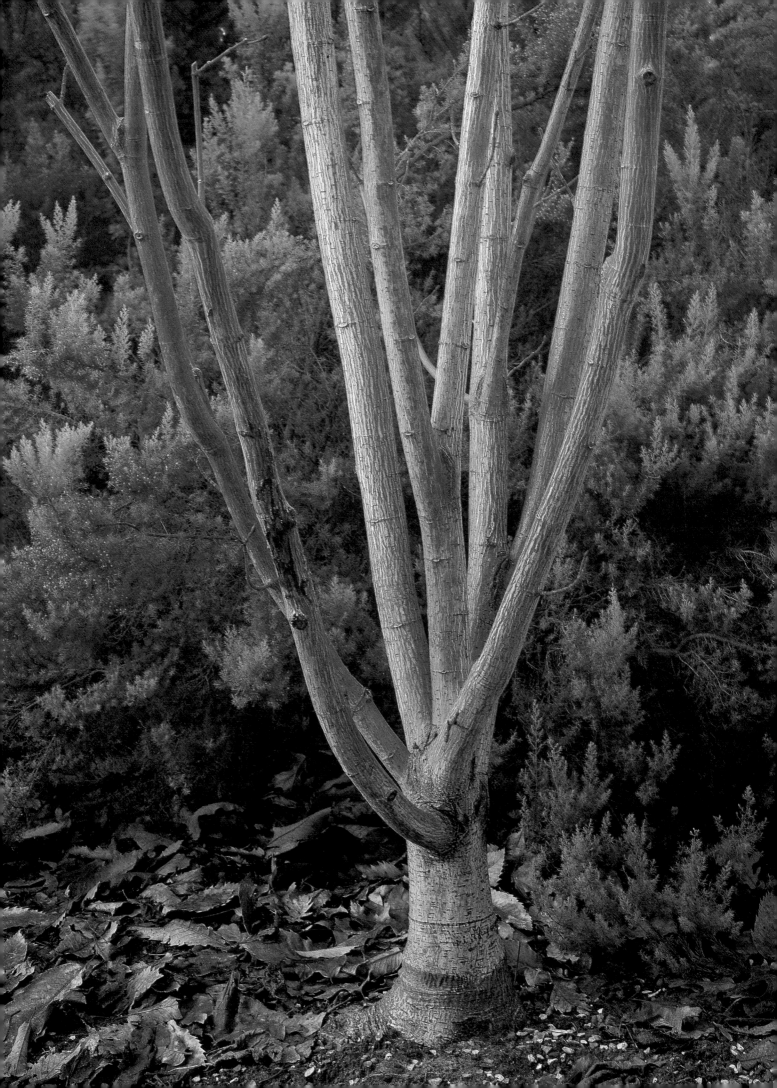

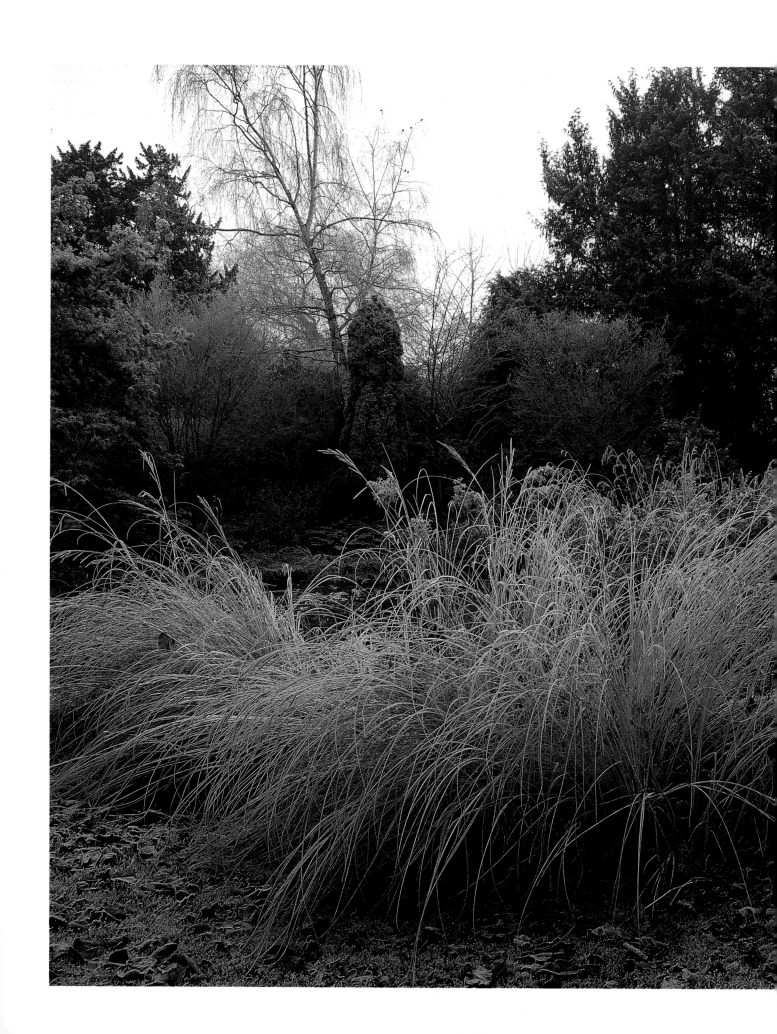

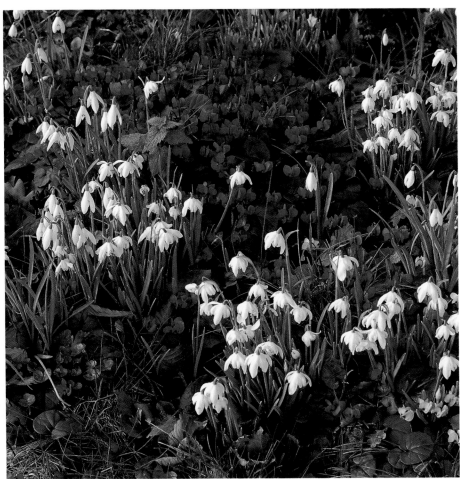

🌼 Low-angled winter sunlight highlights these snowdrops and cyclamen carpeting the ground at the Dower House in Gloucestershire.

(Bronica 6 × 6, 150mm short telephoto lens, Fujichrome Velvia f22, tripod. The Dower House, Gloucestershire.)

🌼 I arrived at The Old Rectory near Reading shortly after dawn and was confronted with this magical scene. The weak, early-morning sunshine makes the grasses in the foreground glow golden brown. There was not a breath of wind so I was able to obtain a pin-sharp image even with an exposure time of 1 second.

(Pentax 6 × 7, 55mm wide-angle lens, Fujichrome Velvia, 1 sec f22, tripod. The Old Rectory, Burghfield, Berkshire.)

🌼 (Overleaf) The soft, shadowless light of an overcast day was perfect for this association of _Sedum spectabile_ 'Carmen', _Dendranthema_ 'Fairy' and _Anemone hupehensis_ var. _japonica_ 'Bressingham Glow'.

(Bronica 6 × 6, 80mm standard lens, Fujichrome Velvia, f22, tripod. Royal Horticultural Society's Garden, Wisley, Surrey.)

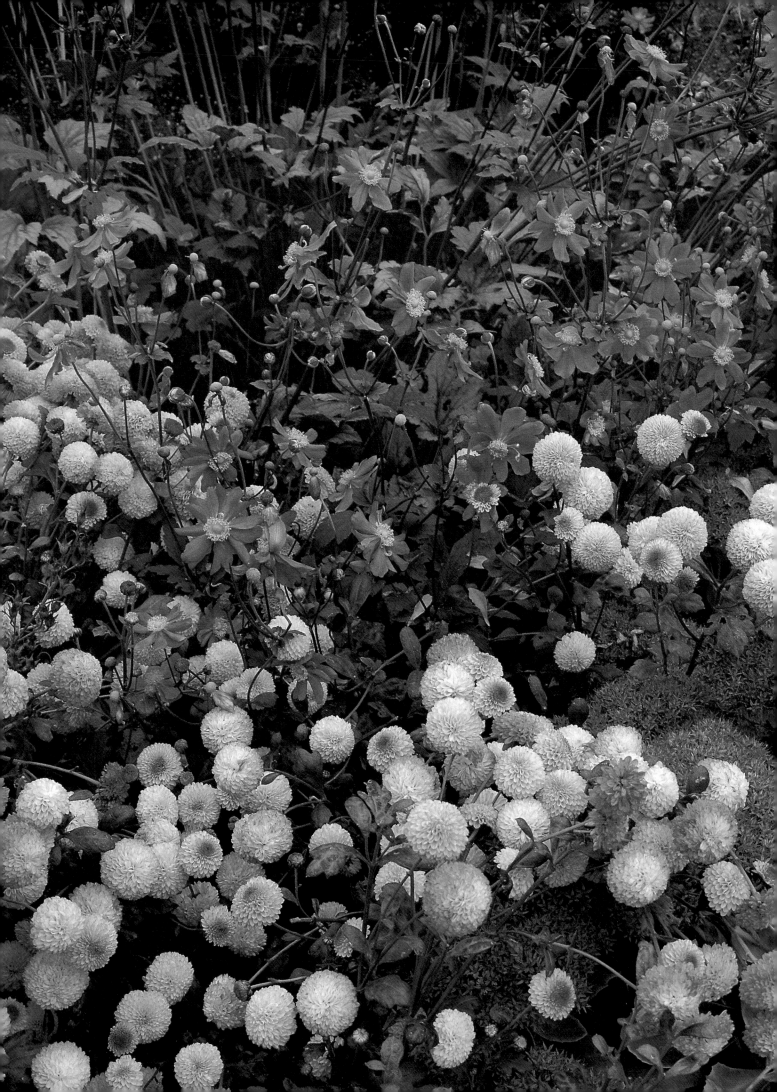

PLANTS AND GARDENS

❧ (Top) Evening sunshine imparts a warm glow to these bright red geraniums and the mellow Cotswold stones.

(Bronica 6 × 6, 150mm short telephoto lens, Fujichrome Velvia, f22, tripod. Lygon Arms Hotel, Broadway, Worcestershire.)

❧ (Above) A macro lens was used for this straightforward portrait of *Rosa* 'Fritz Nobis'.

(Olympus OM2, 90mm macro lens, Fujichrome Velvia, f16, tripod. Hadspen House, Somerset.)

(Left, see page 123)

The Vista

The vista is probably the most important photograph that you can take in the garden. Gardeners throughout history have realised its importance, and it is not surprising that vistas such as the lily pool and wooden bridge in Monet's garden at Giverny, France, and the laburnum arch at Barnsley House, England, have become some of the most popular subjects for painters and photographers.

When shooting vistas, it is usually advisable to maximise depth of field so that the whole of the scene appears in sharp focus. For this reason the smallest aperture possible should be used and the camera focused roughly one-third of the way into the scene. I always try to look for something definite in the foreground on which to focus – an arch, a gate or a clump of flowers, for example.

Choice of lens is an important consideration. If you are trying to include as much of the scene as you possibly can and have little room in which to move around, then consider using a wide-angle lens. If, on the other hand, you want to compress perspective within the scene or capture a vista that cannot easily be approached, then a telephoto or zoom lens may be a better choice. If you do decide to use a wide-angle lens, be careful not to include too much sky in the composition and ensure that the camera back is not tilted up or down when architectural features are present in the composition.

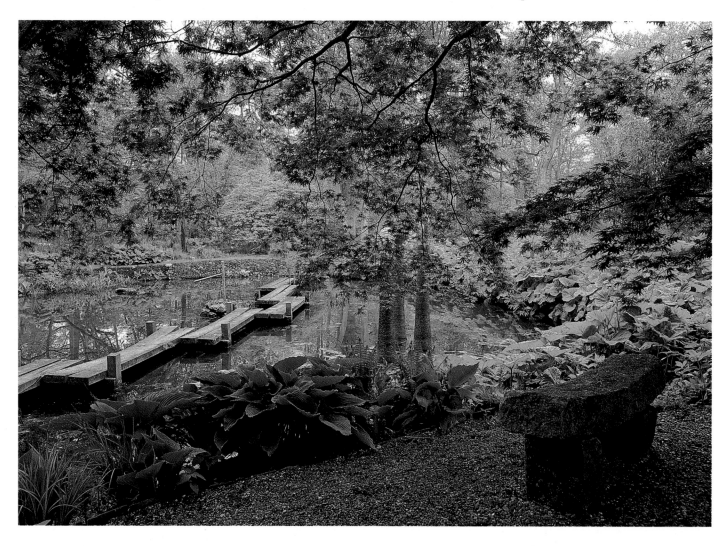

In this view of a stone seat beside a pool at the Hannah Peschar Gallery and Sculpture Garden, I have used the delicate leaves of an acer as a frame in order to add interest to the upper half of the image. Without the acer the picture would have lacked interest.

A small aperture was essential for maximum depth of field in this vista along an avenue of Irish junipers at 40 Osler Road, Oxford. A feeling of depth in the picture has been strengthened by the use of a wide-angle lens. As the junipers get further away they appear smaller, and the edges of the path appear to converge as they extend into the distance.

Both photographs: (Pentax 6 × 7, 55mm wide-angle lens, Fujichrome Velvia, f22, tripod.)

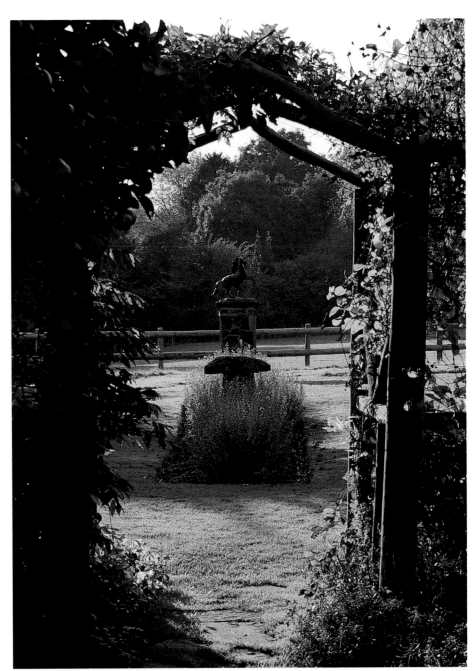

🍂 The graceful curves of an old apple tree provide a frame and foreground interest in this garden vista. Gentle sunshine has created interesting shadows on the perfect lawn.

(Pentax 6 × 7 55m wide-angle lens, Fujichrome Velvia, f22, tripod. 28 Hillgrove Crescent, Kidderminster.)

🍂 A wooden pergola acts as an effective frame for this sculpture of a horse. A telephoto lens compresses perspective, and back-lighting gives a strong three-dimensional feel to the picture.

(Olympus OM10, 300mm telephoto lens, Fujichrome Velvia, f32, tripod. Lower House Farm, Wales.)

Panoramas

Our eyes are able to take in an extensive view of any scene in front of us. To reproduce a similar view on a piece of film, we need a camera especially designed to take panoramic pictures.

One camera which has been manufactured to produce precisely this kind of picture is the Fuji G617 camera, which has a fixed 105mm f/8 lens and produces just four exposures of 6 × 17cm on a standard roll of medium-format 120 roll film. The camera has a very basic viewfinder which allows only about 80 per cent of the photograph to

be seen, so framing can be a problem. Also, because the field of view encompassed by the camera is so wide, light tends to fall off towards the edges of the picture so that there is a lighter spot in the centre of the image. A special filter known as a centre spot must therefore be used to even out the illumination across the whole frame. Unfortunately, this reduces light intensity by about $1^{1}/_{2}$ f-stops, making exposures longer. However, the results from this big camera are very impressive indeed.

❧ Most photographers use the panoramic format to take sweeping views of the landscape. Here, however, I have captured two unusual views of the exotic tropical plants growing inside the Wyld Court Rainforest.

(Fuji G617, 105mm lens fitted with centre spot filter, Fujichrome Velvia, f32, tripod. Wyld Court Rainforest, Hampstead Norreys, Berkshire.)

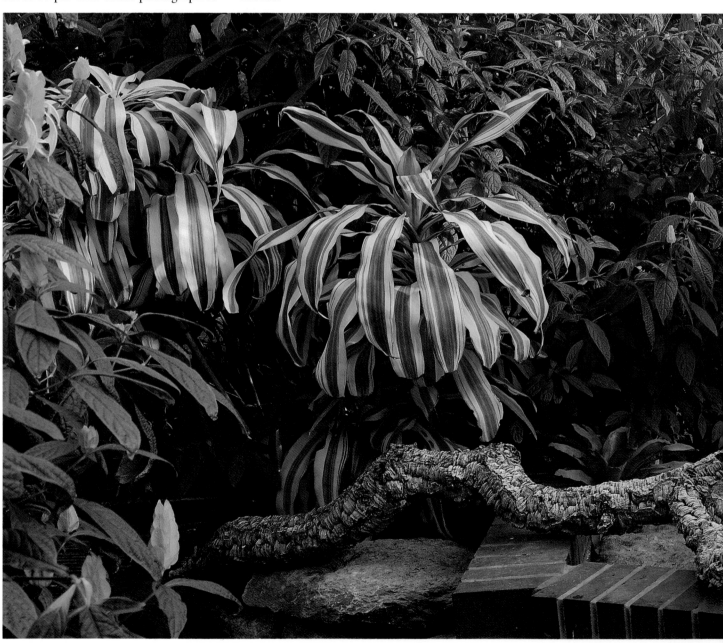

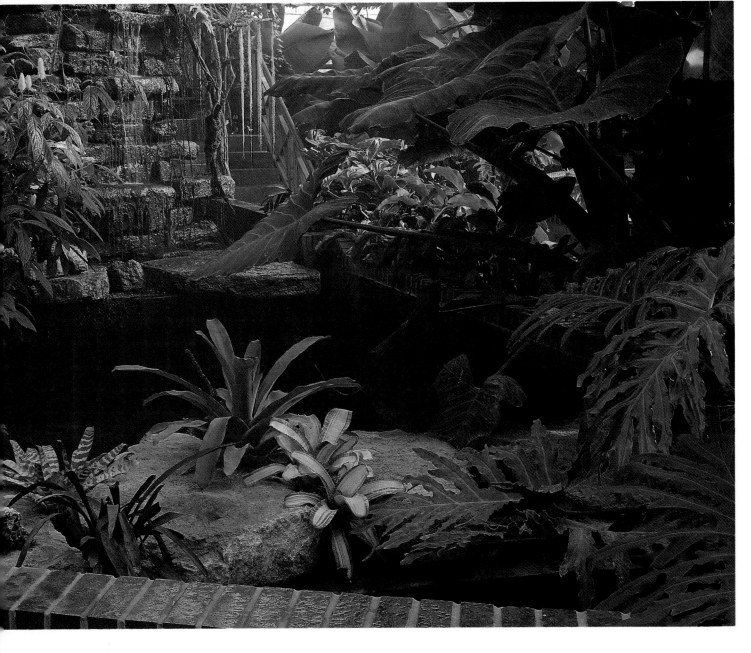

Plant and Foliage Associations

The skilled gardener uses plants to decorate the garden space in the same way as a painter uses paints to bring to life a blank canvas. Like the painter, the gardener tries to arrange the ingredients of the composition, in this case the plants, in a way that is pleasing to the eye, combining colours, shapes and textures together for maximum effect. Working with a changing medium, however, makes the gardener's task more complex than that of the painter, and to produce a succession of delightful plant and foliage associations throughout the four seasons requires great imagination and planning.

Gardens which have been planted sensitively in this way are a real bonus for photographers, since they offer year-round opportunities for picture taking. The sensitive photographer can use the artistry of the gardener to create stunning images of plant and foliage combinations.

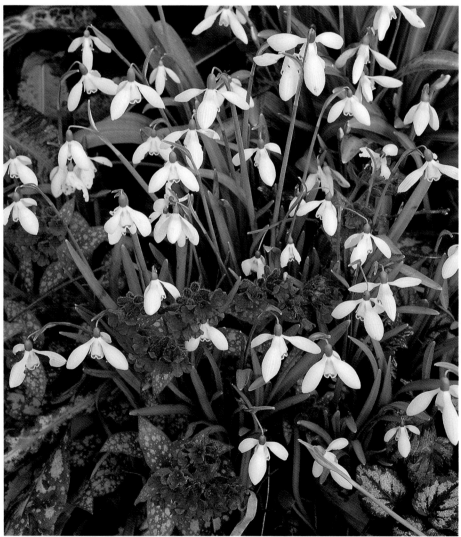

❦ I used a macro lens to isolate this association of snowdrops and pulmonarias. It is better to under-expose snowdrops by about ½ a stop in order to prevent the whites from burning out.

❦ This lovely combination of foxgloves and roses was taken early one morning in a walled rose garden using just a standard lens. To obtain maximum sharpness, I stopped down to f22.

(Pentax 6 × 7, 135mm macro lens, Fujichrome Velvia, f22, tripod. East Lambrook Manor.)

(Bronica 6 × 6, 80mm standard lens, Fujichrome Velvia, tripod. David Hicks' garden, Oxfordshire.)

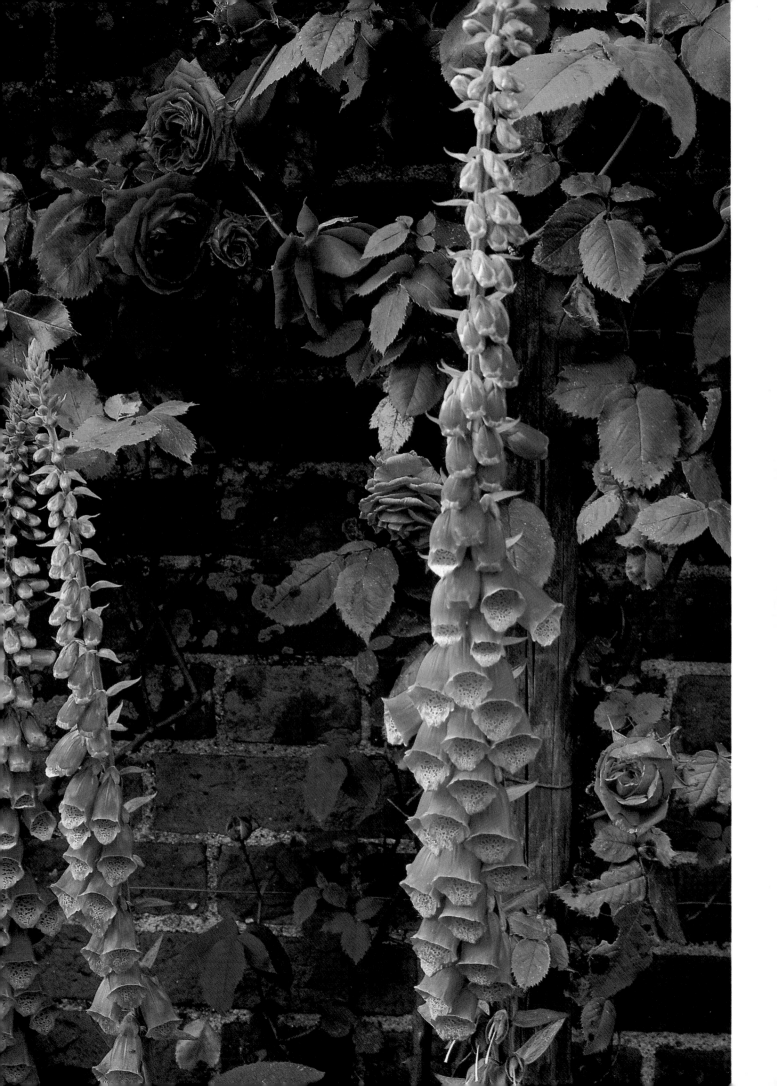

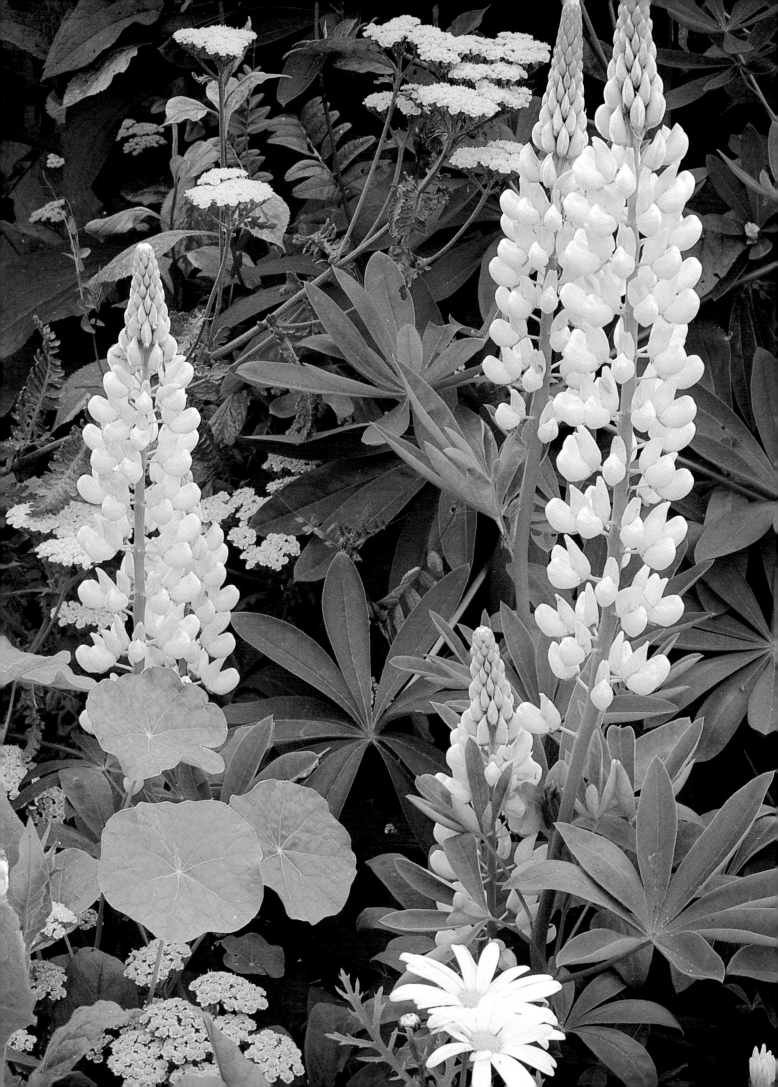

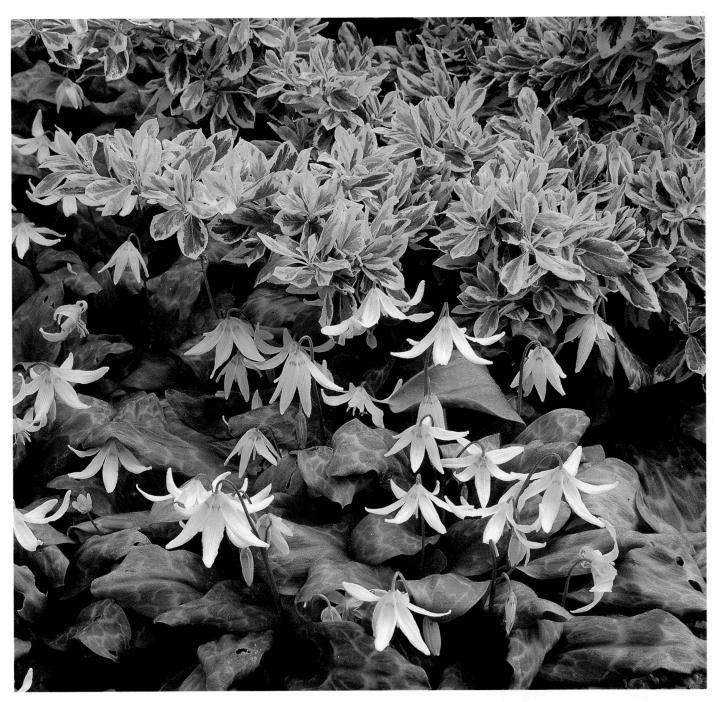

❧ (Above) I love to photograph exquisite plant associations such as this one of *Erythronium* 'White Beauty' and euonymus. A combination of soft morning light and a short telephoto lens has made the association into a striking shot.

(Bronica 6 × 6, 150mm telephoto lens, Fujichrome Velvia, f22, tripod. Beth Chatto gardens, Essex.)

❧ (Left) To show off this association of lupins and achilleas in the yellow border at Hadspen House I used a zoom lens to make the flowers appear closer together and stopped down to f32 for maximum depth of field.

(Olympus OM2, 80–200mm zoom lens, Fujichrome Velvia, f32, tripod. Hadspen House, Somerset.)

❧ In this lovely association of foliage at Hadspen House I placed the main subject – the golden sedge – right in the centre of the frame. For maximum definition I used the smallest aperture possible (f22).

(Bronica 6 × 6, 150mm short telephoto lens, Fujichrome Velvia, f22, tripod. Hadspen House, Somerset.)

Plant Portraits and Close-ups

Understandably, flowers make popular subjects for garden photography. Their simple beauty and grace is usually the first thing that catches our eye when we walk into a garden and the marvellous variety of colours, textures and shapes which individual blooms possess seem all the more alluring when magnified on film. Using equipment especially designed for extreme close-up photography enables us to record with great clarity the elaborate and often highly decorative internal structures of a flower.

A picture is referred to as a close-up if the image on the film is at least one-tenth as big as it is in reality. In other words, to fill the whole of a 35mm frame, a subject would only need to be 35cm wide to be considered a close-up. Wide-angle lenses are unsuitable for close-up work, but standard and telephoto lenses on their own are capable of producing moderate close-up images which are between one-tenth and one-sixth of life-size and by adding certain relatively inexpensive close-up attachments, even greater magnifications can be obtained with these lenses.

The easiest and cheapest way of extending the range of standard and telephoto lenses so that they are able to focus even closer is to add one or more close-up lenses to the front of the lens. These lenses are normally sold in sets of three and each lens has a different strength quoted in diopters (+1 being the weakest, +3 the strongest). Close-up lenses can be used individually or in combination to obtain even greater levels of magnification. Unfortunately, although these lenses do not reduce the amount of light reaching the film, the contrast and sharpness of the image can deteriorate considerably when more than one close-up lens is used. For the best results, use close-up lenses on fixed focal length lenses rather than zooms, and fix the most powerful lens first if using more than one.

A better alternative is to use light, hollow extension rings or tubes which fit between the camera body and the lens, permitting closer focusing. Extension rings can be purchased in a variety of different lengths and, as with close-up lenses, can be used singly or in any combination, with the longest rings giving the greatest level of magnification. As a guide, 50mm of extension with a 50mm standard lens will allow life-size (1:1) reproduction.

Macro lenses, though more expensive than tubes or close-up lenses, permit very close focusing on a subject and are capable of producing images that are up to half or life-size magnification. When used in conjunction with extension tubes, extreme close-ups of up to life-size or greater can also be obtained.

In this shot of ruby chard growing in the vegetable garden at Hadspen House I used a macro lens to restrict the number of hues to just two – red and green, which has created contrast in the picture.

(Olympus OM2, 90mm macro lens, Fujichrome Velvia, f11, tripod. Hadspen House, Somerset.)

Soft, early evening side-light bathes this 'Scharlachglut' rose in a warm glow.

(Olympus OM2, 90mm macro, Fujichrome Velvia, f16, tripod.)

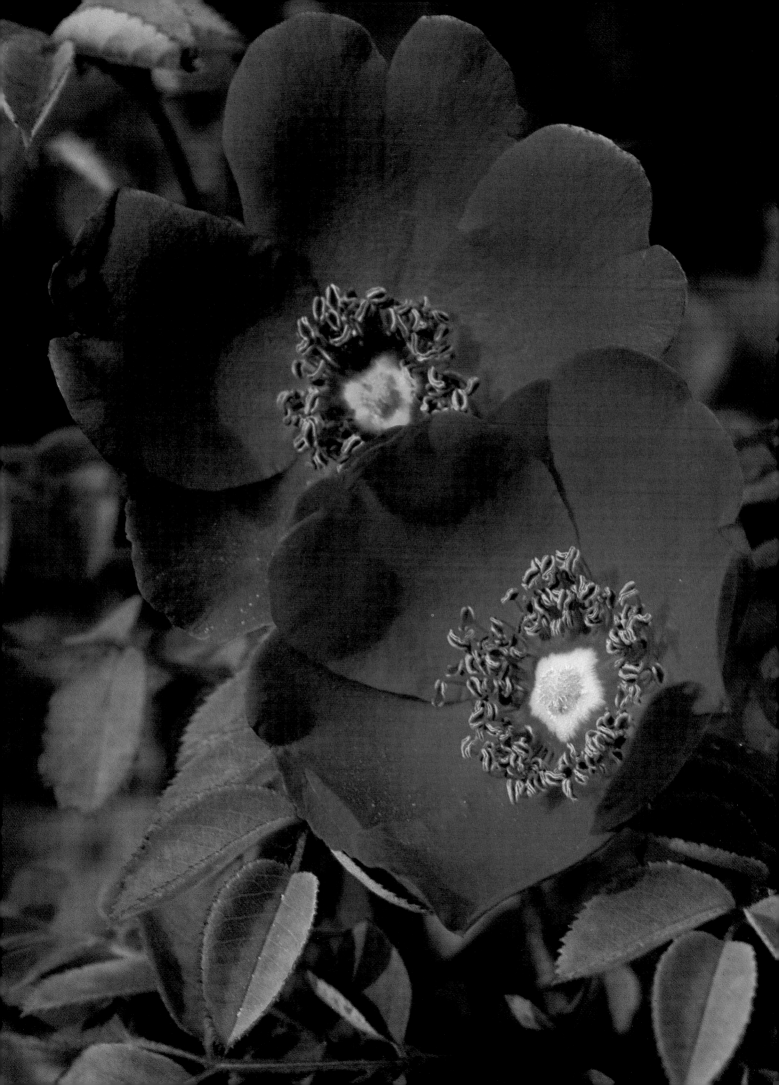

Selecting the Subject

Before commencing to take a plant portrait make sure that you have selected the most photogenic specimen. Choose flowers that are fresh and undamaged, as a shrivelled petal or a diseased leaf will show up in the photograph once it is enlarged. Backgrounds, too, must be taken into account. Simple, uncluttered backdrops work well, as they do not detract from the main subject of the photograph. If your chosen subject is light in colour, then setting it against a dark, velvety background will make it stand out more, giving the picture greater impact. A distracting background can be thrown out of focus, of course, by setting a wide lens aperture so that it appears blurred by minimising the depth of field so that only the flower itself is in sharp focus.

Choosing the right light and weather conditions for a close-up is just as important as it is for a garden vista. Soft, diffused light is often the best light as it is perfect for bringing out the delicate hues and fine details of a

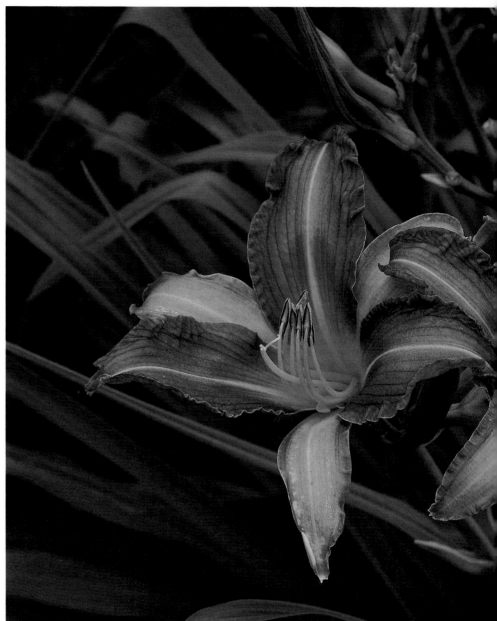

Fuji's Velvia film has brought out the rich colours of these *Hemerocallis* 'Prima Donna' flowers. To make sure that the flowers were pin-sharp I stopped down to f32.

(Pentax 6 × 7, 135 macro lens, Fujichrome Velvia, f32, tripod. The Anchorage, Kent.)

I photographed this 'Glenfiddich' rose just before sunset using a macro lens. The mellow quality of the light has imparted a warm glow to the flower.

(Olympus OM2, 90mm macro lens, Fujichrome Velvia, f22, tripod.)

flower. Back-lighting can be effective too, especially with subjects like poppies that have translucent, paper-thin petals. Side-lighting will help to emphasise the shape and form of individual blooms, but in high-contrast situations it may be necessary to use a reflector to add light to the dark side of the subject.

Flowers always look fresher and more inviting when water droplets cling to the surfaces of their leaves and petals, so use a spray bottle of water if you want to achieve this effect. Alternatively, shoot during or just after a rain-storm, or in the early morning when there is still some dew left on plants.

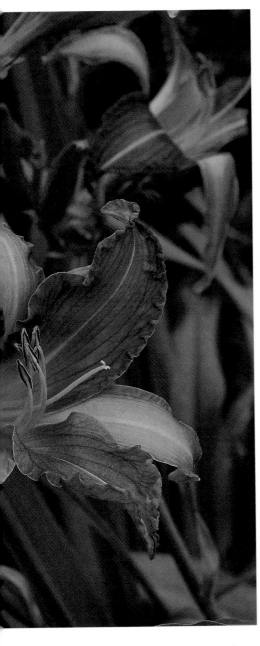

When composing a close-up photograph, always use a tripod and cable release to eliminate camera shake, as any movement of the camera during exposure will be very obvious in the finished photograph. Careful focusing is also essential since high magnifications reduce depth of field considerably, even when small apertures are being used. For ultra-crisp close-ups, it is advisable to use a small aperture such as f16 or f22 so that the main subject at least appears pin-sharp. Use the depth-of-field button if you have one to check how much of the photograph is in sharp focus.

Shooting close-ups outdoors is not as simple as many people believe. Small apertures, though improving sharpness, make slow shutter speeds the norm when using a slow film and natural light. Great patience is therefore needed when working in a garden, since the slightest gust of wind can move the flower stalk just as the cable release is pressed, ruining the photograph. The effect of the wind can be considerably reduced or even eliminated altogether by erecting a wind shield or light tent around the subject. However, this can be time-consuming and a better alternative is to push a knitting-needle or bamboo cane into the ground beside the subject, which is then attached to the support with a paper clip or elastic band.

The drooping flowers of *Phygelius aequalis* 'Yellow Trumpet' form their own 'natural' composition which has been captured with a macro lens.

(Olympus OM2, 90mm macro lens, Fujichrome Velvia, f16, tripod.)

Architectural Features and Garden Ornaments

Architectural features and garden ornaments such as walls, paths, gazebos, arbours, statues, containers and furniture form the structural 'bones' of a garden and reflect the personality and style of the owner or garden-maker. Because they are relatively permanent features, they can be admired and photographed at any time of the year. Indeed, as I have already pointed out, architectural features and ornaments actually take on an added importance in winter when they become the dominant focal points in a garden.

In addition to architecture and ornamentation within the garden itself, consider also the role of the house and the way that it bonds with its garden. In Monet's garden at Giverny, for example, the architecture and decoration of the house forms an integral part of the background scene from almost

❧ By shooting this grotto by Julian Bannerman on an overcast day I was able to show clearly the different materials that were used in its construction. The empty chair by the window adds scale to the composition.

(Pentax 6 × 7, 55mm wide-angle lens, Fujichrome Velvia, f16, tripod.)

every angle of the surrounding flower garden. Including the house in the background helps to establish a strong sense of place and adds perspective to garden scenes.

One piece of equipment that can be invaluable when photographing architectural features is the shift lens (described on p 26). If you do not possess this piece of equipment, then ensure that the camera back is kept level, as tilting the camera upwards to take in a structure or building will lead to converging verticals in your pictures. Always mount the camera on a tripod and use a spirit level if you have one to check that the camera is correctly aligned.

❧ I switched cameras and used a 200mm lens to pick out this detail.

(Olympus OM2, 80–200mm zoom lens, Fujichrome Velvia, f22, tripod.)

❧ The delightful Surrey woodland garden created by Hannah Peschar and Anthony Paul displays contemporary outdoor sculpture in a natural setting. In this photograph of a ceramic head by sculptor Pat Volk, the large rounded leaves of *Petasites japonicus* add balance to the composition when shot with a wide-angle lens.

(Pentax 6 × 7, 55mm wide-angle lens, Fujichrome Velvia, f22, tripod. Hannah Peschar Gallery and Sculpture Garden, Surrey.)

Pattern and Abstracts

Pattern – the repetition of similar shapes, angles or colours – is everywhere in the garden, and learning to recognise subject pattern and then to incorporate it within a composition can add strength and visual impact to your garden photographs.

In order to make the most of pattern, try to make it the dominant element of the photograph. Ruthlessly exclude from the picture any part of the scene that makes no contribution to the pattern. Experiment with different lenses in order to simplify the composition – the simplest photographs often turn out to be the most successful. A zoom or telephoto lens is often ideal for isolating a particular pattern from a more general scene. Remember, too, that unsuspected patterns can sometimes be found simply by shooting from a high or low viewpoint, or by moving in very close.

Once you start looking hard for the pattern and symmetry to be found within plants and gardens, you may begin to notice even more abstract lines and shapes that can be used to create unusual and thought-provoking images. Creating photogenic abstract pictures can be great fun. However, it can be more difficult than it actually seems because the photographer must learn to look beyond the simple record shot and 'see' flowers and gardens in a new and intriguing way. The best abstract photographs will puzzle the viewer and provoke their imagination. The subject of the photograph may have been discovered by the photographer within a flower, garden vignette or garden scene, but the viewer may not at first be aware of what the subject of the picture is in reality.

✿ The arching, ghostly white stems of *Rubus cockburnianus* resemble a steel engraving when rimed with frost.

(Pentax 6 × 7, 135mm lens, Fujichrome Velvia, f16, tripod. Brook Cottage, Oxfordshire.)

✿ For this abstract photograph of the bark of *Betula* 'Jermyns' I used a combination of three extension tubes on my 80mm lens in order to fill the frame completely with the subject. Soft light has brought out the details of the bark that would have been lost in stronger lighting.

(Bronica 6 × 6, 80mm standard lens with 3 extension tubes, Fujichrome Velvia, f22, tripod.)

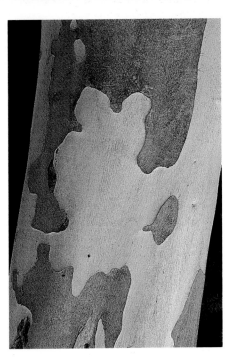

✿ The mottled cream and grey bark of *Eucalyptus pauciflora* subsp. *niphophila* creates a fascinating abstract picture.

(Olympus OM2, 90mm macro lens, Fujichrome Velvia, f8, tripod.)

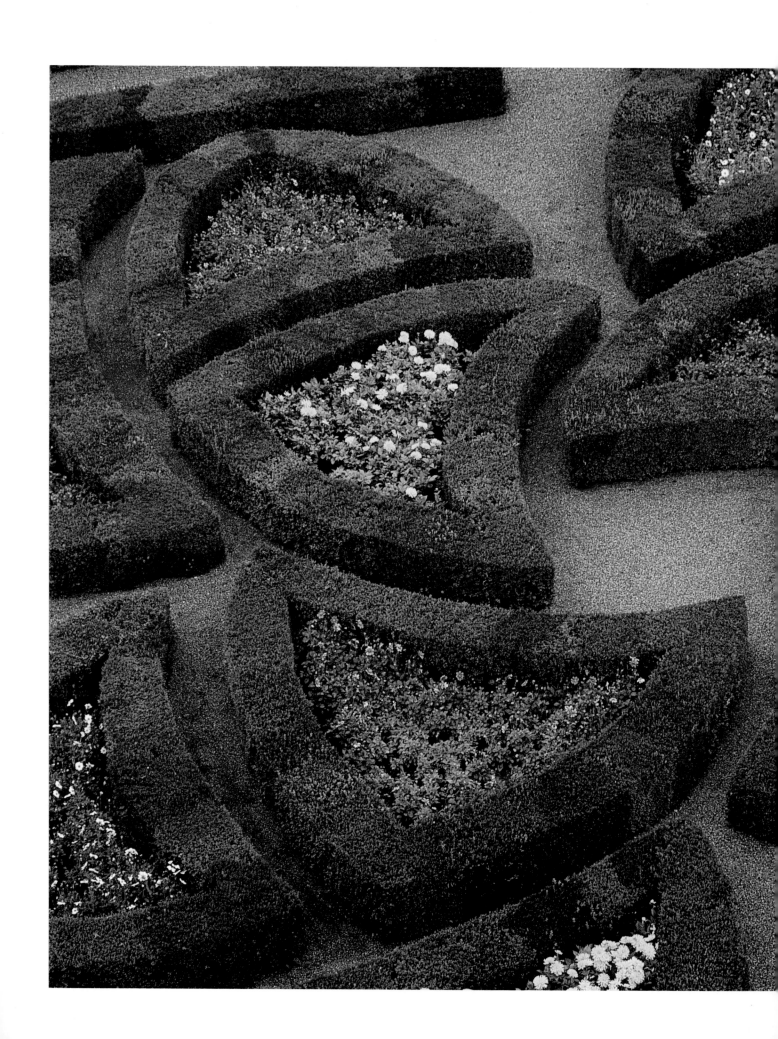

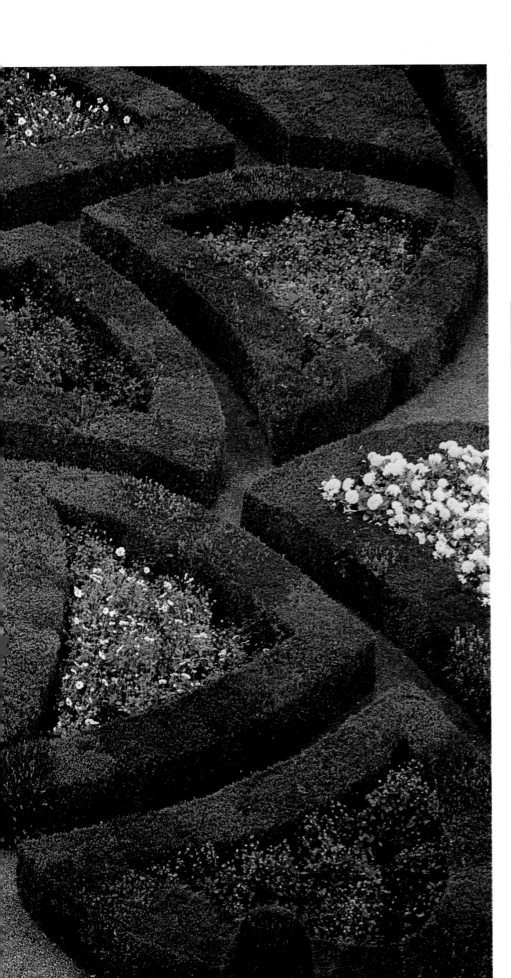

❦ The Château de Villandry in the Loire valley has arguably the most photogenic garden in France. From high up on the castle walls I was able to look down on to the great parterre and use a telephoto lens to isolate a small section of it.

(Olympus OM10, 300mm telephoto lens, Fujichrome Velvia, f32, tripod. Château de Villandry, Loire Valley, France.)

❦ The plate-like, yellow flower heads of this achillea create a more subtle, but still discernible pattern. I used a telephoto lens to compress perspective and to crowd the image with blooms.

(Olympus OM2, 300mm telephoto lens, Fujichrome Velvia, f32, tripod.)

Choosing a Theme

One of the first problems facing the newcomer to plant and garden photography is deciding what subject or subjects to photograph first. Since the range of photogenic subject matter in a garden is so vast, the best way to get started is to pick a horticultural subject that you are familiar with and then to put all your effort into recording just that subject and nothing else on film. For example, if you have a passion for growing old-fashioned roses, then it makes sense to begin by documenting them, perhaps as a series of plant portraits. Alternatively, you could record the internal structure of your roses using a macro lens and a ring flash. In both of these examples, by choosing a theme to document, you are subconsciously setting yourself a goal and this in turn will help to increase your chances of producing a successful set of photographs.

On these pages, I have chosen to document different types of container and the plants that are grown in them.

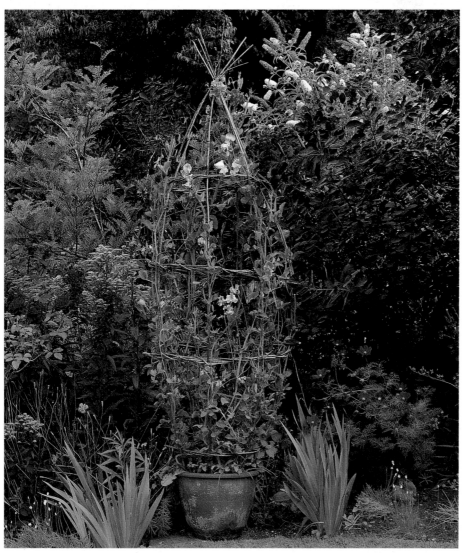

🌿 This beautiful wigwam of *Lathyrus odoratus* was photographed on my Pentax 67 camera from a distance of around 6m (20ft). The shape of the wigwam dictated the choice of format. As there was no wind, I was able to use an aperture of f32, with a slow shutter speed, so that everything appeared pin-sharp.

(Pentax 6 × 7, 135mm lens, Fujichrome Velvia, f32, tripod. Vale End, Surrey.)

Under Glass

Conservatories and glasshouses are great places to take plant pictures. Protected from the ravages of the weather, plants tend to be in prime condition indoors. Furthermore, because the photographer has complete control over the movement of air, wind is not a problem. Outdoors, even the faintest breeze can spoil a close-up, but under glass, long exposures without the use of flash are possible providing the camera is mounted on a tripod. If the glass under which you are photographing has been whitewashed or frosted in order to reduce the power of the sun's rays, there is an added bonus: even on a very sunny day, the light will be nicely diffused and will fall softly and evenly on the plants.

Photographing under glass also has its drawbacks. Because the heat from the sun is magnified under glass on a hot summer's day, the temperature inside a glasshouse can be unbearable, making photography an uncomfortable experience. Even on a cold day, heated glasshouses can cause problems. A cold camera brought into a hot, humid glasshouse will quickly steam up with condensation and the only solution is to wait until the camera has warmed up.

Another problem commonly encountered under glass is the presence of unsightly objects such as pipes, vents, benches and fans, which can often intrude into a composition. Similarly, on very bright days, the strong shadows cast by the framework of a glasshouse or conservatory can spoil an otherwise attractive scene.

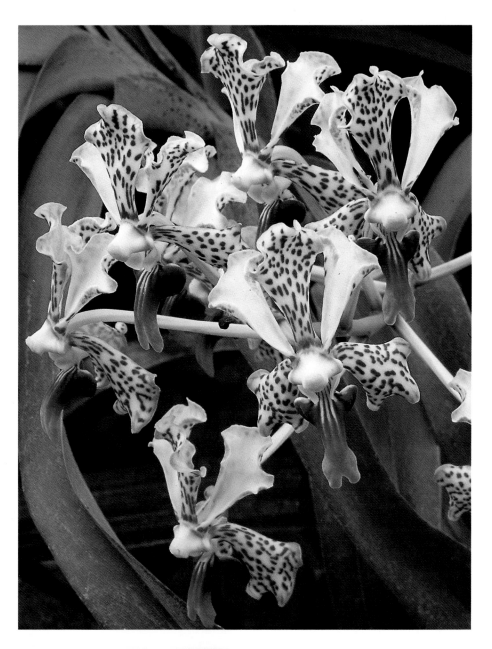

❦ (Previous page) These terracotta pots beside a doorway in London were captured early one spring morning. Soft, even lighting coupled with a small aperture of f22 has enabled me to show maximum detail.

(Bronica 6 × 6, 50mm wide-angle lens, Fujichrome Velvia, f22, tripod. 8 Malvern Terrace, London.)

❦ I had to let my equipment 'warm up' for about ten minutes before capturing *Vanda tricolor* var. *suavis* in the Orchid House at the Royal Horticultural Society Garden, Wisley. The portrait was taken with natural light and a macro lens.

(Olympus OM2, 90mm macro lens, Fujichrome Velvia, f16, tripod. RHS Garden, Wisley, Surrey.)

❦ I was unable to get close to these *Rhodanthemum hosmariense* growing in a glasshouse, so I used my zoom lens to fill the frame with blooms.

(Olympus OM2, 80–200mm zoom lens, Fujichrome Velvia, f22, tripod. RHS Garden, Wisley, Surrey.)

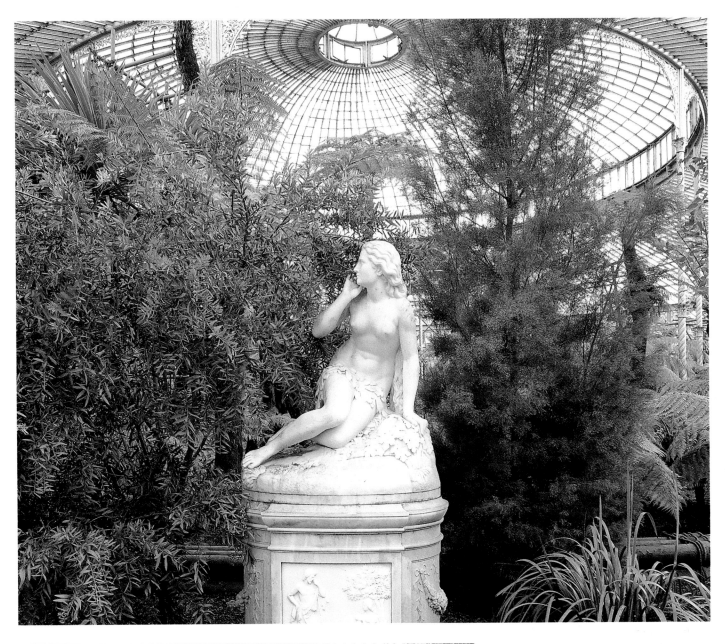

❦ Bright, overcast lighting provided an ideal opportunity to photograph this marble statue inside the magnificent Kibble Palace glasshouse in the Glasgow Botanic Gardens.

(Bronica 6 × 6, 80mm lens, Fujichrome Velvia, f22, tripod. Kibble Palace glasshouse, Glasgow Botanic Gardens.)

❦ In order to show a large amount of the Kibble Palace glasshouse, I used a wide-angle lens and made sure that the camera back was kept level so that the verticals did not appear to converge.

(Olympus OM2, 21mm wide-angle lens, Fujichrome Velvia, f22, tripod. Kibble Palace glasshouse, Glasgow Botanic Gardens.)

Photographing Sequences

Photographing the same garden scene at different times of the year and in different weather conditions from exactly the same position using the same lens can be a fascinating exercise and is a great way to show how specific parts of a garden can change over time. The most striking comparison shots are those that show a garden in the summer and then under snow or frost.

For a sequence to work, the scene should contain at least one focal point that can easily be identified by the viewer – for example, a building, a path, a tree, a statue or a seat. Without such visual clues, the impact of the sequence will be lost because there will be nothing to link the pictures together.

✿ These three photographs of designer Anthony Noel's garden in London show how the same scene changes over time. *Right:* In spring, bulbs such as narcissus and muscari bring splashes of yellow and blue. *Far right:* By summer, the planting has fleshed out, with lavender and white valerian. *Below:* By autumn, the scene has changed again.

(All three photographs – Pentax 6 × 7, 55mm lens, Fujichrome Velvia, f16, tripod. Anthony Noel's garden, London.)

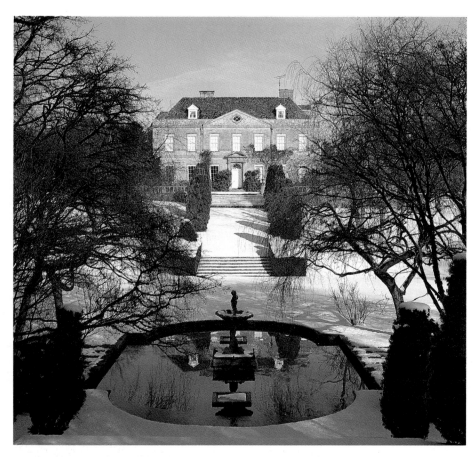

✿ I shot this snowy scene of Cornwell Manor in Oxfordshire from some steps beside the road. A series of bracketed photographs ensured that I obtained the correct exposure for the scene.

(Bronica 6 × 6, 80mm lens, Fujichrome Velvia, f22, tripod. Cornwell Manor, Oxfordshire.)

✿ The same view in spring.

(Bronica 6 × 6, 80mm lens, Fujichrome Velvia, f22, tripod. Cornwell Manor, Oxfordshire.)

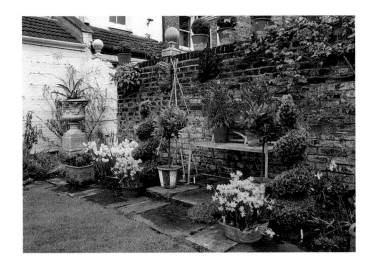

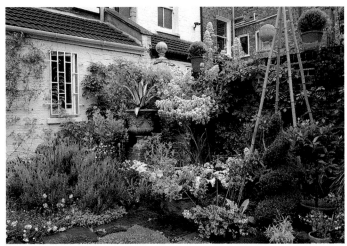

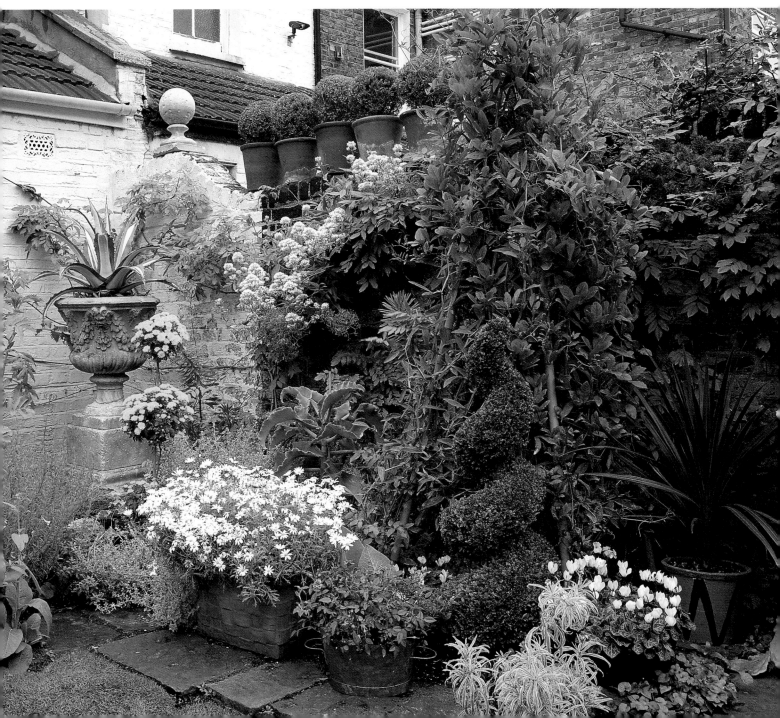

Documenting One Garden

A CASE STUDY

A garden is a living space which is in a constant state of flux, changing in appearance not just in different lighting and weather conditions but also over time – from day to day, from season to season and from year to year. Because of this, no single photograph can ever portray all of a garden's charms, and no single photographic shoot can ever do justice to a garden. It is only by returning again and again with the camera that the true character and feeling of a garden can be brought out on film.

When documenting a garden for the first time, I always try to resist the temptation to start snapping away as soon as I set foot through the entrance. Instead, I like to stroll around without a camera, making a mental note of any vistas, design elements and planting schemes that I think will make a good photograph. When I am satisfied that I have picked out the main targets for photography, I set about the task of photographing these targets as quickly as possible. Just as someone in a supermarket uses a shopping-list to ensure that all the goods they require end up in their trolley, so my mental 'checklist' of images helps me to ensure that I do not forget any important photographs.

When compiling my mental checklist, what images do I try to include? First, because I want to show the overall feeling of the garden and the way that it fits into its surroundings, I look for general or 'establishing' views of the garden. For example, if the garden is in the countryside and is surrounded by hills, I try to include these in the picture; if it is a roof-top garden in the middle of a large city, then I would want to show some of the nearby office blocks and streets. General views usually mean shooting with wide-angle lenses, often from a high viewpoint. They are vital for establishing a sense of place.

Next, within the garden itself, I look for tighter compositions that show a specific aspect of the garden's design or planting. This could be a fountain, a group of containers or a border full of flowers, for example. Specific views should be used to pick out the most unusual or striking elements contained within the garden's framework and are important for revealing a garden's personality and individual identity.

Finally, I try to focus on the more intimate aspects of a garden which often pass unnoticed but can produce simple but telling compositions. This kind of photograph could show something as simple as a frame-filling close-up of an individual flower or an architectural detail such as the carving on a stone ornament.

PROFESSIONAL TIPS

CHECKLIST

❧ **P**ick out the main design elements and planting schemes; the vista best conveys a garden's overall shape.

❧ **D**epict the general view: a sweeping panorama will establish a garden in its setting.

❧ **L**ook for elements that reveal the garden's individuality: a fountain, a view. Note focal points that will be effective for sequence photography (seat, statue).

❧ **L**earn to recognise pattern (shapes, colour); try making it the dominant element.

❧ **N**otice plant associations: the skilled gardener can produce a succession of delightful combinations of colour, shape and texture throughout the seasons.

❧ **F**ocus on the more intimate aspects: an architectural detail, a particular flower.

❧ During the past three years I have documented Anthony Noel's remarkable London garden in every season and in all kinds of weather. Here I used a step-ladder to gain extra height and a wide-angle lens to show as much of the garden and surrounding office blocks as I could. I focused the camera on the watering can on the right of the picture and stopped down to f16 for maximum depth of field.

(Olympus OM10. 21mm wide-angle lens, Fujichrome Velvia, f16, tripod. Anthony Noel's garden, London.)

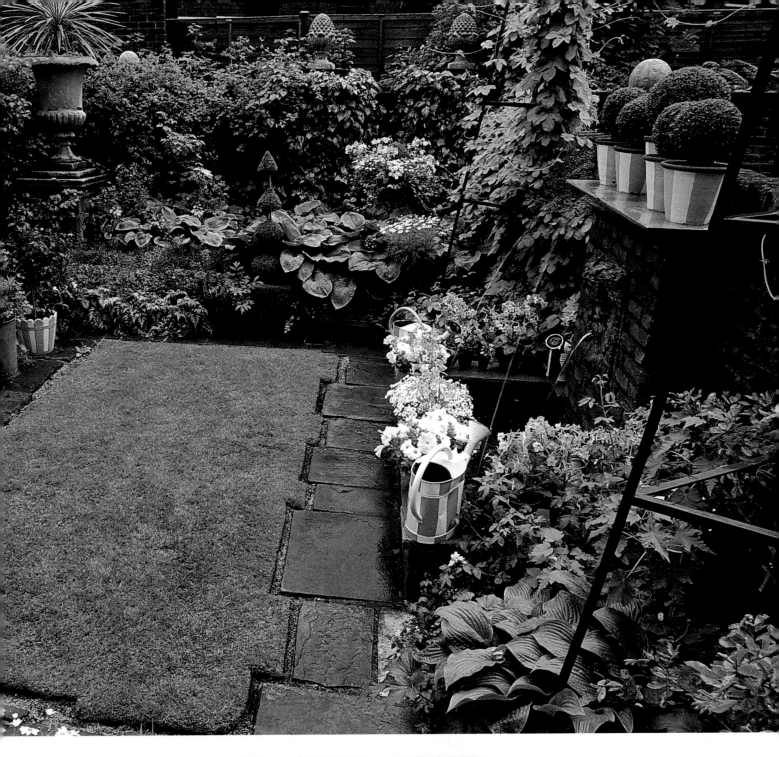

Here I have made an amusing image out of these striped terracotta pots standing on a windowsill. Notice how the strength of the picture lies in the repetition of similar shapes.

(Olympus OM10, 90mm macro lens, Fujichrome Velvia, f22, tripod. Anthony Noel's garden, London.)

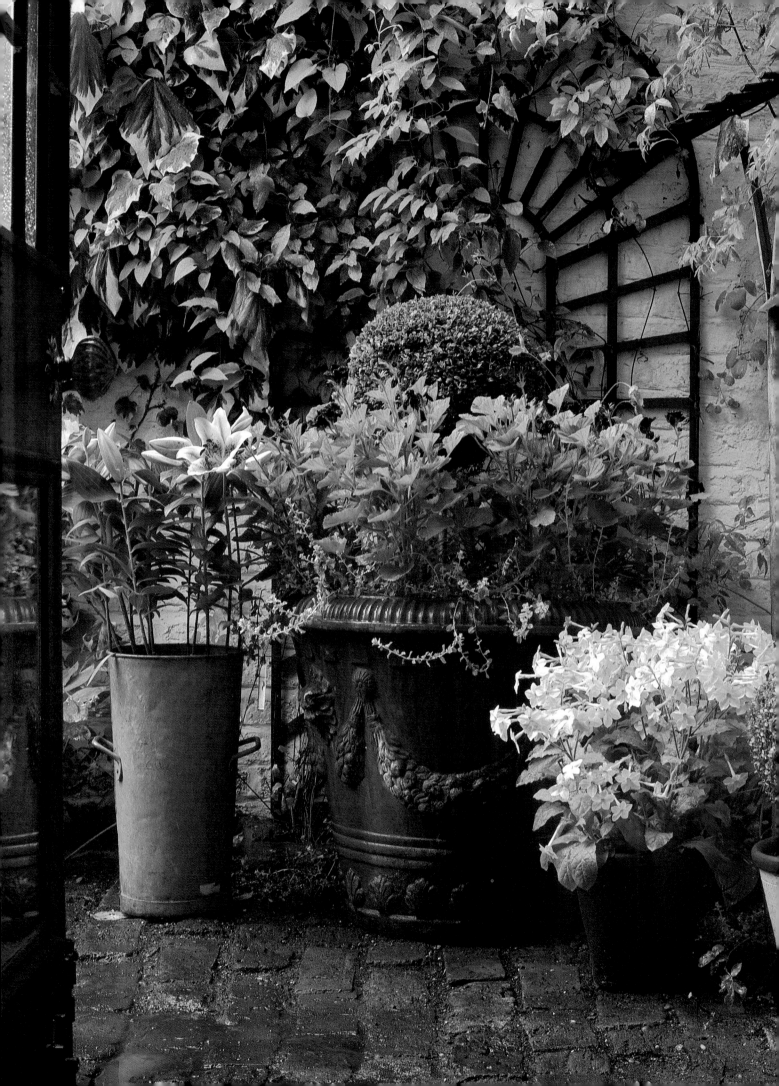

🌿 I used a zoom lens to pick out this painted antique watering can.

(Olympus OM10, 80–200mm zoom lens, Fujichrome Velvia, f11, tripod.)

🌿 Light rain has made these pots of *Lilium speciosum* var. *rubrum* sparkle. As the garden is so small, I was forced to use a wide-angle lens in order to get both pots of lilies in the picture.

(Pentax 6 × 7, 55mm wide-angle lens, Fujichrome Velvia, f16, tripod.)

🌿 I used a zoom lens to fill the frame with this wall-mounted ornament.

(Olympus OM10, 80–200mm zoom lens, Fujichrome Velvia, f11, tripod.)

🌿 It was pouring with rain when I took this shot through the back door of Anthony Noel's flat. The rain, coupled with bright, diffused lighting, has actually enhanced the green foliage so that the whole picture shines. The doors create an effective frame for the scene, leading the eye to the terracotta containers and wall.

(Bronica 6 × 6, 80mm lens, Fujichrome Velvia, f16, tripod. Anthony Noel's garden, London.)

SELLING YOUR PICTURES

Seeing your own photographs reproduced in print can be immensely satisfying. I remember very clearly experiencing a great rush of adrenalin when I first saw my pictures splashed across the pages of a national photographic magazine. Ecstatic, I raced off to the local newsagent, bought twenty copies of the magazine, and dashed home to show all my family and friends. Today, seven years on and with thousands of photographs in print, I still get that buzz of excitement every time one of my pictures is published.

Taking garden images that are suitable for publication is not that difficult. Anyone who is able to use a 35mm SLR camera with a reasonable degree of competence has the potential to produce saleable garden photographs, even if he or she has little or no knowledge of plants. What *is* difficult is finding and then reaching the right market for your garden pictures. There is, for example, no point in trying to sell a picture of a clematis, even if it is beautifully composed and pin-sharp, to a publisher who is producing an illustrated book on fuchsias. On the other hand, for a magazine editor who is looking to illustrate an article on climbing plants, the clematis photograph may be perfect. It may sound obvious, but the most successful garden photographers are those who are consistently able to supply editors and art buyers with *exactly* the right images time and time again.

RESEARCHING AND APPROACHING THE MARKETS

If the golden rule of successful freelancing is to provide picture buyers with the images that they need, how do you go about finding out what these requirements are? The answer is to research your markets thoroughly *before* you make any attempt to submit any of your work.

Without doubt, the biggest market for freelance photographers is the world of publishing – newspapers, magazines, books, part-works, calendars, greeting cards, postcards and posters. All provide potential outlets for plant and garden photography, so study these markets carefully and familiarise yourself with the kind of garden images that are being used by these mediums – I spend at least half a day a week browsing through bookstores, gift shops, newsagents and garden centres in order to keep up-to-date with the latest publications.

Once you have decided where in the market you think you have a good chance of selling your work, the next step is to go ahead and actually start submitting your pictures for possible publication. Sometimes it is useful to phone the editor or picture buyer before submitting your work, to make sure that they are interested in seeing what you have to offer. Even if they are not looking for the subjects you have at the moment, don't be put off. Use your call as an excuse to find out what they would like to see pictures of in the future, then go all out to take exactly those kinds of pictures.

❧ Magazines, books, calendars and greetings cards are all potential outlets for your plant and garden photographs.

When preparing a submission, always give a clear indication of the use to which you feel the material should be put. For example, if you have targeted a specialist gardening magazine and you have half-a-dozen striking plant portraits, you may feel that they should be considered as possible front-cover material, so say so. If, on the other hand, you have documented a single garden, then indicate clearly that you feel the set should be used as a feature on that garden in the magazine. By having a clear goal for your pictures you are actually increasing the chances of having your material published, because the editor can immediately see a use for the images you have submitted.

Of course, if your submission is sub-standard, it will almost certainly be rejected. Make sure, therefore, that you edit your selection ruthlessly. Even one poorly composed or out-of-focus picture can spoil a portfolio. Always submit top-quality, original transparencies – *not* prints – for possible publication. As a general rule, transparencies should be pin-sharp and around $\frac{1}{3}$ to $\frac{1}{2}$ a stop under-exposed with deep, saturated colours. Never send transparencies which are out of focus, unsharp or washed-out and over-exposed, as these will be unsuitable for reproduction.

The format of the pictures that you take can influence your chances of making sales to printed media markets. If an art buyer or editor is presented with two transparencies of a similar garden scene – one taken on 35mm film and the other on medium-format roll film – the chances are that he or she will choose the medium-format image rather than the 35mm one, simply because the larger transparency looks more impressive on the lightbox. I am not saying that medium format is necessarily better than 35mm, just that it can sometimes have a greater impact.

Good presentation of your material is also crucial. Potential picture buyers receive lots of pictures every day, so for your set of images to stand out above the rest, they need to be pre-

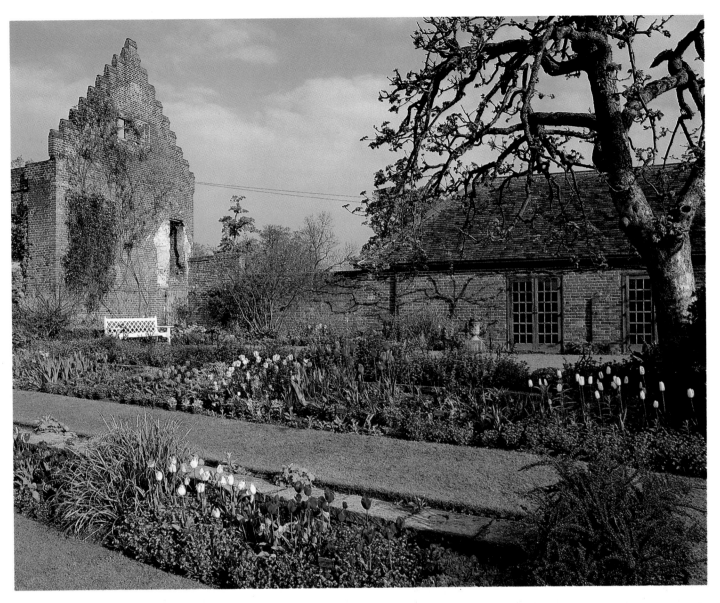

sented in a neat and professional manner. Transparencies should be properly mounted in plastic or card masks and placed in plastic slide-wallets for easy viewing. Cataloguing your slide collection will help you to find the right picture more easily. Use a straightforward A–Z or numerical system. Transparencies should be well captioned, with as much information as possible printed, rather than handwritten, on the mount (I always carry a notebook with me when I am working in a garden so that I can note down plant names as I photograph them) and a reference number to identify uniquely that particular shot. A typed delivery note, listing all the pictures being sent, should also be enclosed with each submission.

Sending your precious transparencies by post can be a risky business, so make sure that you submit material in a padded or hard-backed envelope to reduce the risk of it being damaged. Always insure the contents of the submission for a reasonable sum of money in case the package is lost or damaged and enclose a stamped addressed envelope for the return of your material.

If you are serious about trying to sell your work to markets such as magazines or books, you cannot wait around for a commission. You have actually to go out and create pictures. In my first two years as a freelance garden photographer, I sold photographs for sixteen separate articles on different gardens to one British glossy magazine without ever being offered a commissioned assignment. You simply have to bombard editors and picture buyers with so much work that they are even-

✤ A combination of strong composition, bright colours and a perfect setting has made this photograph of the sunken garden at Chenies Manor, Buckinghamshire irresistible. To date the image has sold seventeen times.

(Pentax 6 × 7, 55mm lens, Fujichrome Velvia, f22, tripod. Chenies Manor, Buckinghamshire.)

tually forced to sit up and take notice of you. I have always found that if I know that my work is as good as or better than the work that is currently appearing inside a certain magazine, I will eventually be able to make sales to that market.

Obviously, shooting material speculatively can be a risky business. If you go and shoot a set of pictures that no one is interested in, you may well have

thrown a lot of money down the drain. But after a while you should begin to understand *exactly* what kinds of pictures each market requires.

If you are unhappy about selling, or simply do not have the time to market your own pictures, you may want to consider placing your work with a photographic library which specialises in this kind of material. The library acts as a sort of 'middle-man', receiving submissions from photographers and then marketing this material to a large, even worldwide, market.

PROMOTION

If you are serious about selling your garden pictures on a long-term basis, you will need to think very carefully about promoting not just your work but yourself as well. A well-presented, extensive portfolio of beautiful pictures is obviously an important starting point, but don't under-estimate other promotional tools such as advertising, personalised stationery, business cards, published work and personal recommendation.

Many people believe that advertising yourself and the photographs you take is an expensive exercise, but nothing could be further from the truth. If, for example, you have several pictures published in a gardening magazine, go out and buy half-a-dozen copies and mail these to other rival magazine editors with a covering note detailing other shots that you have in your collection. If any of the editors are looking for the kind of material that you are offering, the chances are that they will be in contact with you. In this example, for the price of a few copies of the magazine and a first-class stamp, you will have picked up a useful contact for the future.

OBTAINING PERMISSION AND GIVING SOMETHING BACK

If you are fortunate enough to have a photogenic garden of your own, then you have the distinct advantage of being able to carry out your picture taking whenever you wish without having to seek permission for photography. However, if you are not lucky enough to own a garden, or you simply

Even the most simple photograph can earn you money if marketed in the right way. This image of a perfect lawn with stripes has been used as a background for a magazine feature on lawnmowers.

(Bronica 6 × 6, 80mm lens, Fujichrome Velvia, f16, tripod.)

wish to capture the wealth of design ideas and plantings to be found in other gardens, then there are certain practices which need to be observed.

As a general rule, hand-held photography is permitted free of charge in most gardens which are open to the general public. However, many of the larger gardens which are owned by organisations are now starting to charge a fee for photography with a tripod. Although this may seem a little unfair on the photographer, it is worth remembering that in recent years the costs of running a garden have risen considerably and as a consequence owners have had to become more commercially minded. It is therefore always

advisable to check in advance whether a tripod can be used and if a fee is payable.

Thankfully, most gardens open to the public which are owned by private individuals do not charge for photography. Obviously, if the garden is owned by a friend, then a quick telephone call may be all that is needed to receive permission to take pictures, but if the garden owner does not know you, it is always best to send a letter requesting permission well in advance of your intended visit. By doing this you will be giving garden owners a chance to say 'yes' or 'no' without putting them under any pressure.

Never forget that working in someone else's private garden is a great honour. Making and maintaining a beautiful garden can take an immense amount of time and effort and owners deserve to be given something back in return for their generosity in allowing you to record their own artistry. For this reason, I have a policy of sending owners a set of prints or transparencies of the pictures that I have taken of their gardens as a way of thanking them.

Gardens to Visit

The Royal Horticultural have several gardens located throughout Britain where photographers will find masses of inspiration. At Wisley Gardens there is a modest scale of fees for photography; however, for people with hand-held cameras who want to photograph for their own records, there is no fee. For other photography, including the use of a tripod, please enquire before you enter the garden. Rosemoor and Hyde Hall currently have no fees. Please check times before travelling.

RHS Garden, Wisley
Woking
Surrey GU23 6QB
Tel: 01483 224234

RHS Garden, Rosemoor
Great Torrington
Devon EX38 8PH
Tel: 01805 624067

RHS Garden, Hyde Hall
Rettendon
Chelmsford
Essex, CM3 8ET
Tel: 01245 400256

Other RHS affiliated gardens of interest are:

Sir Harold Hillier Gardens
and Arboretum
Jermyns Lane
Ampfield, Romsey
Hampshire SO51 0QA
Tel: 01794 368787

Harlow Carr Botanical Gardens
Grag Lane
Harrogate
North Yorkshire HG3 1QB
Tel: 01423 565418

University of Liverpool Botanic
Gardens
Ness
Neston
South Wirral L64 4AY
Tel: 0151 336 2135/7769

Acknowledgements

I would like to extend my thanks to the following people who have helped me with my photographic career: Jane, my wife, for her faith and constant support; my mother and father for helping me in my first photographic endeavours; Brian Didriksen for being so generous with advice on photography and for lending me so much of his photographic equipment; Anthony Noel and Eluned Price for their friendship and support over the past few years and, finally, Nigel Warren at Colour Processing Laboratories Limited, Reading, for processing my films so expertly.

Special thanks are also due to the following people who have helped in the production of this book: Jo Weeks, Sue Cleave and Piers Spence at David & Charles for their understanding and patience; Roger Hammond for his sympathetic design; Susanne Mitchell of The Royal Horticultural Society for her guidance; Eluned Price and Lee Frost for help with text and Jonathan Topps at the Fuji Photo Film Ltd for loan of film and equipment.

Picture Credits

I would like to thank the following owners whose gardens are featured in this book: Sandra and Nori Pope, Malley Terry, Gilly Hopton, Jack Swan, Rosemary Verey, Esther Merton, John Bond, Daphne Foulsham, Len and Wendy Lauderdale, Ann Huntington, Colonel Watson, Pam and Peter Lewis, Mr and Mrs Norton, The Hon Mrs E. Healing, Anthony Noel, Carol and Malcolm Skinner, Wendy Francis, Mr and Mrs D Hodges, Mr and Mrs J Heywood, Eluned Price, Hugh and Judy Johnson, Lady Clark, Pru Leith, Alistair and Elizabeth MacLeod Matthews, Pam and Nicholas Coote, Lesley Jenkins, Beth Chatto, Dr and Mrs G Thomas, Derrick and Rowlatt Cook, David Hicks, Ros Wallinger, The Cottrell Dormer family, Margaret Fuller, Caroline Cordy, Mr C.H. Bagot, Mrs R. Paice, Caroline Todhunter, Roy and Barbara Joseph, Lady Taylor, The Hon Peter Ward, Lady Anne Rasch, Paul Picton, The Vestey family, Mr E. L. de Rothschild, Chris and Donna Dumbell, Mr and Mrs J.A. Goodall, Anthony Paul and Hannah Peschar, Mr and Mrs Glynne Clay, Barrie Hindon, Candida Lycett Green.

Index